Dec -

MW00332512

To celebrate
one of your many
loves,

from the one
who loves
you!

Merry Christmas

Bob Langrish's
WORLD OF HORSES

The mission of Storey Publishing is to serve our customers by
publishing practical information that encourages
personal independence in harmony with the environment.

English-language edition published in 2018 by
Storey Publishing
210 MASS MoCA Way
North Adams, MA 01247
storey.com

All rights reserved. No part of this book may be reproduced without written permission
from the publisher, except by a reviewer who may quote brief passages or reproduce illustrations
in a review with appropriate credits; nor may any part of this book be reproduced, stored
in a retrieval system, or transmitted in any form or by any means — electronic, mechanical,
photocopying, recording, or other — without written permission from the publisher.
The information in this book is true and complete to the best of our knowledge.
All recommendations are made without guarantee on the part of the author or Storey Publishing.
The author and publisher disclaim any liability in connection with the use of this information.
Storey books are available for special premium and promotional uses and for customized editions.
For further information, please call 800-793-9396.

ISBN: 9781635861259
Copyright © 2018 by Editions Glenat
Couvent Sainte-Cécile
37 rue Servan,
38008 Grenoble

This book was conceived, designed, and produced by Editions Glenat

Printed in Belgium by Graphius
10 9 8 7 6 5 4 3 2 1

Library of Congress Cataloging-in-Publication Data on file

Bob Langrish's WORLD OF HORSES

Text by **Jane Holderness-Roddam**
Foreword by **George H. Morris**

Storey Publishing

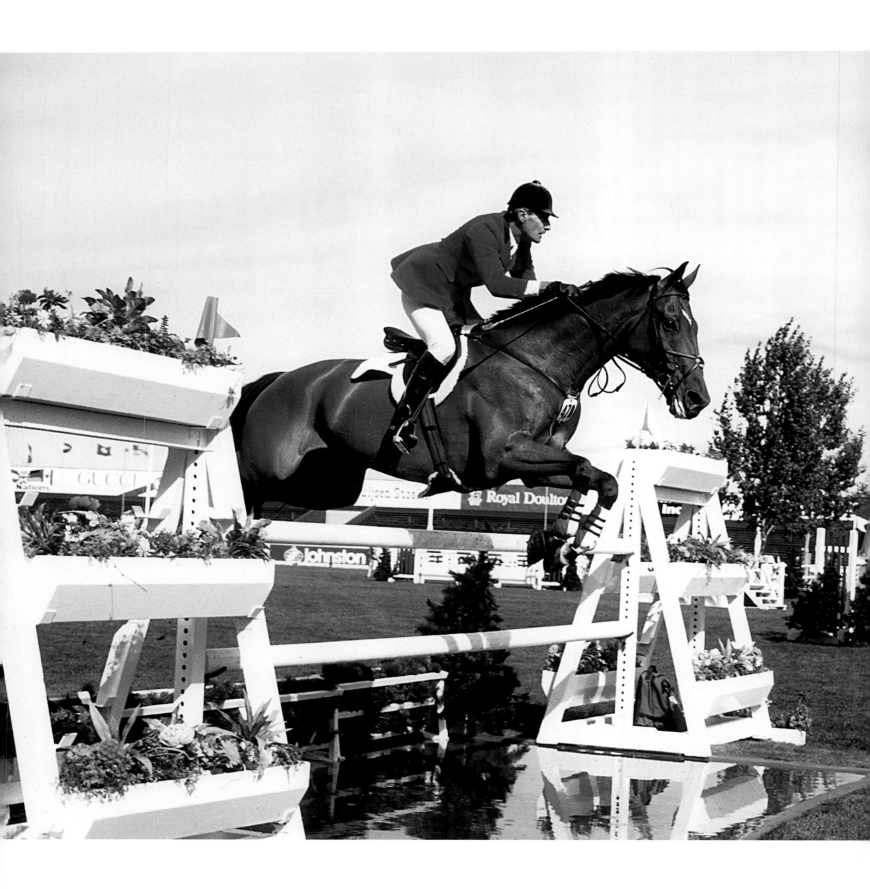

FOREWORD

I have known Bob Langrish for more than 30 years, during my competitive and training career and also while I was chef d'equipe to the American show jumping team. I have worked with him on some of my books and on articles for magazines around the globe. Bob is internationally acclaimed as one of the world's top equestrian photographers.

His other passion, away from the competition scene, is the horse at liberty, photographing breeds from around the world. Bob has put his expertise into capturing the beauty, agility, and presence of the horse "running free" with as great an impact as his photographs of competing horses.

The anecdotes and funny stories that complement the pictures will enhance the book and imbue it with a human interest. I am sure that Bob, like me, will have many more situations and experiences that cannot be printed, as we have both travelled the world extensively.

Jane Holderness-Roddam's words will further the book's success. I also know Jane very well. She is an Olympic gold medallist, and since she is involved in many different areas of the equestrian world, her knowledge is vast.

George H. Morris
Olympic Medalist and Chef d'Equipe,
U.S. Equestrian Team

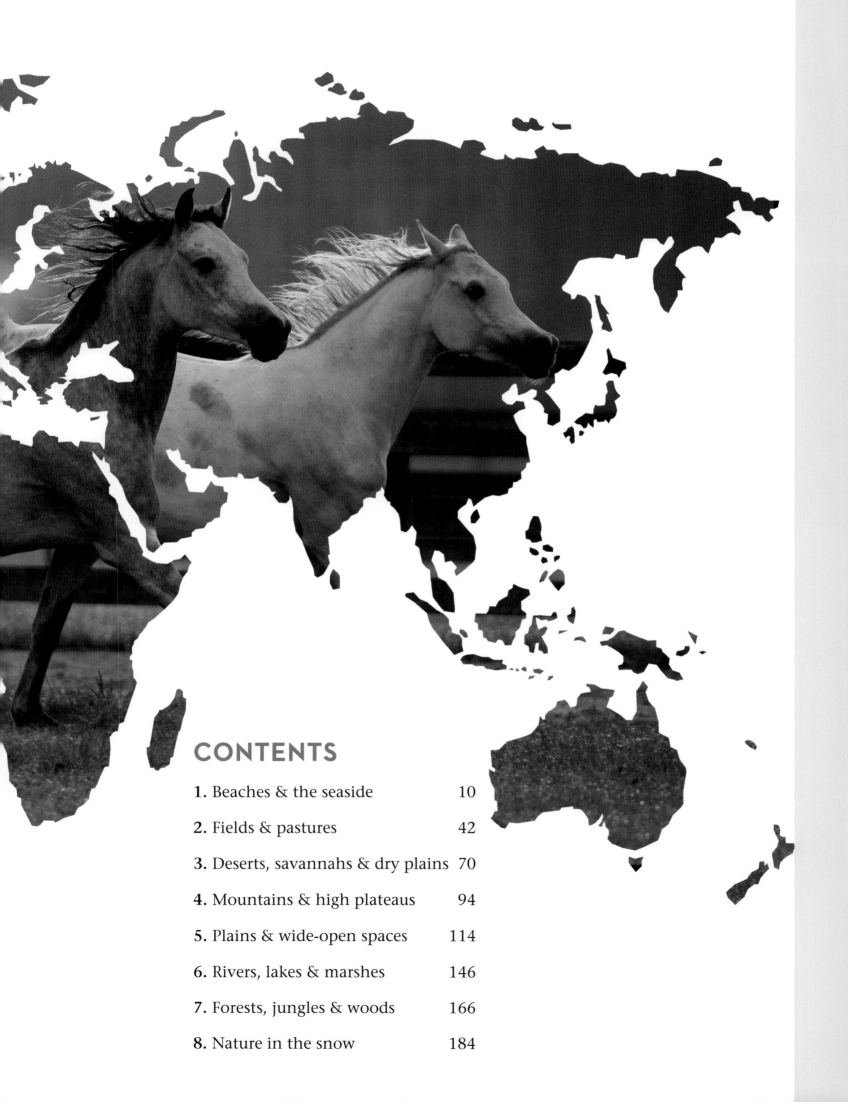

CONTENTS

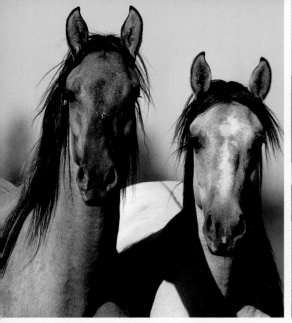
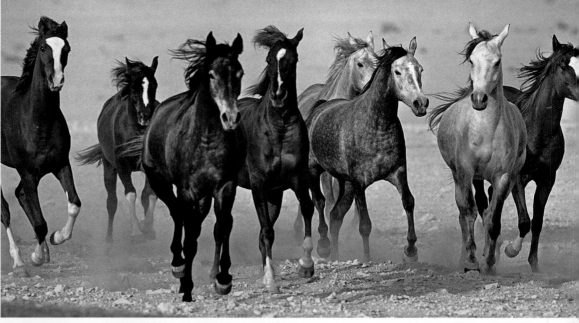
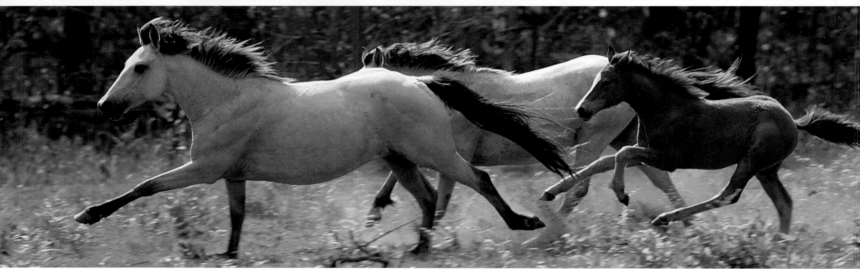

Bob Langrish's *A World Of Horses* presents magnificent insights into four decades of travelling the world photographing horses and ponies, both in their natural habitats and in domestication all over the globe.

Bob's pictures depict some of the most beautiful animals on earth in stunning surroundings. Accompanying these images are numerous stories of how he was able to take some of these pictures despite real hazards and unforeseen obstacles that arose during photo shoots. Sometimes, even the best-made plans just did not work, and hours of meticulous planning occasionally came to nothing because of unexpected pitfalls. It is not possible to predict the outcome of every photographic scenario!

I have known Bob for most of my writing career, and his passion for these beautiful animals is clear in the way he presents his subjects to the viewer, catching not just their images, but their characters. He has often had the opportunity to share a wealth of fascinating background information on how some of the breeds came into being, their histories, or how they were handled when first discovered—such as with a herd of Nevada Mustangs he photographed in a holding pen in the USA.

Bob learnt that inmates from the local jail had been assigned to break in the Mustangs so that they could then be sold to the public for $125 each. This program was supervised

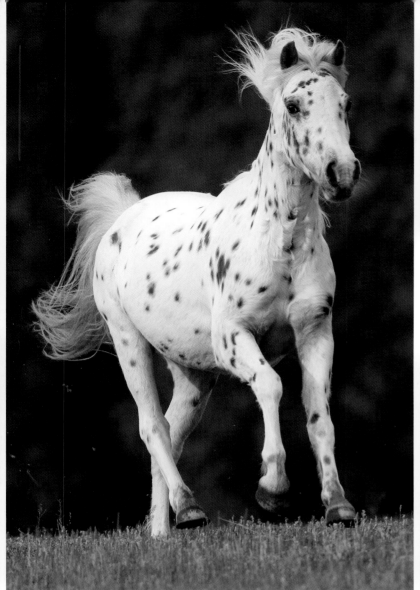

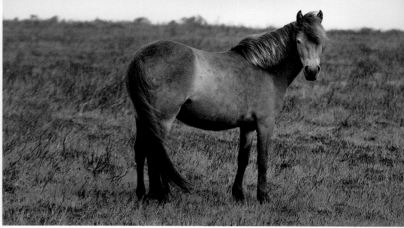

INTRODUCTION

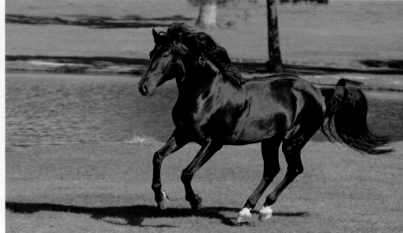

by the Bureau of Land Management, which monitors and oversees the training and welfare of these horses. It seemed a win-win situation to Bob, as it gave the inmates a useful job while also ensuring the horses had a future. They would have had a precarious existence if left to fend for themselves.

Bob's travels have taken him to virtually every region, country, and continent where horses and ponies are known to exist. He has met so many amazing owners and stewards of these horses, affectionately known to those who love them as man's best friend. He has walked with kings and sheiks, as well as with some of the poorest owners who rely on the horse for their very survival. He has seen first-hand that all share the same special bond with this special animal, which has enriched human life since time immemorial.

It has been a real pleasure for me to listen to Bob's stories of all his travels, several of these in the company of his wife, Pam. I've also had the privilege to hear how he learnt his trade, to relive with him many of his stories, and to share in his passion for photographing what must be one of nature's most endearing and revered species. The following pages are filled with his beautiful images of numerous breeds from around the world, both ancient and modern, which will surely enrich every horse lover's book collection.

Jane Holderness-Roddam

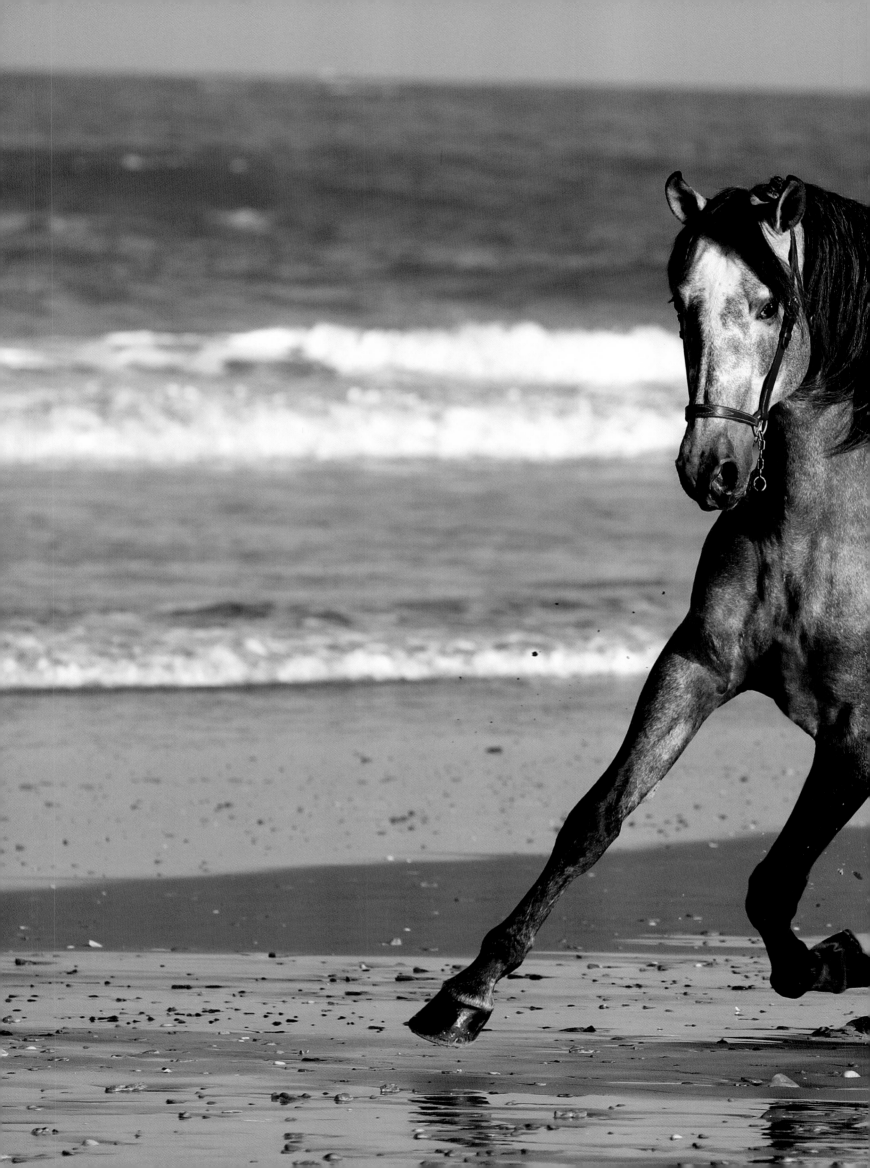

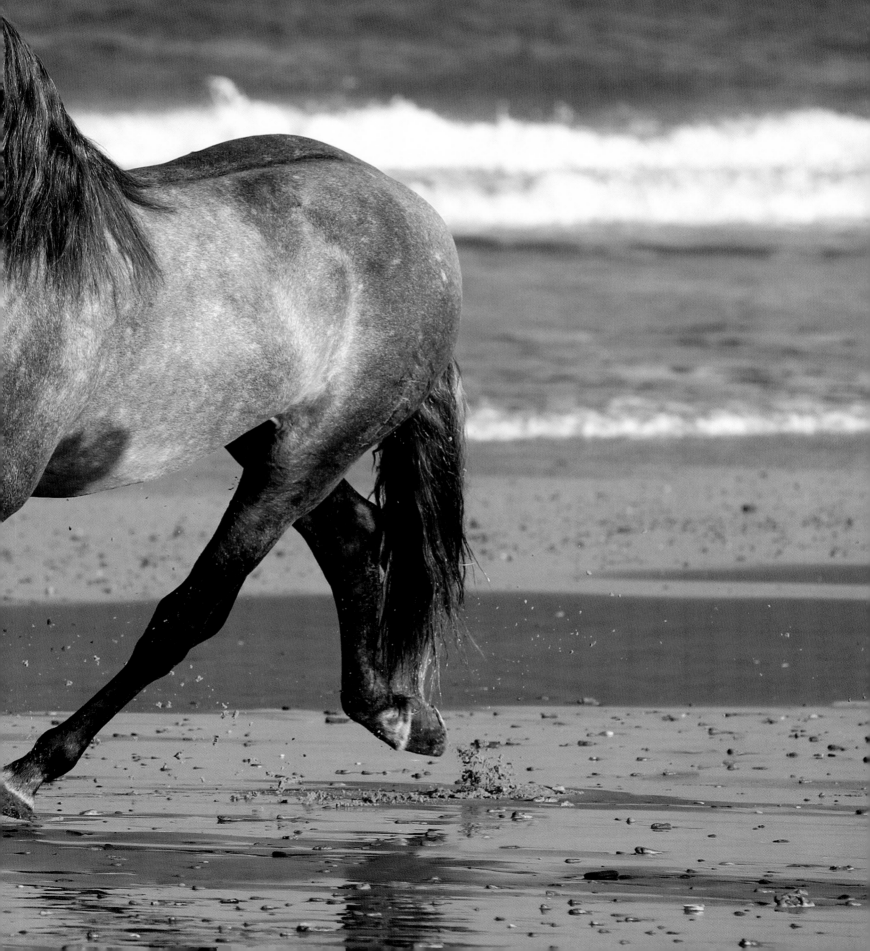

BEACHES
& THE SEASIDE

Few animals actually live beside the sea, but many breeds of horses and ponies have roamed by the seaside for thousands of years. The coastal environment is fairly harsh, with strong winds, salty waters, and sparse tough grasses and prickly shrubs on which to feed. Seaweed, however, if available, is rich in nutrients and a great source of energy.

The Camargue ponies in France are typical of these seaside marshland animals, as are the Chincoteague and Banker ponies of the USA. The Eriskay ponies of Scotland and Norwegian Fjords in northern Europe, as well as several pockets of semi-wild animals in various countries, can be seen living partially by the sea and roaming along the beaches. These animals have adapted well to their salty environment, because some of them were shipwrecked centuries ago. Pictures taken by the sea always have a dreamy feel to them because everybody loves the sea and its mystery. To get the seaside pictures required for the numerous books and magazines Bob has illustrated was not always an easy task, and Bob admits sometimes resorting to the use of more domesticated horses to get certain shots. He often had to persuade a fit groom to run the horse along the beach on the offside and then airbrush out the lead rein when required. The reason for Bob's huge collection of photos is that he always retains the copyright on all his pictures so that he can use them for future projects. He may take one hundred pictures of a subject when the publisher will only use three or four, hence the variety and scope available.

On some occasions, the horses were lightly hobbled to keep them in a certain location. Bob sometimes followed semi-wild horses and ponies to a location to catch them in the early dawn and could then photograph them rearing and playing together on the beaches. Generally, dawn and dusk are the times when most animals, particularly the youngsters, tend to play together. These are the best times to catch foals cavorting with their friends.

The Arabian, the king of all horses, is probably the most photographed of all the equine breeds. Bob's pictures truly capture the magic of this spectacular breed in several waterside locations around the world. Arabs and Andalusians are Bob's two favourite breeds to photograph, as they are so expressive and beautiful.

Over the past forty years, Bob has visited most venues where horses exist, and one of his favourite occupations is to find something striking in each area he visits. In this section, he has captured some wonderful images of horses by the sea – some posed for specific projects and other occasions when he has been lucky enough to come across that perfect moment when everything just seems right!

Previous double page:
The magnificent Andalusian stallion Coqueta, owned by brandy magnate Señor Osbourne, proudly shows off his paces beside the sea in Spain. To make this picture, the trainer had to run alongside the horse on the off side; then Bob later airbrushed out the lead rein. It can be very difficult to take photographs to order in some locations and many have to be set up specially, as in this case, but what a fabulous result! ❶

Opposite:
This young bay Arabian colt owned by a Saudi Arabian prince was photographed in the Seychelles. His gleaming coat and large eyes and nostrils, typical of the breed, show off the Arabian features very well. Bob recalls asking the hotel owner if he knew of any horses in the vicinity and was pointed in the direction of this stunning location where an early morning appointment resulted in these photos. ❷

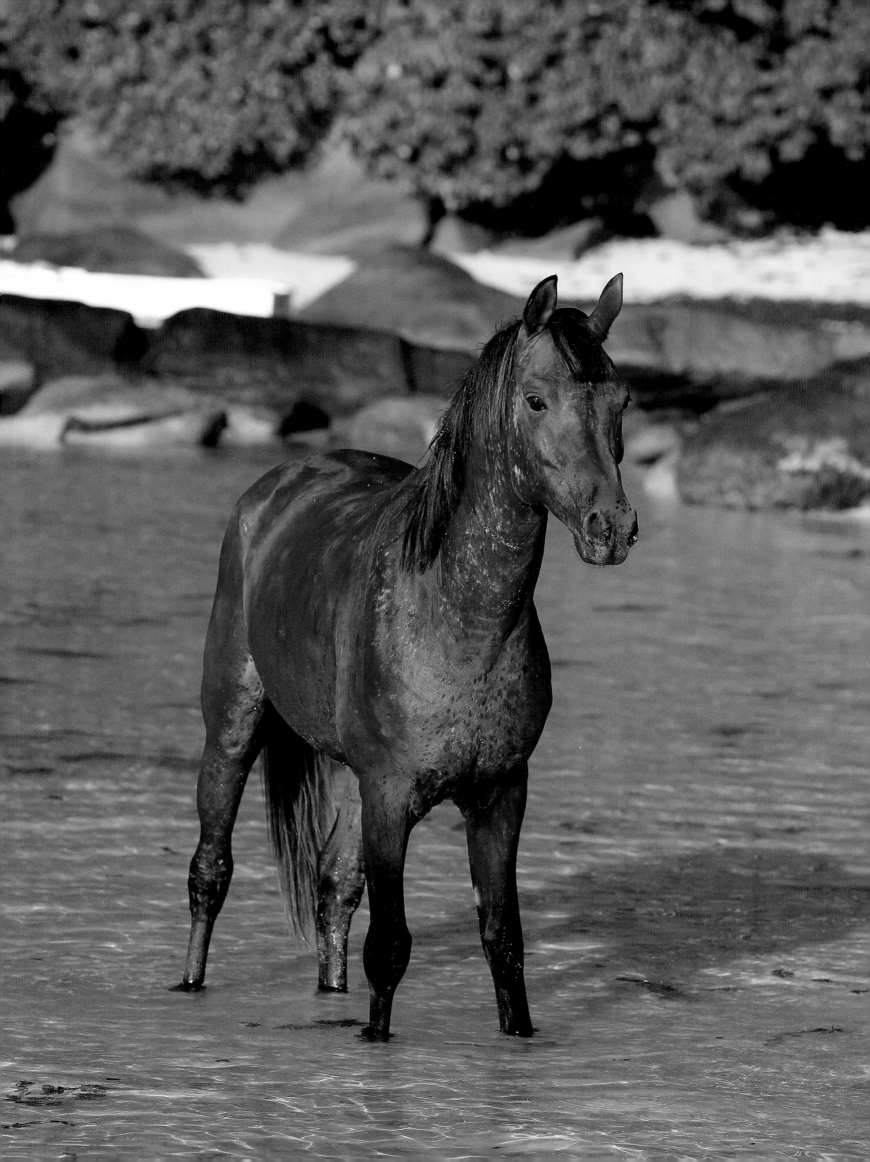

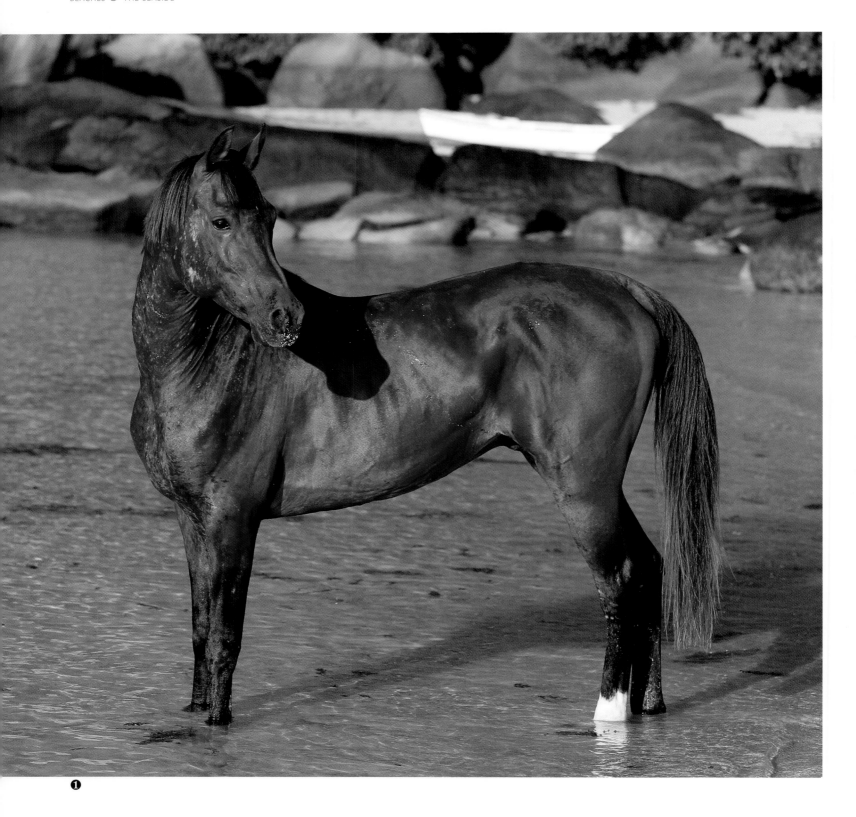

❶

The same horse as on the preceding page, shot from a different angle and looking back at the photographer. Bob excels at drawing attention to the camera by making strange noises. His efforts almost always have the desired effect of getting the animals to look round in this way. To keep this valuable colt in place long enough to get some photos, he was lightly hobbled to ensure he didn't run off. ❶

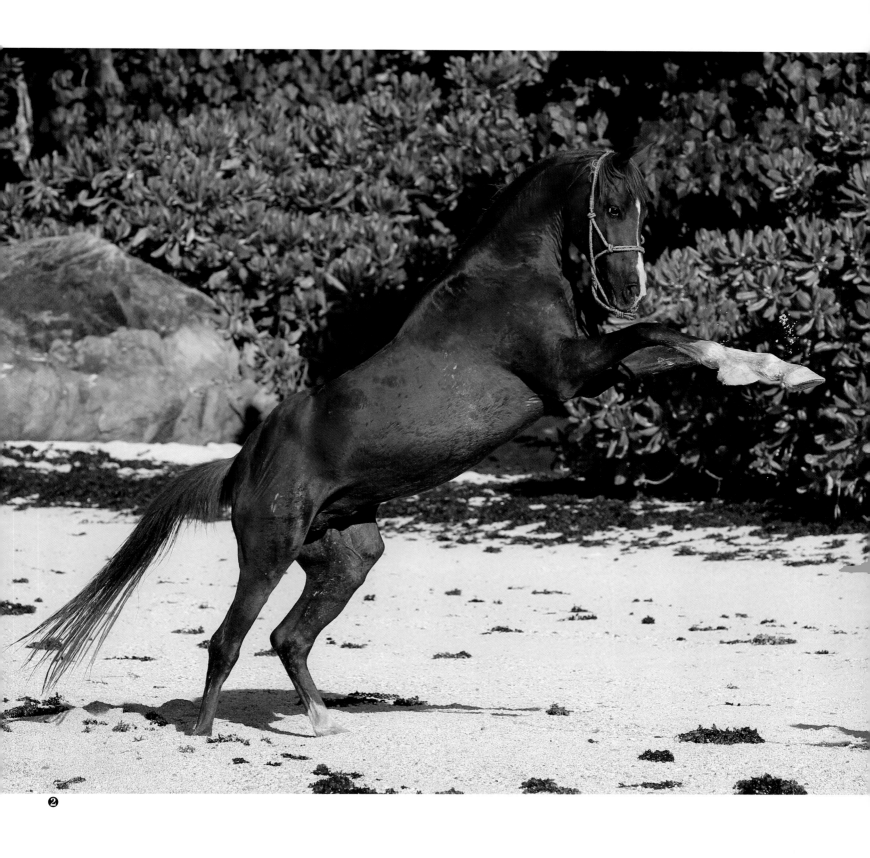

Shot in the same location, this stunning chestnut
colt was not so obliging and refused to get into
the water, but Bob managed to capture his reaction
to the sea. The saying "you can lead a horse to water,
but you can't make him drink" comes to mind!
It seems the horse's reaction had more to do with
the fact that he was more accustomed to the safety
of the desert. "You want me to go where? No, no,
I am a desert horse and definitely not a sea horse!" ❷

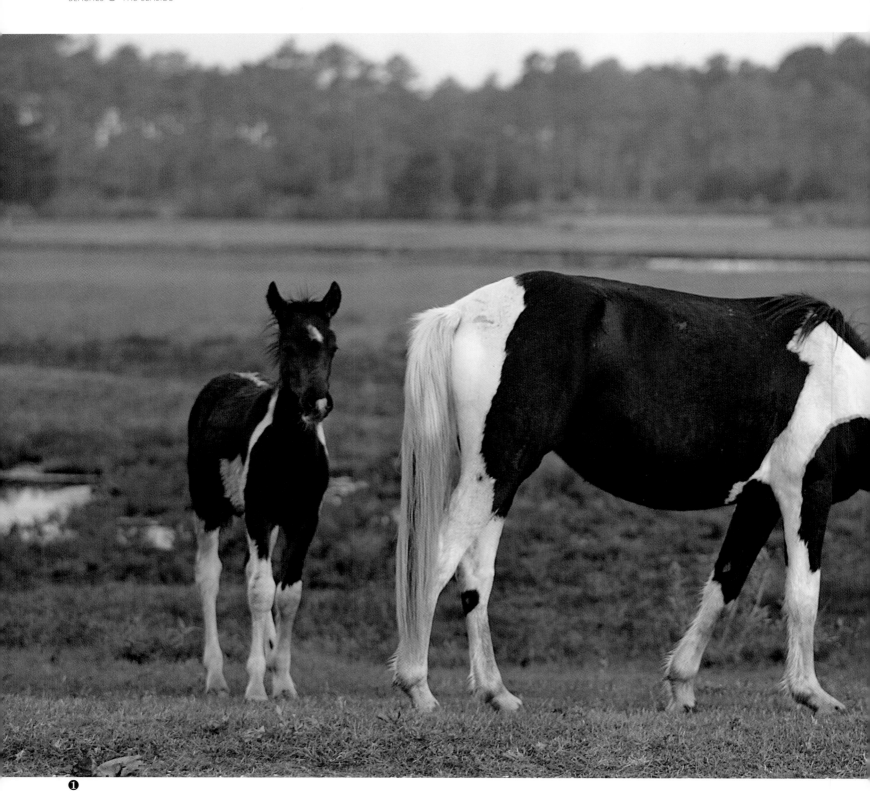

Chincoteague ponies have an interesting history. Found off
the mainland of Virginia on the islands of Chincoteague and
Assateague, they are thought to have swum ashore in the 1700s
after escaping shipwrecked Spanish galleons off the coastline.
Another theory suggests they may have been brought to the
islands at around that time by Virginian farmers keen to avoid
a livestock tax. Often pinto, they vary greatly in colour and have
adapted to the salty, marshy conditions of the region. ❶

❶❷

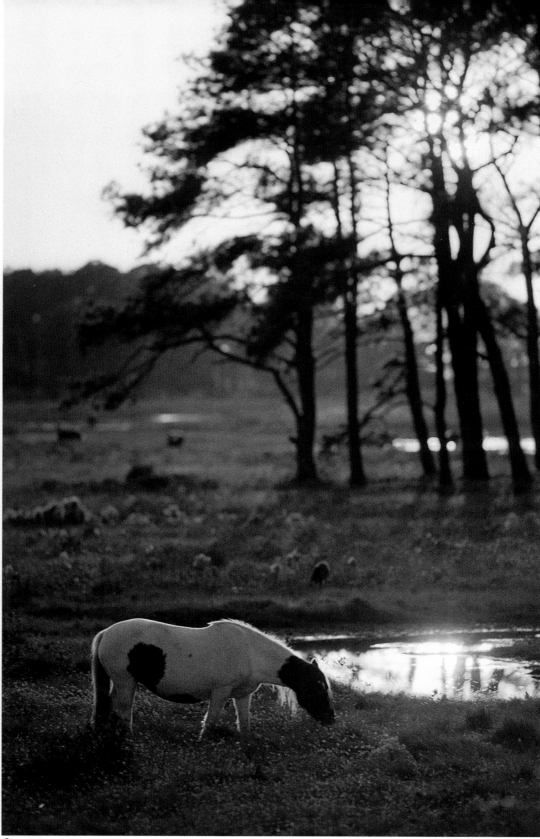

❷

The famous Chincoteague swim takes place annually on the last Wednesday and
Thursday in July. Ponies from both Islands are rounded up and swum to Chincoteague,
where they are penned for branding, health checks, and sale. Crowds of up to fifty
thousand people gather to watch the spectacular event, which generally takes
little more than fifteen to twenty minutes to actually accomplish. The breed was
immortalized by Margaret Henry's book *Misty of Chincoteague*, written in 1947 and
loosely based on the story of the weanling she bought from a Chincoteague sale.
It was later made into the film *Misty* and helped to raise funds to preserve the breed. ❷

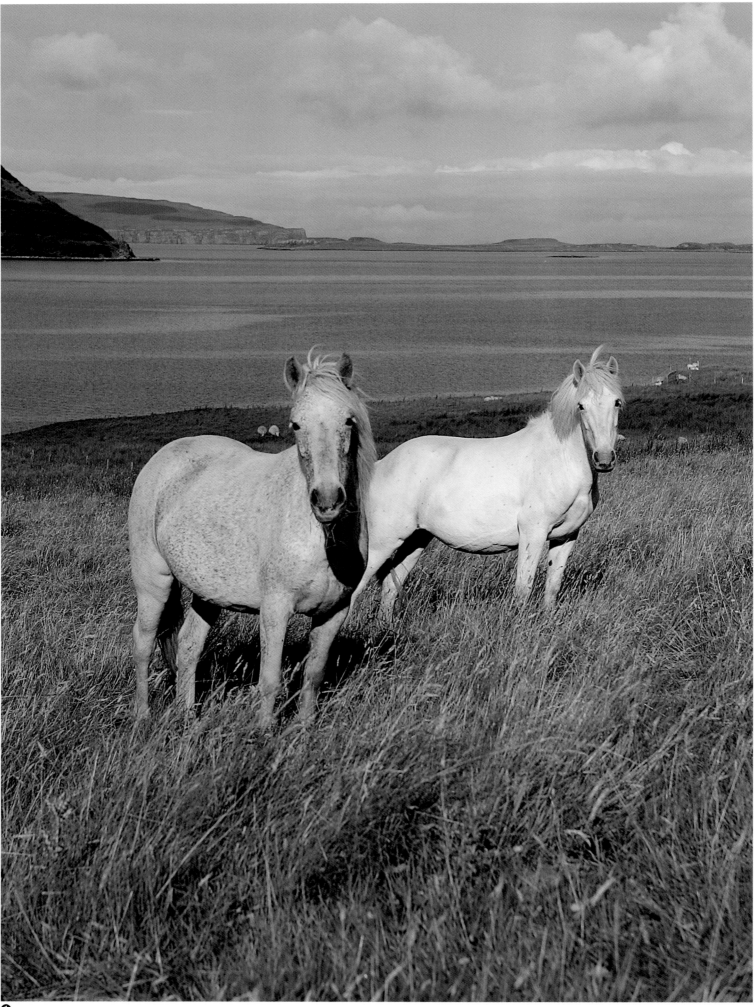

❶

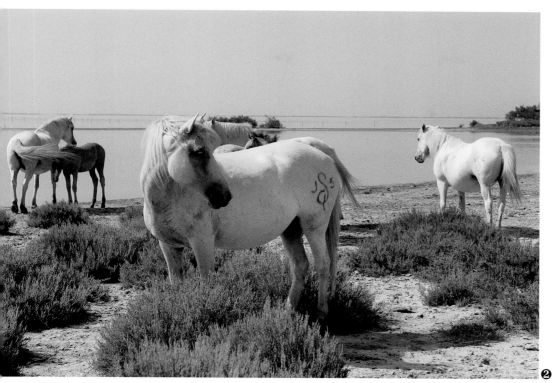

Left:
The Camargue horse of southern France is often known as the "white horse of the sea" because of its pale colouring and the location in which it lives. It is an ancient, tough breed that has existed for centuries, but there is evidence of Spanish and Arabian influence in its conformation. It is extremely calm, intelligent, and trainable. Trick rider Lorenzo, "the flying Frenchman," has enhanced the Camargue's reputation with stunning trick-riding displays around Europe, in which he performs a variety of unusual stunts while standing on the backs of a team of these horses—including jumping and vaulting them! ❷

❷

Opposite :
The rare Eriskay pony is found in the Outer Hebrides (or Western Isles) of Scotland. They are extremely tough and strong-willed, qualities which must have helped them survive the harsh conditions and made them useful for agricultural purposes on the islands. Eriskays are now on the critical list as a breed as mechanisation has taken over most of their former roles. Standing between 12 and 13.2 hands high, they are generally grey when fully grown, although they are usually born with bay, brown, or black colouring. ❶

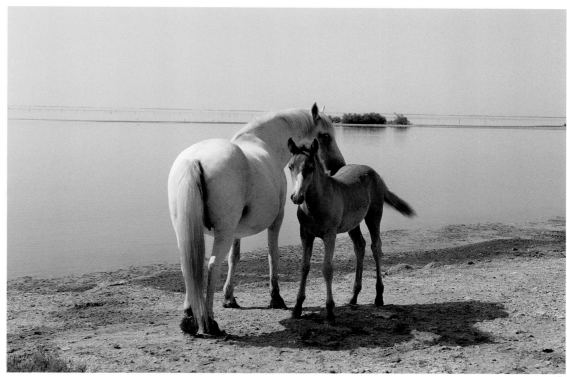

❸

❶

❷❸

Above:
"I was driving around the Camargue trying to find horses in the water, when I saw a group of them at the back of a farm house. I went to the front door of the house and asked the owner "Do you speak English?" She then asked me if I spoke French. In my bad schoolboy French, I told her that I worked for Cheval magazine in Paris and wanted to photograph the horses. She came back in perfect English, saying that her daughter's bedroom walls were full of all the poster pictures I had taken over the years. She then happily took me to the horses and directed me to other locations in the Camargue." ❸

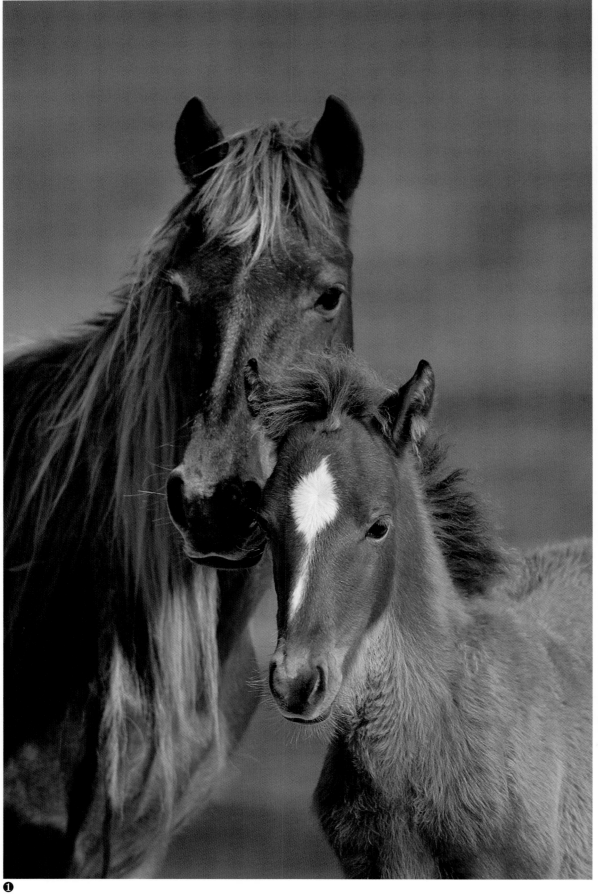

❶

❷

A lovely study of a Banker mare and foal taken on the Outer Banks of North Carolina on the Beaufort coast. As with many American breeds, the Banker horse is descended from Spanish horses brought over by explorers sent by Spain to the New World, where they served as saddle horses and agricultural workers. During the colonial era, the Spaniards' fortunes were mixed; at times, they were forced to leave their horses behind when disease took its toll or they met fierce resistance from local tribes. ❶

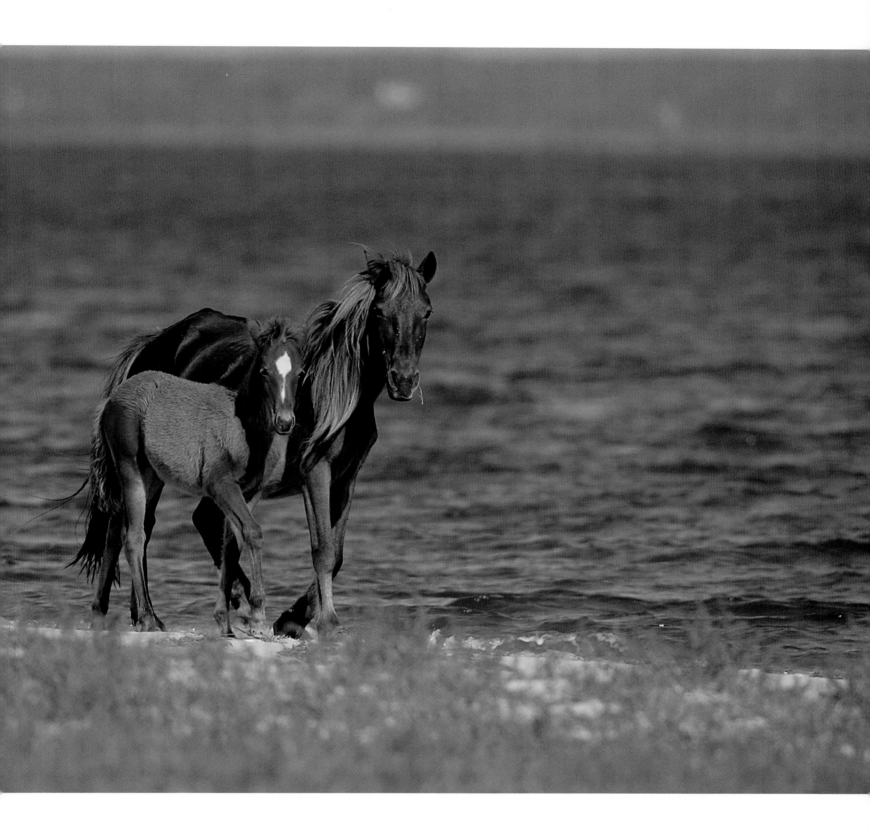

Banker horses continued to thrive as their numbers grew. It is interesting to note that many have gaited paces, which is inborn and not trained into the horses, and ensures comfortable paces for riders. Modern urbanization caused the breed to suffer considerably during the late 1990s when their traditional feeding grounds eroded and several were killed on new roads. The National Parks Service took steps to protect the horses because people recognized that this ancient and remarkably pure breed is well worth preserving. Bob recalls traveling to the islands in a small boat, and on returning to the quay he leant forward and felt the expensive lens in his pocket fall into the sea. He rang the photo company in New York as he was due in North Dakota the next day, and sure enough a replacement lens was waiting for him on his arrival the next day. Saved! ❷

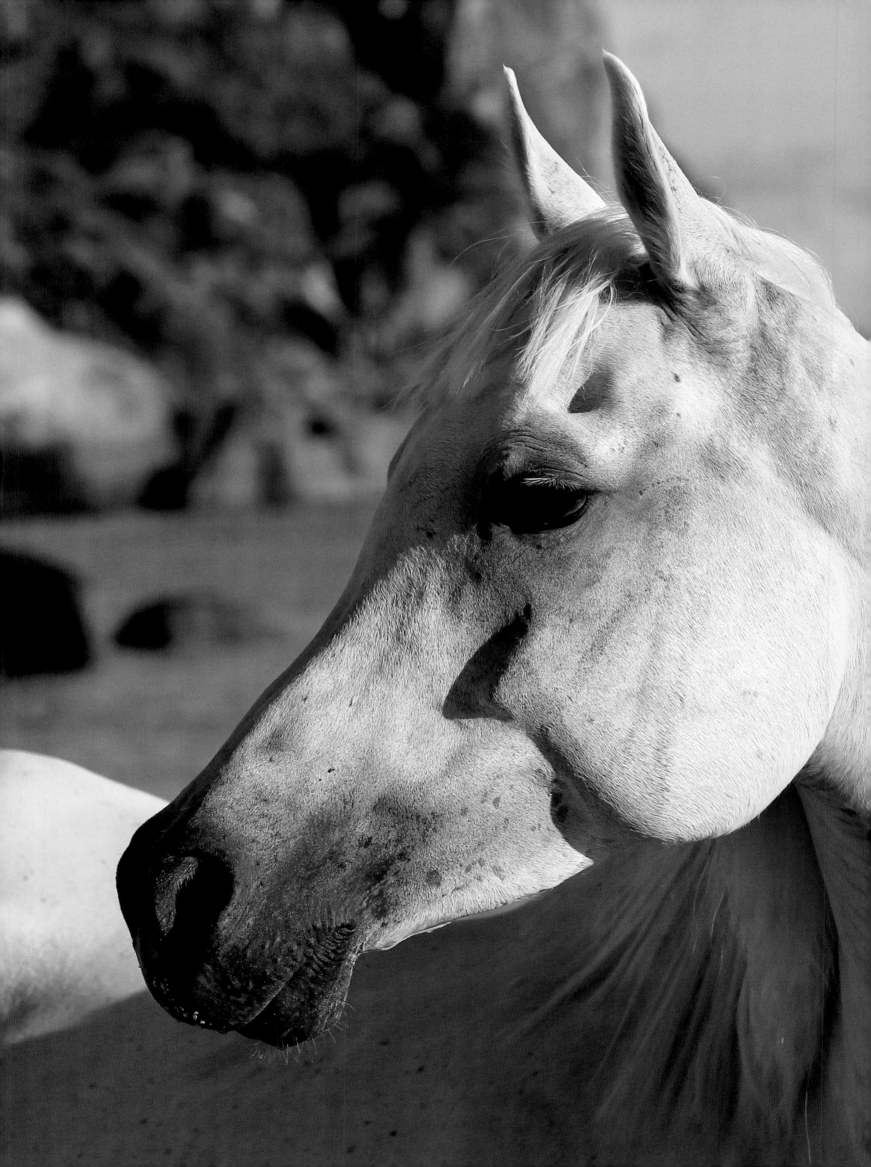

By using a long telephoto lens, the photographer can punch out the background and give a totally different perspective from other pictures set on the beach. This beautiful study of an Arabian was accomplished by lightly hobbling the horse so he could not gallop off into the unknown. ❶

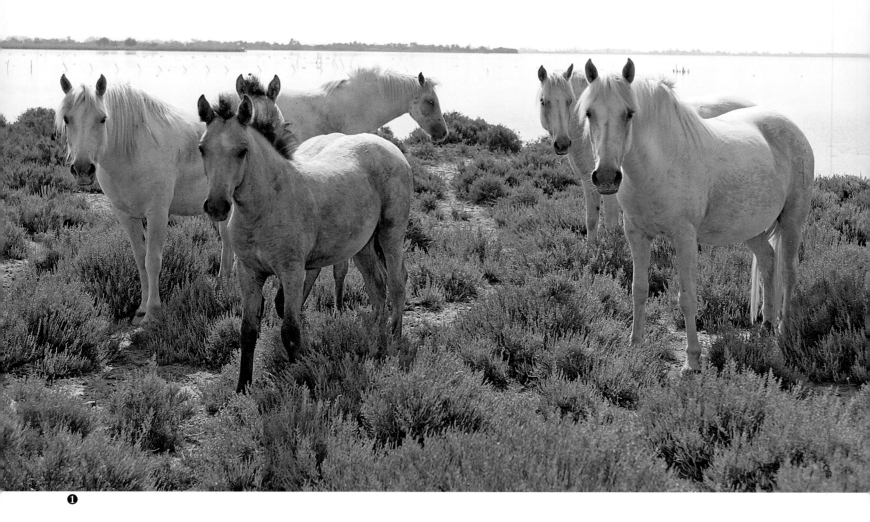

 (marker on photo)

Camargue mares and foals down by the beachfront.
The darker foal in the foreground is still showing the
bay brown colour he was born with in the brown tinge
of his mane. Greys are generally born bay, brown,
chestnut, or black, and their coats lighten in colour
each year as they age.

This Norwegian Fjord pony was a family pet and easily
persuaded to canter along the beach toward a group
of friends who had a bucket of food. Not all pictures
are so easy to achieve, but it is always a pleasure when
your subject is so obliging! This ancient breed has
remained popular in many parts of the world, thanks to
its physical strength and mild temperament. Its unusual
mane and distinctive colour are widely admired.

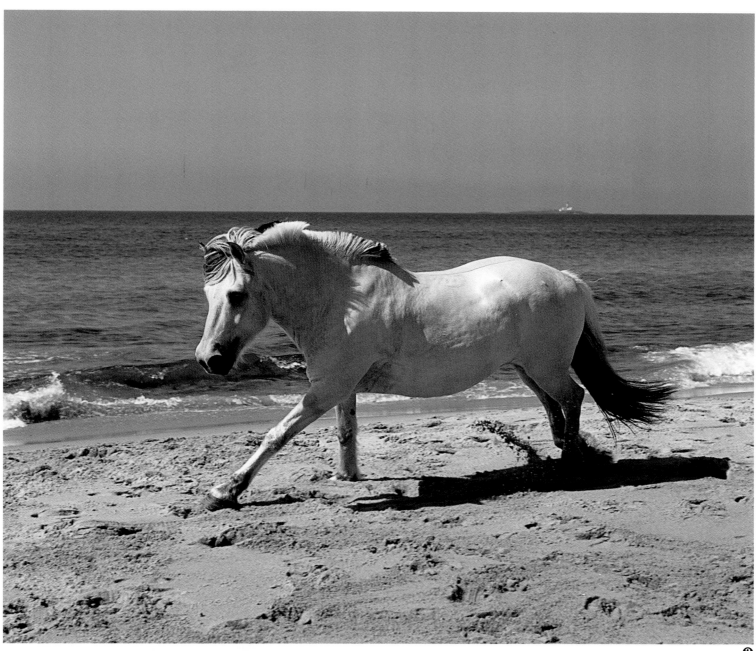

②

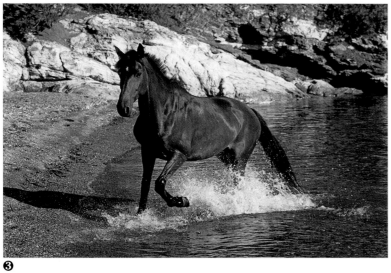

③

Bottom:
The Maremmano is a breed indigenous to Italy. Rather than take a traditional sideways conformation picture, Bob persuaded the owner to lead the horse twenty yards or so into the sea, then take off the lead rope and hope it would turn back toward the beach, which it did. "Love it when a plan comes together!" ③

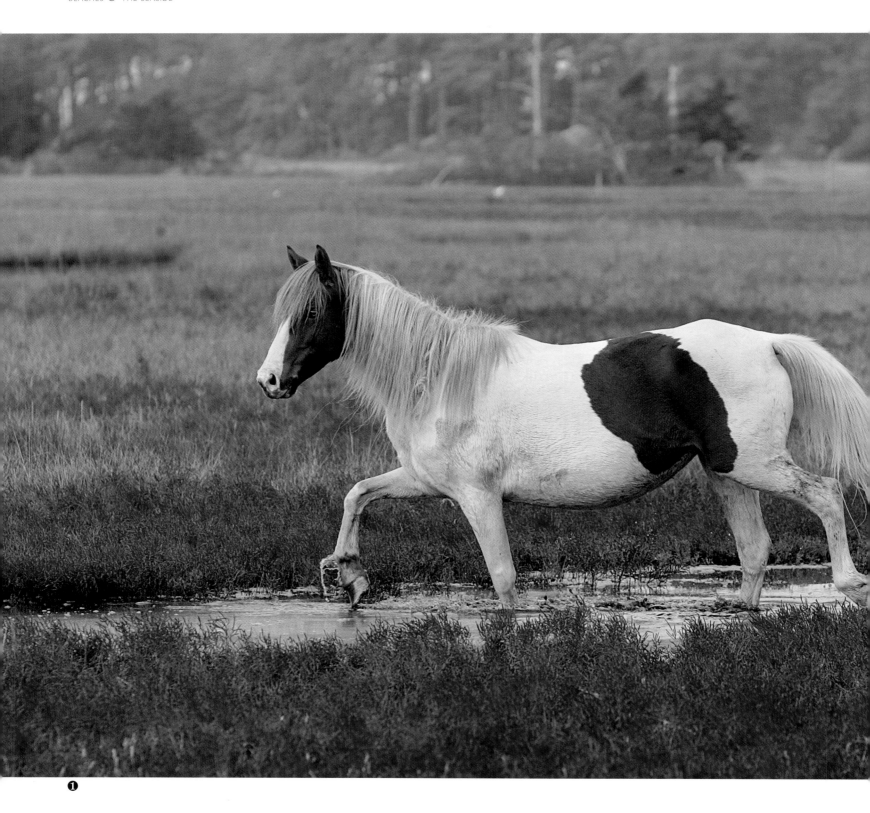

❶

A beautiful Chincoteague pony splashes through
the water with picturesque red spring flowers in
the background. The breed was made famous
by the film Misty, based on Margaret Henry's 1947
book about the Chincoteague yearling she bought
at one of the annual sales. The Chincoteague pony
has remained a favourite with American tourists
who flock to see the animals swim between the
islands of Chincoteague and Assateague each July.
A statue of Misty has been erected on the island. ❶

❶❷

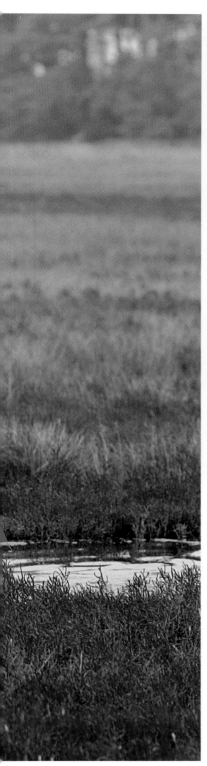

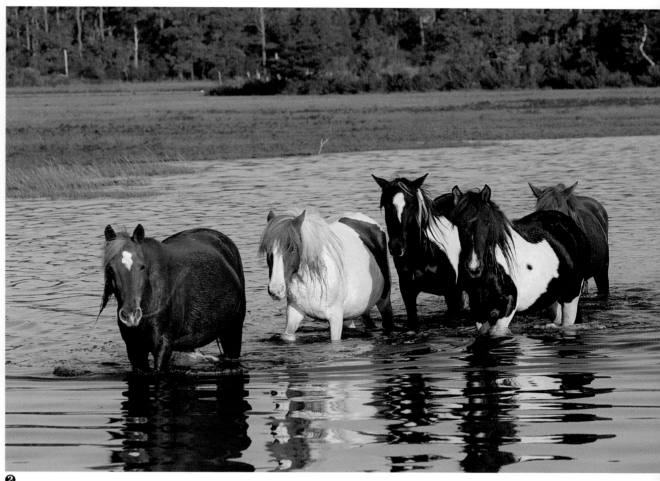

It is easy to see how happy these Chincoteague ponies are in their marshy habitat. They have adapted very well to the salty marshes, and though most initially had solid colouring, they now come in a wide variety of pinto patterns and colours. In 1990, a foundation and museum were established to ensure the breed's history and some memorabilia would remain available to educate visitors to the island on how these tough horses have survived into the 21st century. ❷

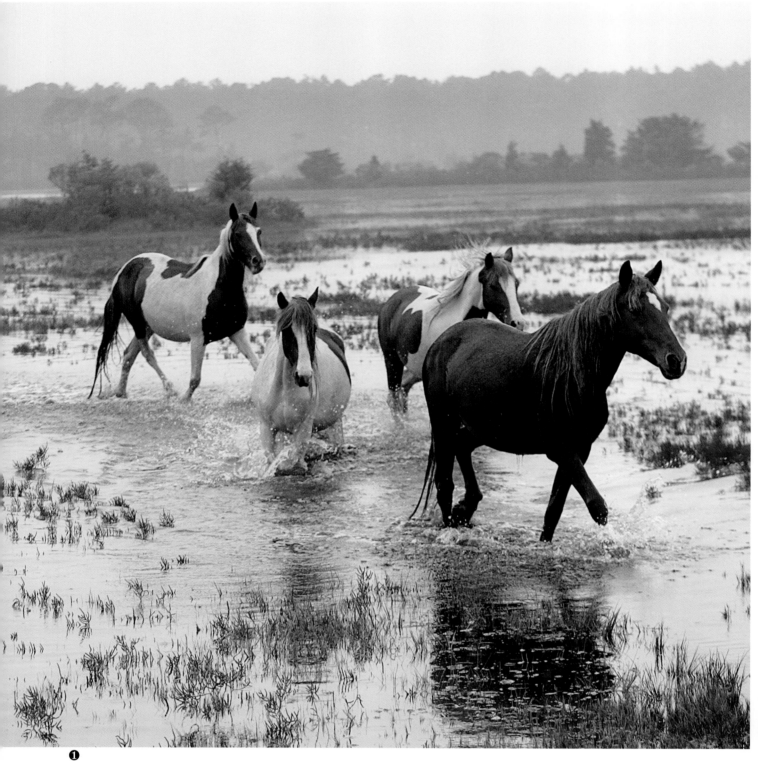

❶

❷

Splashing through the marshes against a lovely background, these Chincoteague ponies are teaching their young how to navigate the watery conditions. The practice of pony penning, in which the animals were rounded up to determine ownership, began in the early 1800s. ❶

By 1920, Assateague Island changed ownership, and most of the ponies were moved to Chincoteague Island, which had become a well-known tourist attraction. The pony penning was run by the Volunteer Fire Company which had been set up following several bad fires on Assateague Island. Originally the ponies were called Assateague horses, but after their relocation to the other island, the Chincoteague name stuck. ❷

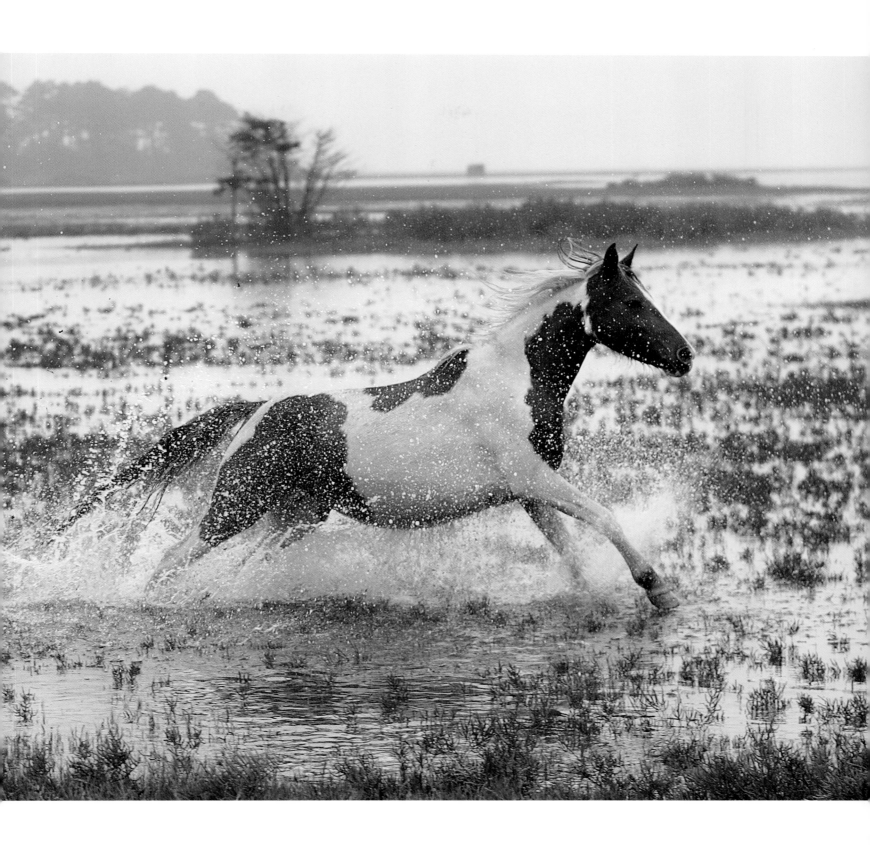

Next double page:
The thoughtful expression on this fine Arabian face
perhaps belies the fact he had to be lightly hobbled
to keep him still long enough to get several pictures.
His gleaming chestnut coat and flaxen mane are
typical colours to be found in this breed. The white
pattern down his face is called a blaze and is a great
distinguishing feature by which many horses can be
identified from a distance. ❸

❶❷

❸

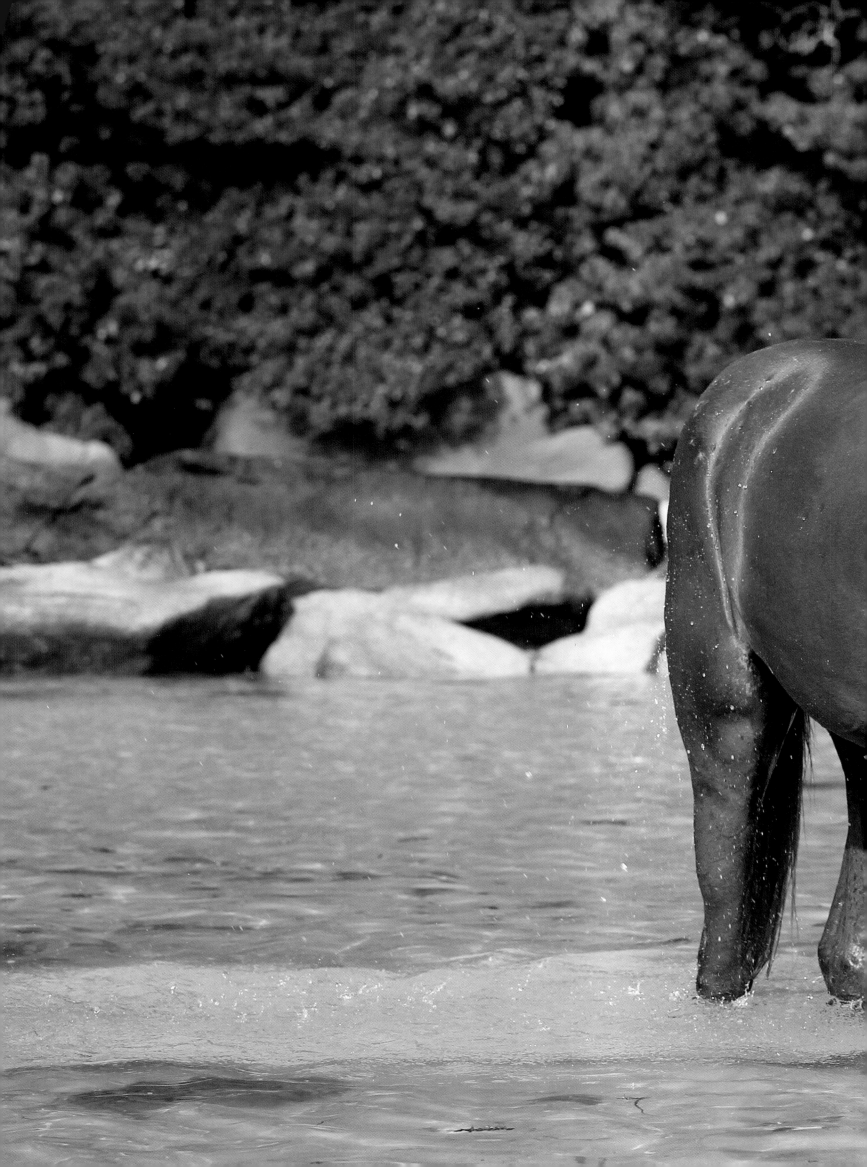

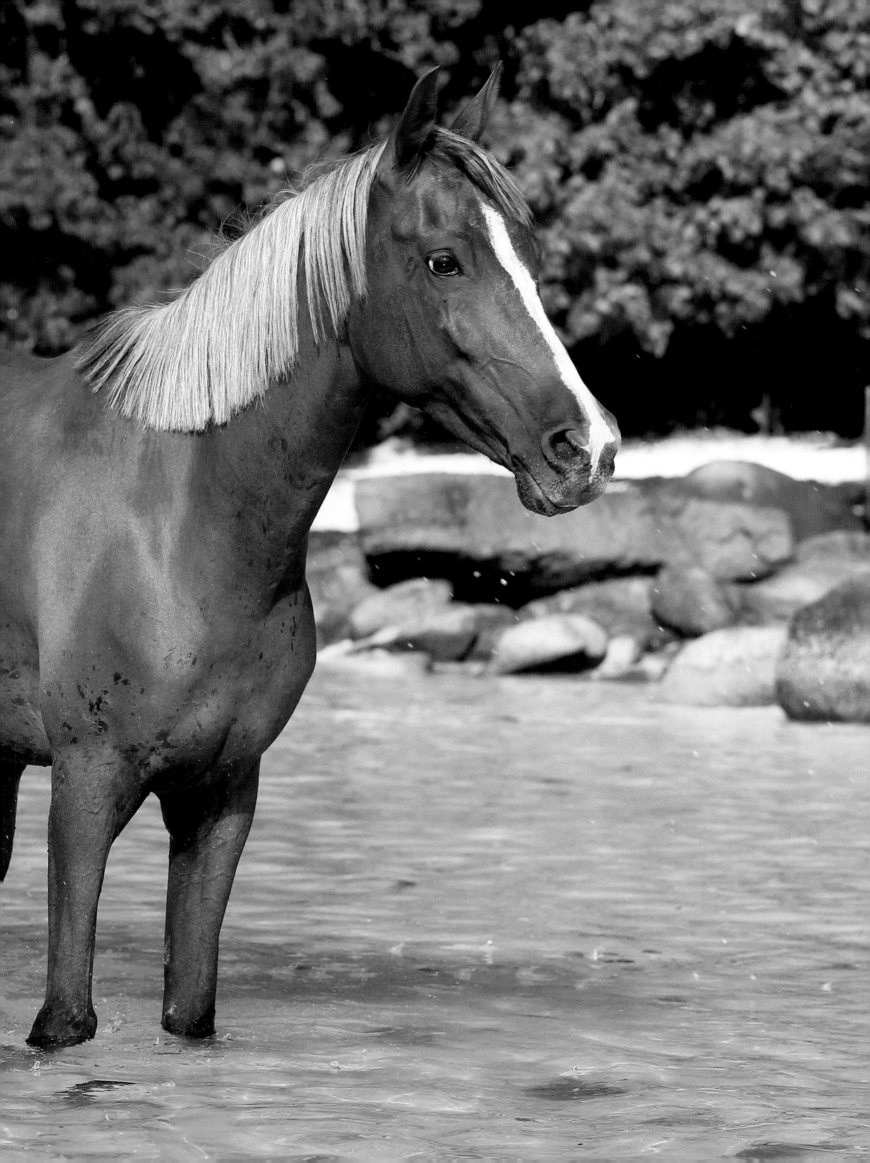

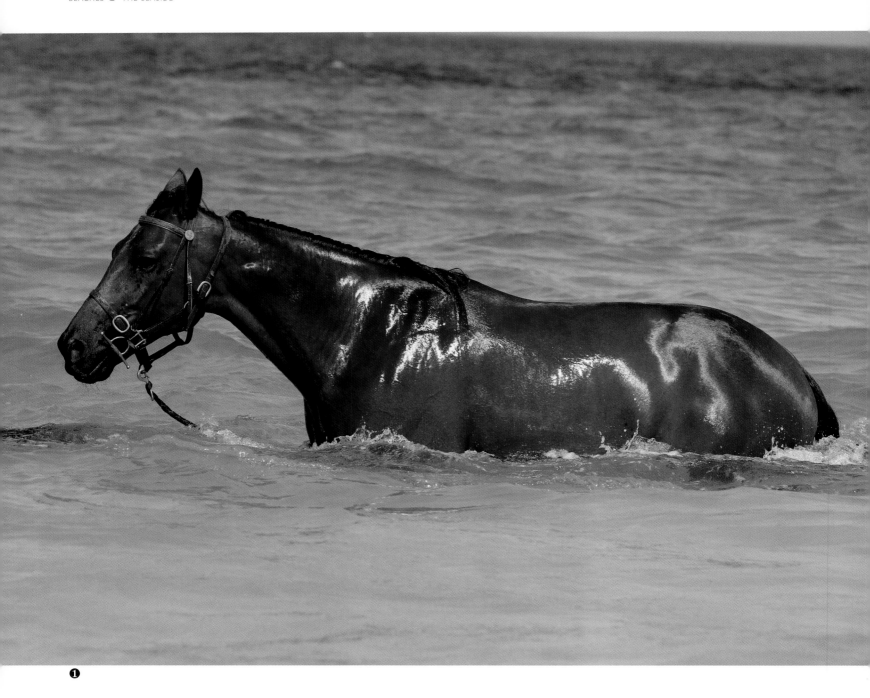

❶

Above:
This Standardbred was swimming in the sea off Perth, Australia. Bob says, "I was on the beach with my wife, Pam, when we saw a group of what appeared to be competition horses being led into the sea for exercise. We then realised this was a Standardbred used for harness racing worldwide. Most racing yards would have access to swimming pools or water treadmills, but here in Australia they just bring them to the sea and swim them for fitness training!" ❶

Opposite:
This black Friesian stallion is Diablo, owned by Ramon Bacerra, who trains his horses to perform tricks.
He also owns a pinto called Texana (page 36 and page 110). "We took a group of horses on an early morning onto a beach in California for a photoshoot. It wasn't until after we left that we were informed we should have taken out a $10,000,000 insurance bond. WHOOPS!" ❷

❷

❶

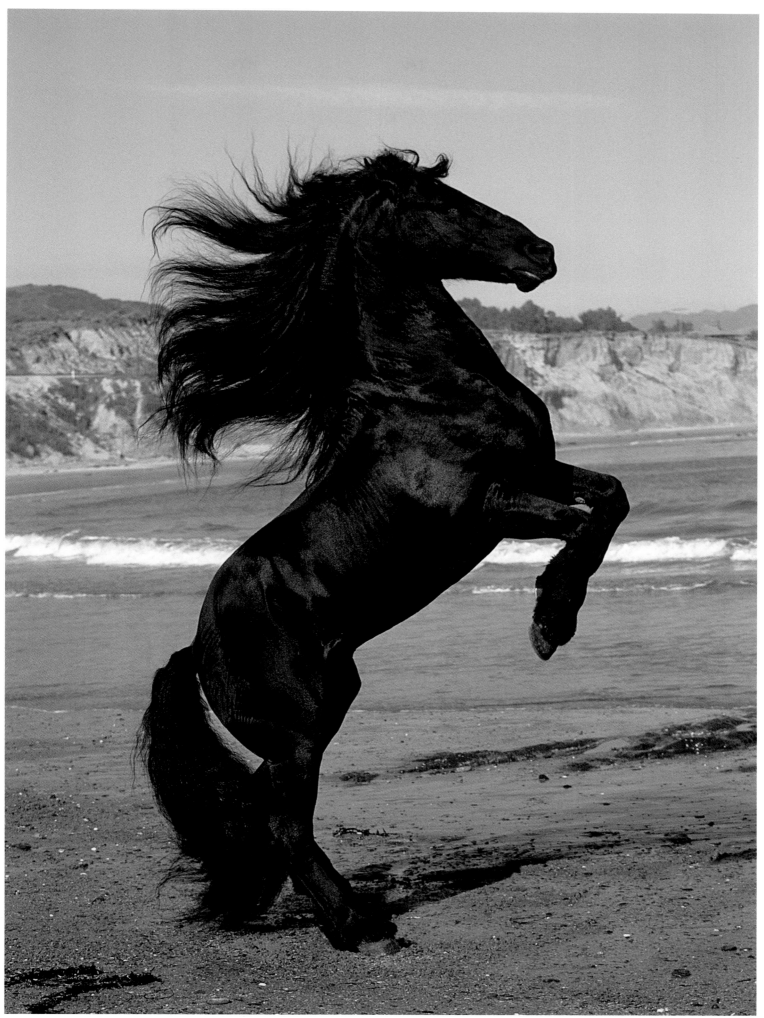

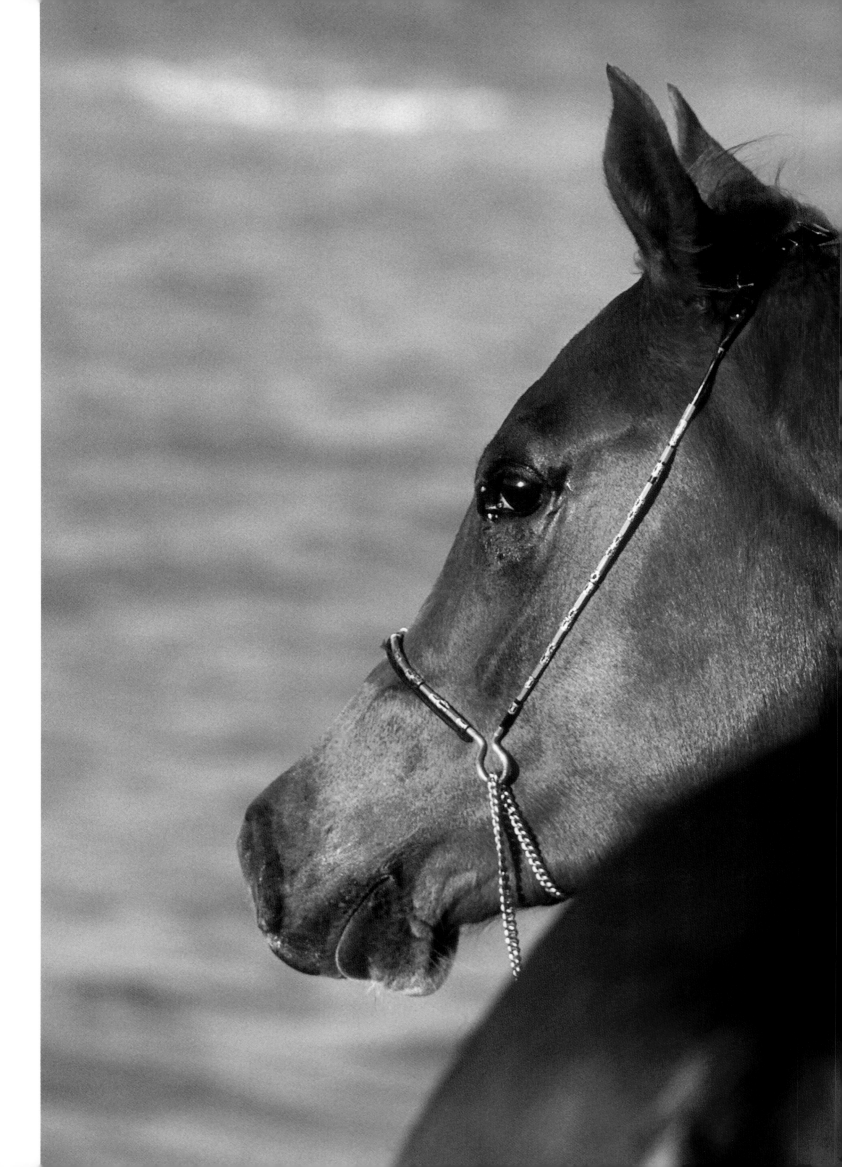

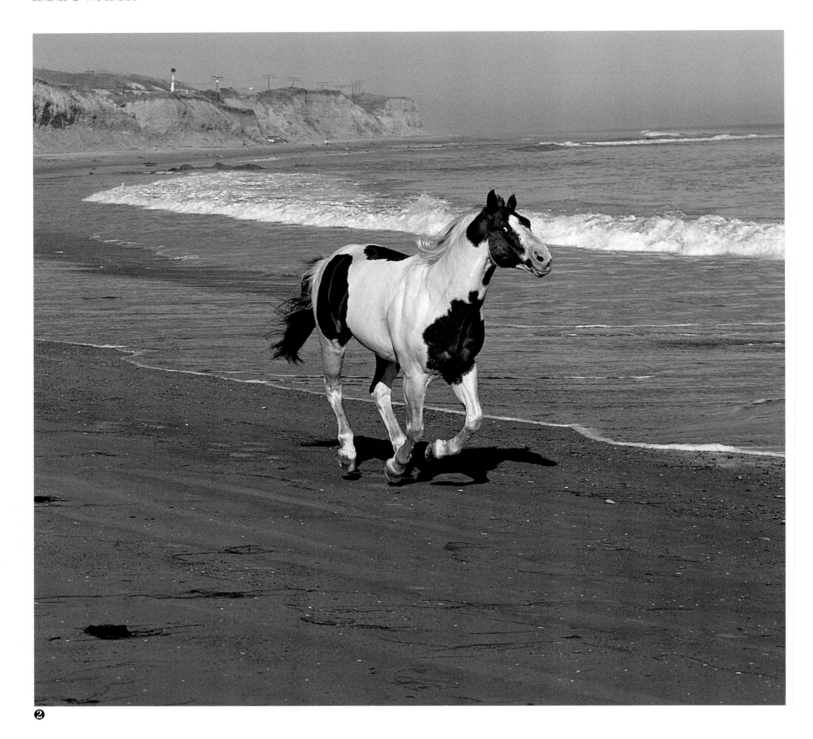

❷

Previous double page:
This study of an Arabian mare from the Royal Stables was taken in Abu Dhabi. By standing behind the horse and making strange noises, Bob was able to get her to look inquisitively over her shoulder, and the seaside scenery provides a great contrast of colour. Curious by nature, horses usually will oblige if they think something unusual is in the offing. ❶

❷

❶❸

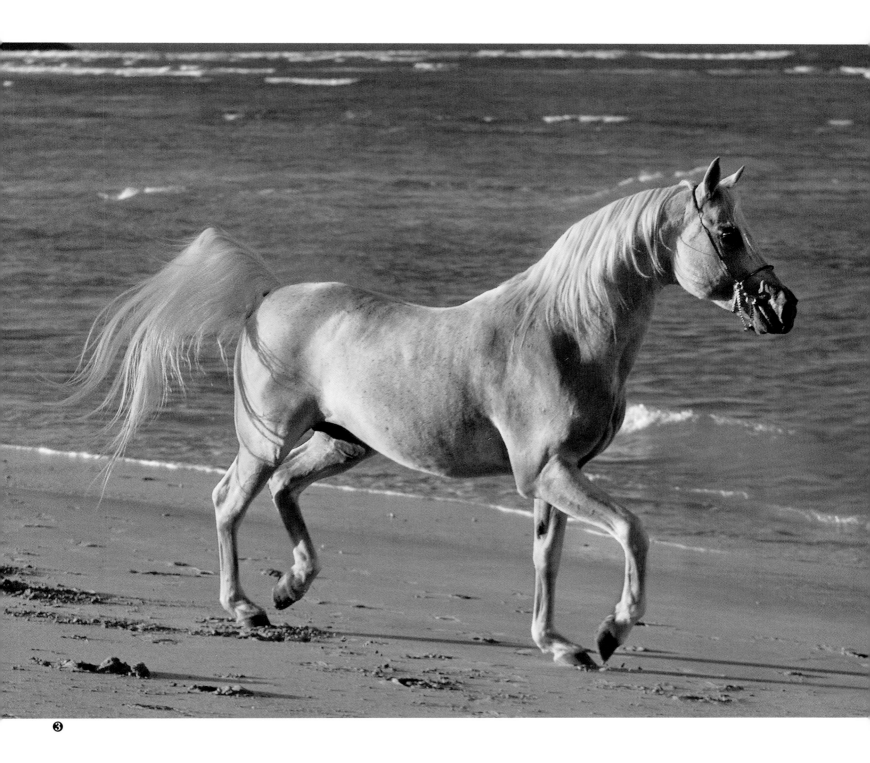

❸

This is an early morning shot taken on the beach in California. This impressively coloured animal is a trained trick horse. He was taken to the beach and led one hundred metres or so from his friends and then let loose. He galloped straight back to them. You always hope and pray that shots like this go as planned, and luckily for Bob this one horse did just as he was asked! ❷

A beautiful Arabian from the Abu Dhabi Royal Stables was trotted along the beach with a groom on the off side so that the lead rein could be airbrushed out later. The early morning sun glinting off the horse's grey coat gives the picture dramatic appeal and clearly shows the horse on two diagonal legs in the two-beat trot gait. ❸

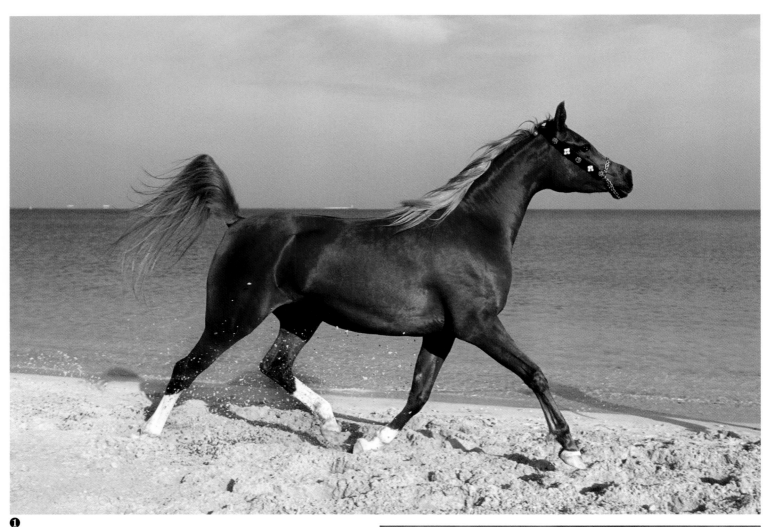

❶

This fine animal strikes a typical Arabian pose as he trots purposefully back to find his friends. See the power in his stride and the high tail carriage, dominant traits of this breed not found to the same extent in any other. The rich chestnut/sorrel colouring, flaxen mane, and hind white stockings ensure this horse sticks in the memory. ❶

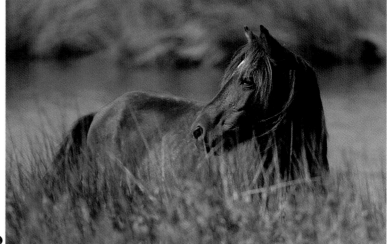

❷

Above:
The rare Banker Pony is captured on film, thanks to a long telephoto lens. The wild ponies are found on the Beaufort coast's Outer Banks in North Carolina. Pony sized, but with horse proportions, these tough little animals are descended from shipwrecked Spanish horses and have remained remarkably pure ever since. ❷

Opposite:
Feral features of long unkempt mane, strong whiskers, and a rather suspicious nature mark this Chincoteague stallion. It is very difficult to get close to these animals without them running away, so Bob used a telephoto lens to get this picture. It can take time to achieve the desired picture of such sensitive creatures. ❸

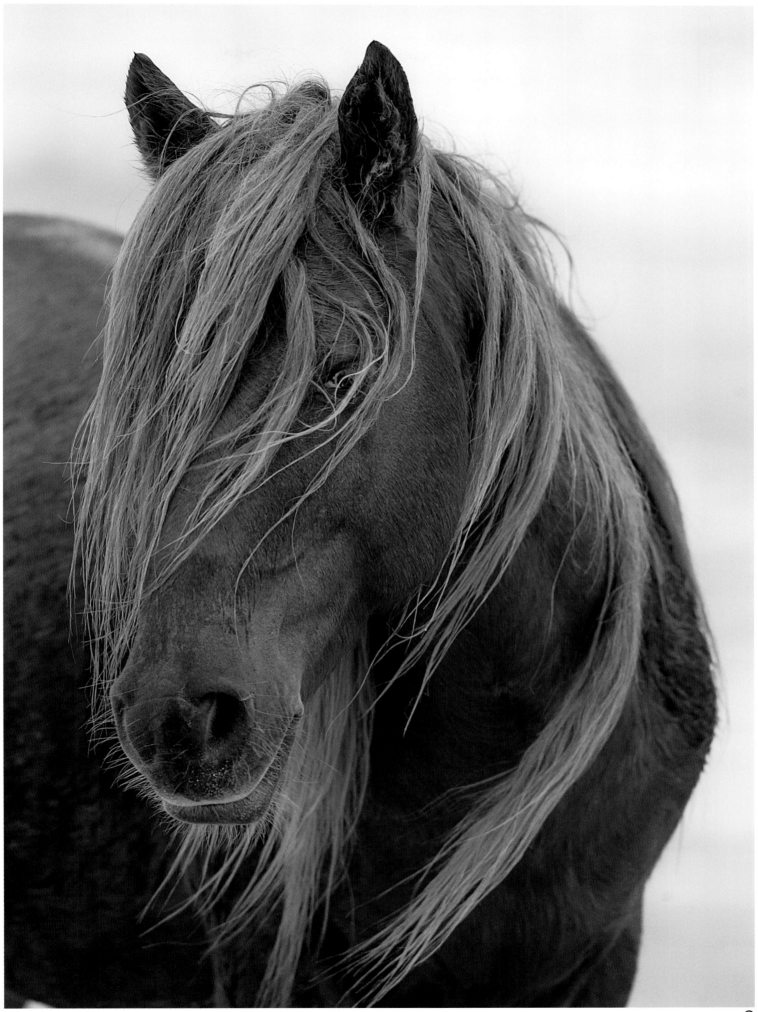

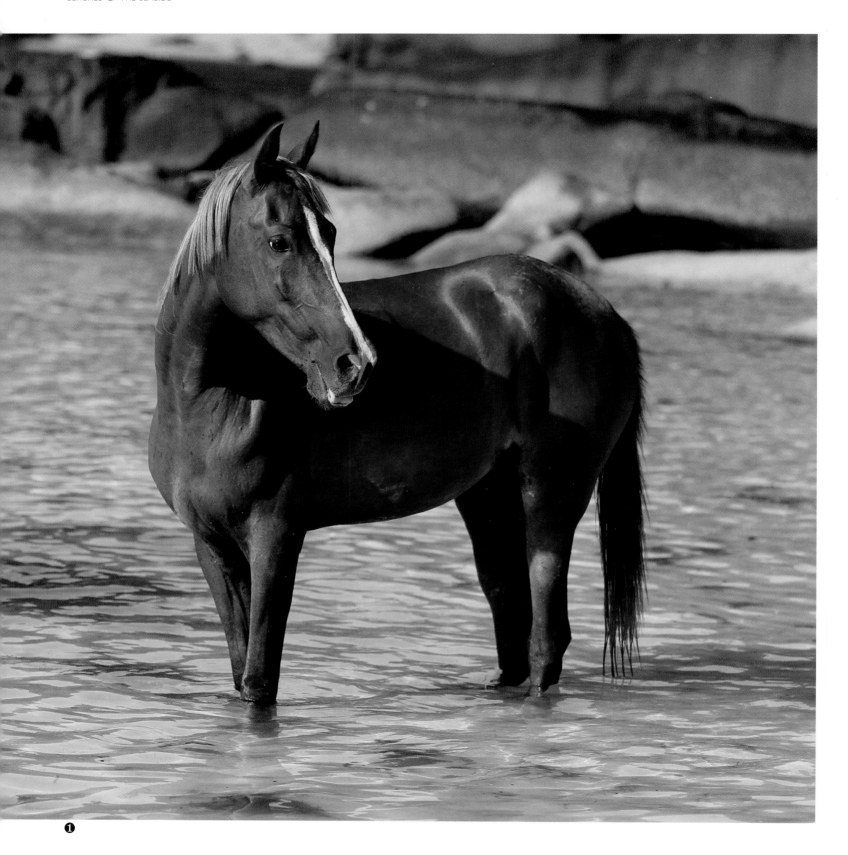

❶

Something interesting has caught the attention
of this young Arabian colt in the Seychelles, and
he looks around to see what it was. The wispy end
of his tail is an indication of youth, for it has not
yet reached full thickness. It takes approximately
six years for most horses to reach full maturity,
although breeds and types vary. ❶

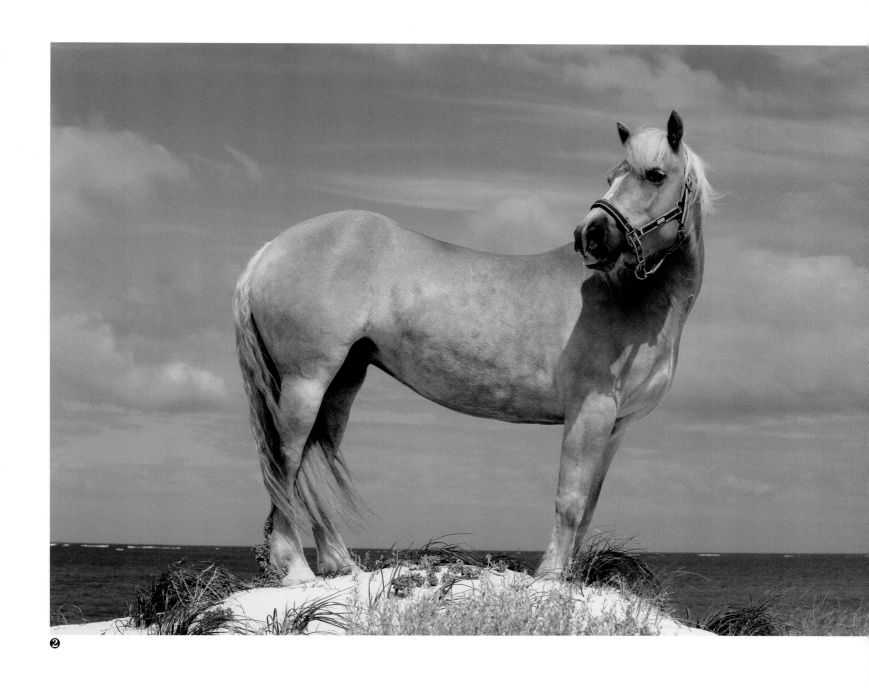

❷

This Haflinger was photographed on the beach in Perth, Australia. Bob was taking pictures on a dog beach with his wife, Pam, who was photographing dogs for calendars, when four Haflingers arrived to swim with their riders. Bob persuaded one of the owners to position this horse atop a sand dune; he airbrushed out the lead rope later. ❷

❶

❷

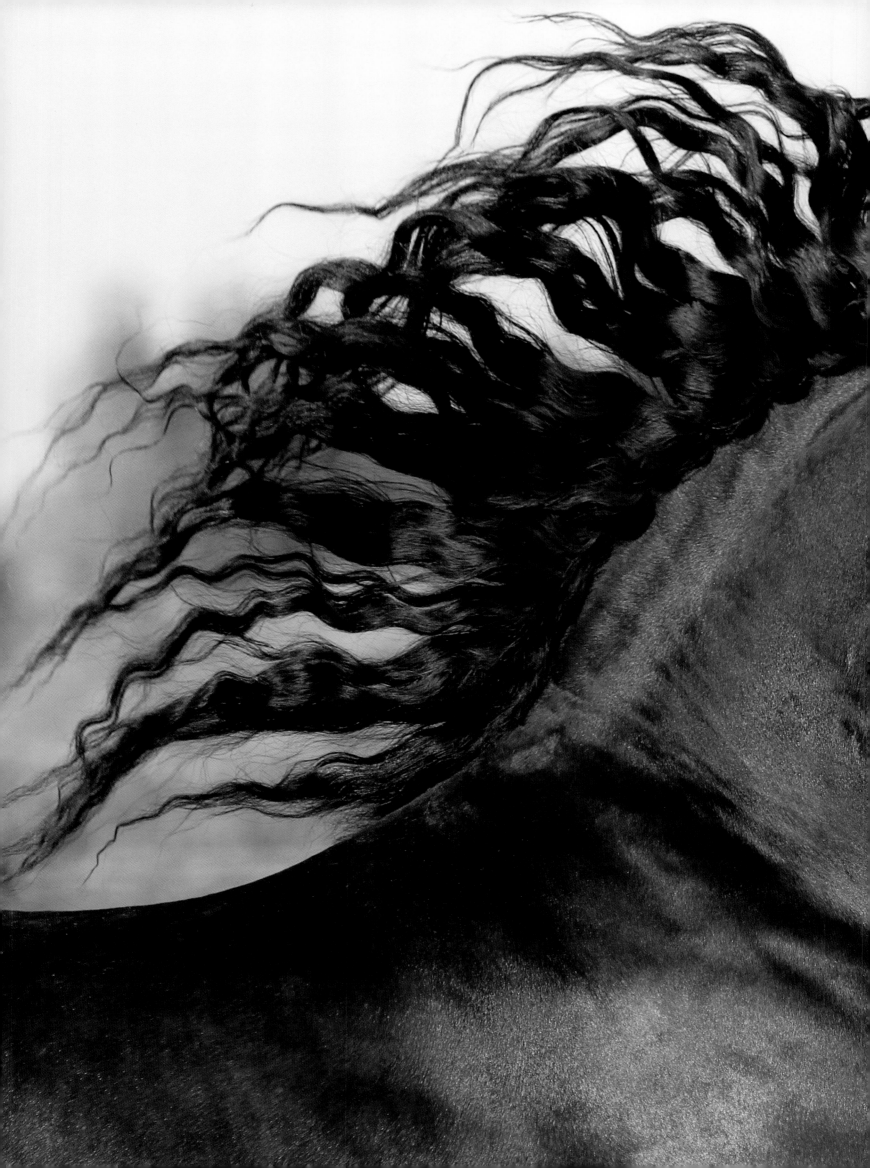

FIELDS
& PASTURES

Springtime, when the flowers are out and the trees are in full foliage, is an ideal time to get good pictures of horses running through pastures of buttercups or other vividly coloured flowers. Bob explains that the art of getting good photographs in open spaces is to avoid capturing obvious fencing or enclosure lines in the picture, unless they enhance the image. The animals may be contained in a small fenced paddock of just a few acres or hectares, or they may roam for miles in a place where it could take days just to reach one edge of their enclosure.

This section contains a wide variety of pictures taken in locales from the USA to Australia and South Africa to the UK. Each area uses a different means of securing their stock, depending on location and circumstance. Fencing must be safe and secure, with consideration to where it is and whether there are other animals in close proximity. In very large areas, there are less likely to be many problems as the animals have the space to disperse and roam. Smaller paddocks must be secure enough to contain the animals, especially if they are turned out alone.

Whether their enclosures are made of rails, boards, hedges, walls, wire, or electrified material, horses often will find a way of escaping in the most unlikely situations and at the most inopportune moments. The more domesticated they are, the more likely they will escape. When all areas are regularly checked and secured, it is better for all concerned. Bob's travels have taken him to so many different countries that he has seen just about every way of containing a horse or pony that there is to see.

Bob worked closely with the Park Rangers in many areas, especially in such places as Exmoor and Dartmoor in the UK, where it can be difficult to locate the animals without local knowledge. He always tries to get pictures of the ponies in their natural habitat during the summer as well as the winter, if possible, to demonstrate the hardiness of the breeds he photographs. He believes in the adage "if you scratch my back, I will scratch yours" and has been happy to help breed societies and the Rangers by giving them pictures free of charge. The images help raise awareness and educate people, which ultimately helps the ponies.

Previous double page:
A picture in Bob's signature style: a horse with long flowing mane in pin-sharp focus against an out-of-focus background. Whether layman or equestrian professional, anyone can enjoy this type of picture. Bob's subject is a Friesian horse that has just shaken his head to show off his fine, thick mane. ❶

Opposite:
This photo was taken on a Quarter horse farm in Texas early one morning. Bob intended to take pictures of horses in the sun but arrived to find a heavy mist! A Texan cowboy out at work on his horse loomed out of the mist to welcome Bob. ❷

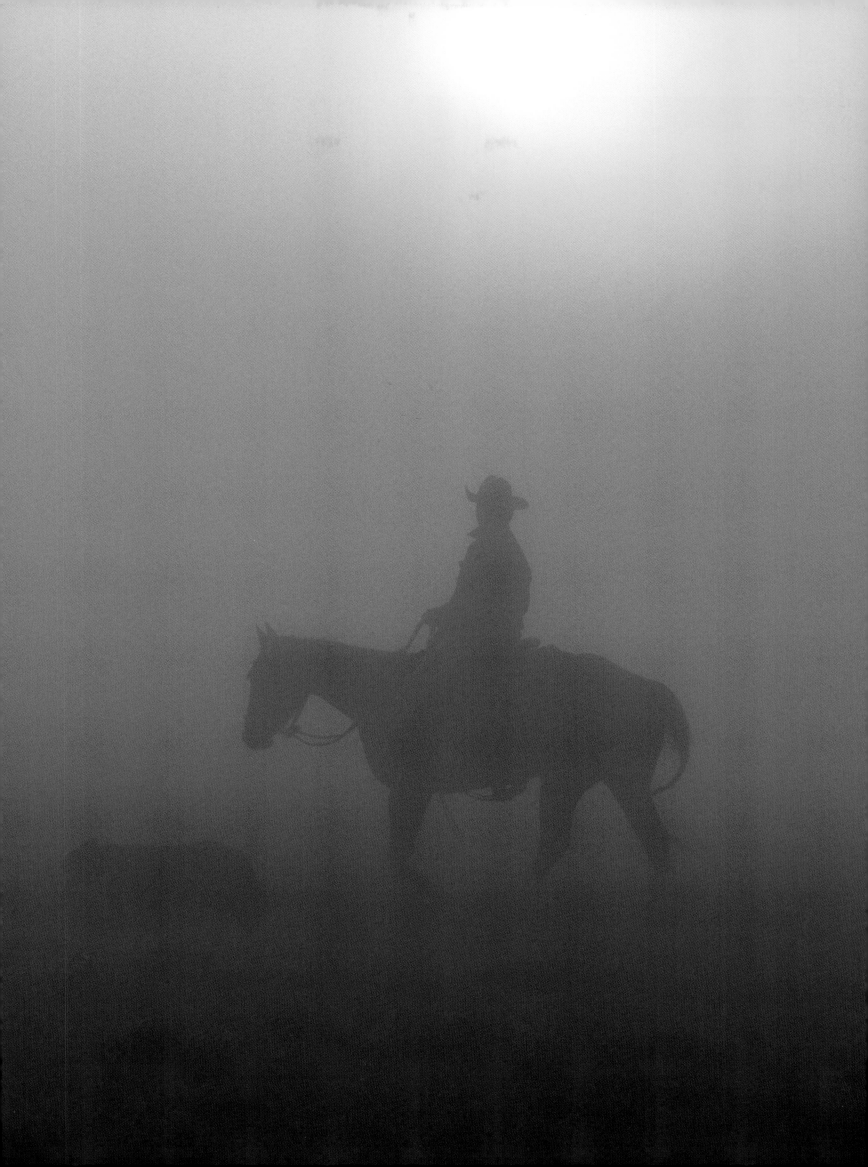

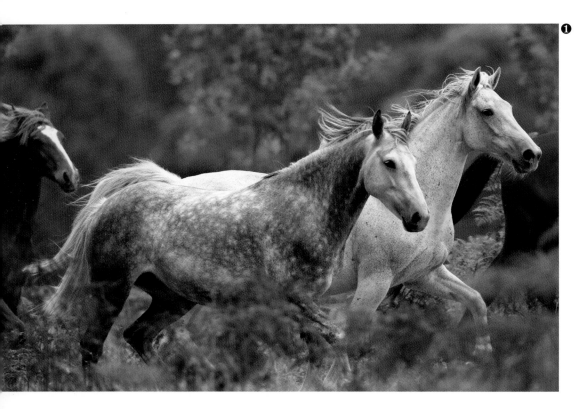

❶

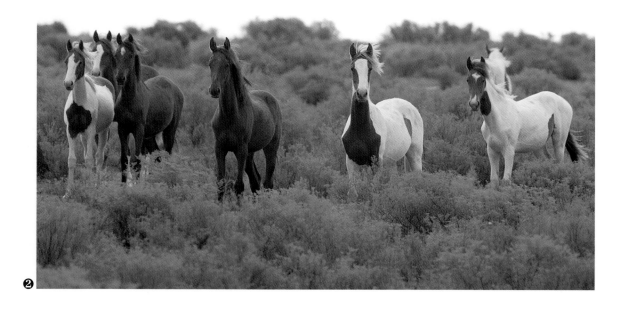

❷

These Brumbies in Australia were not entirely wild; they were photographed on a farm where they were chased to give the impression of being out in the wild without any fencing. Brumbies have had a varied existence, adapting to their circumstances over the years. Horses were first brought to Australia from South Africa in 1788. The long, difficult journey caused many horses to sicken and die on the way. Those that survived flourished in the fertile Australian countryside. ❶

"These horses were standing beside the road as we drove down the Garden Route in South Africa." Bob isn't sure what breed they are, but from previous experiences in South Africa, he thinks they could possibly be Boerperd horses. Naturally inquisitive, horses will usually stop and look to see what is happening, as this group did when they noticed they were being photographed ❷

❷❸

❶

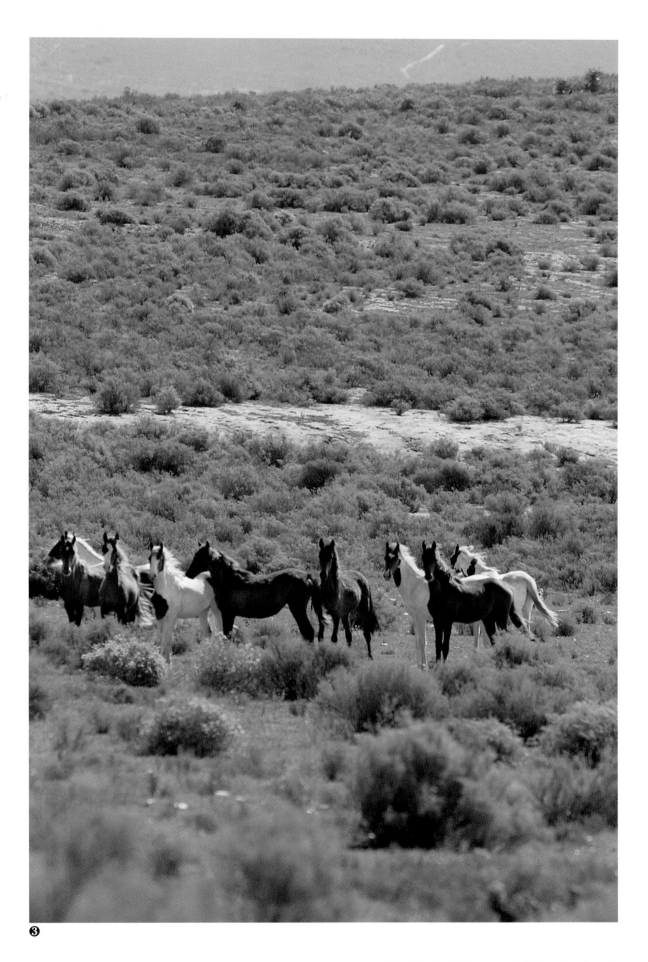

❸

For this shot, Bob concealed himself and made strange animal noises which made them turn around to looksee what was going on. Herd animals by nature, horses in the wild generally follow one another's lead, so if one runs off the rest inevitably follow. **❸**

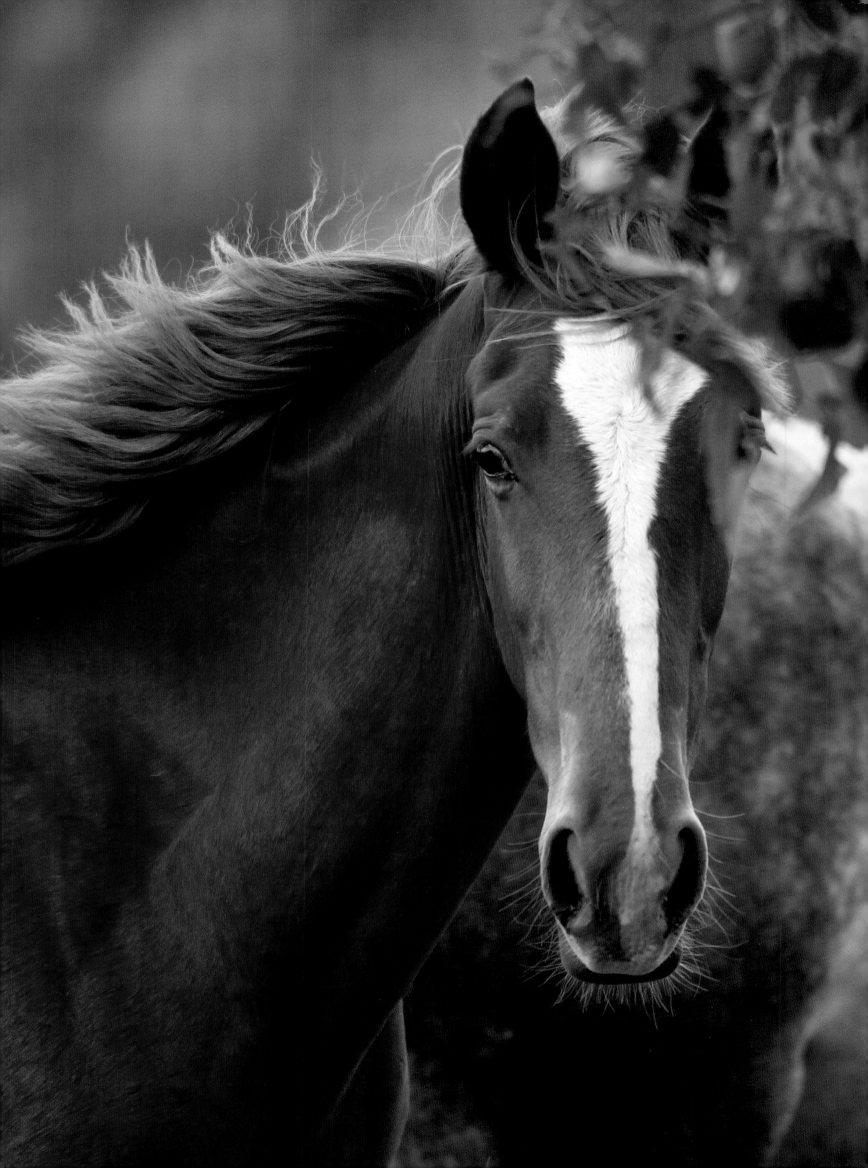

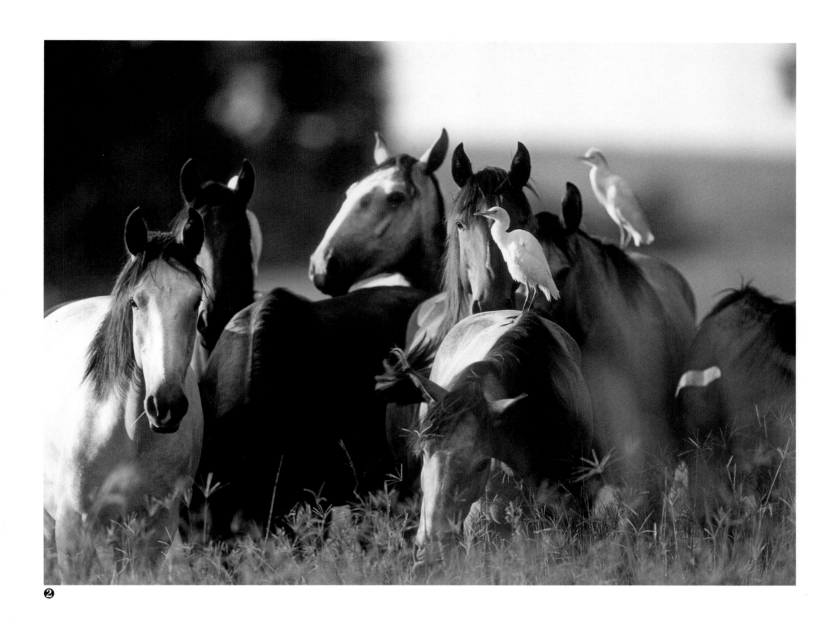

❷

Opposite:
A fine head of a Brumby in Australia. The breed has changed and evolved over the years. Brumbies come in all colours and are tough, surefooted, and intelligent. The Brumby varies in height from around 14 to 15.2 hands high. They seem to have developed a love-hate relationship with their human compatriots, since so many have bred freely and they have become too numerous to manage effectively. ❶

Above:
This image was taken at Interagro Lusitanos, the biggest breeding farm in Brazil with over more than six hundred horses located at Itapira, a couple of hours by car from Sao Paulo. Bob was out on an early morning drive around the massive farm when he came across the egrets making a feast of the bugs on the horses. The early morning sun added a certain aura to the picture. ❷

❷

❶

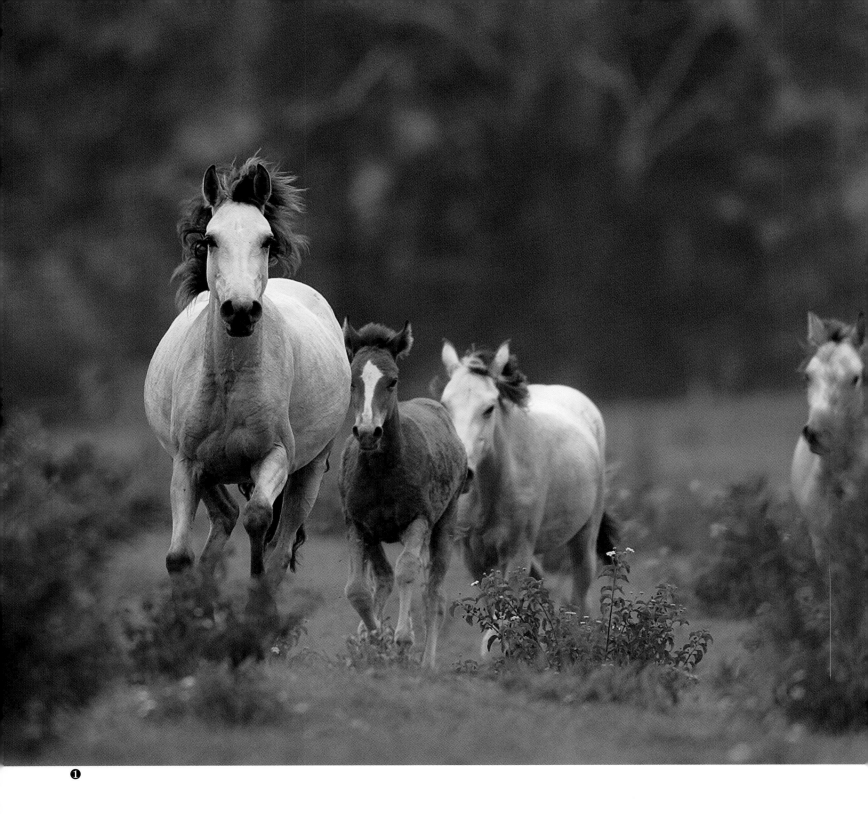

❶

These wild Brumbies galloping through the bush with a young foal brings back vivid memories for Bob. He recalls being on a 5,000-acre farm with the horses running wild. He hid behind a tree and rested his 500-millimetre lens between the branches. The horses were running towards him, and as they got closer he realised his lens was stuck fast and he was unable to move left or right! Swearing to himself, he said he would never do that again. **❶**

❸

❶❷

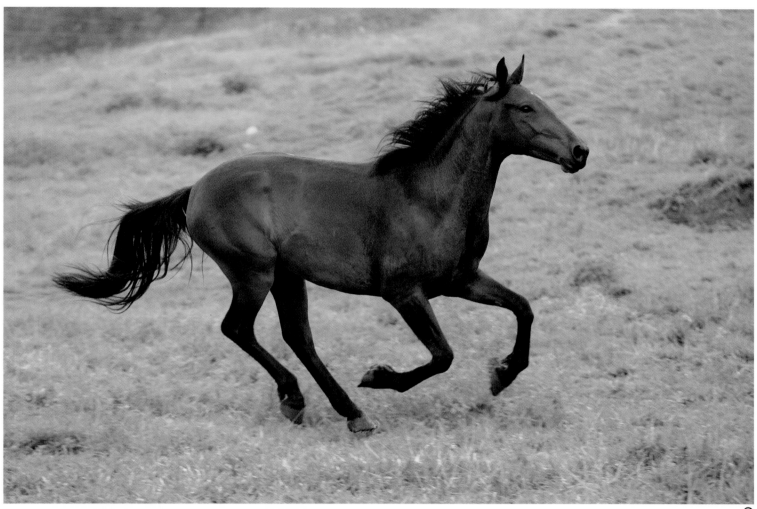

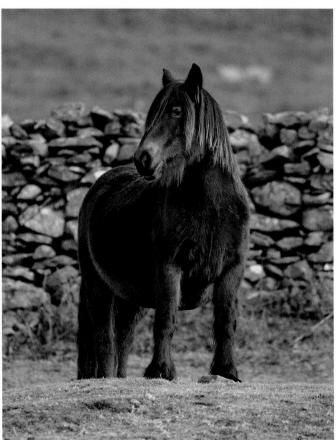

Above:
The handsome Waler is a breed developed in Australia. This one was photographed at Talara Stud. With added infusions of Thoroughbred, Arabian, and some Quarter Horse blood during the last century, this horse has evolved into a very useful, robust, and athletic breed. The Eventing World Champion Regal Realm, ridden by Lucinda Green, was bought over to Europe from Australia in the 1970s, and his success really put the breed on the map. ❷

Left:
The Dales pony is one of Britain's nine native pony breeds and is usually found on the eastern side of the Pennine Hills. It is very strong and hardy and over the years has grown bigger than its closest cousin, the Fell pony. The Dales pony was bred upward with some of Britain's heavier and larger horses during the Industrial Revolution. This pony is standing in a dip which makes him appear smaller than he actually is! ❸

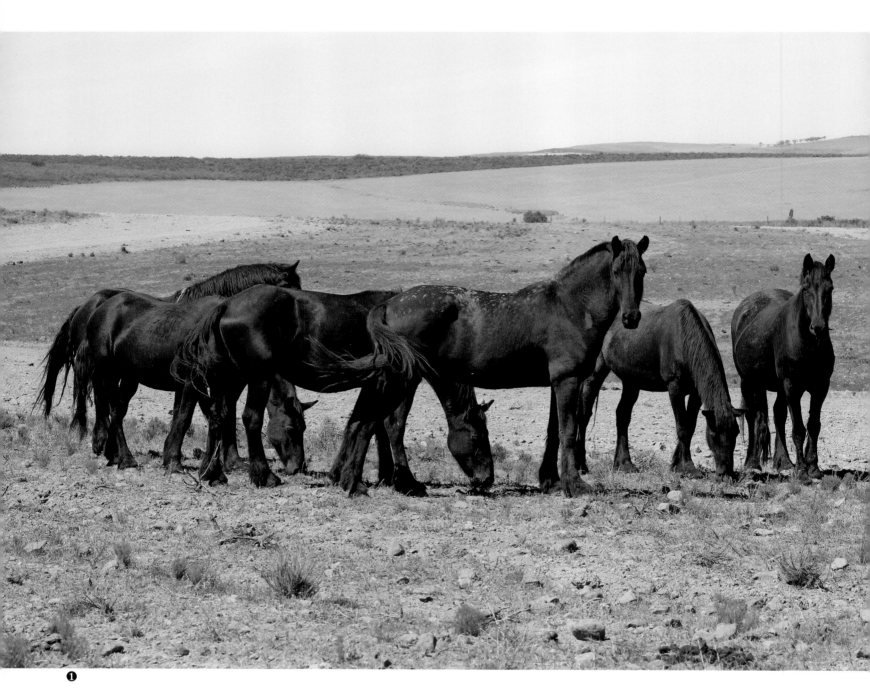

❶

Above:
A herd of Friesian horses roams the arid countryside of South Africa. Friesians originated in the province of the same name in northern Holland, which borders the North Sea near Denmark. Always black in colour, they have a striking, noble aspect with a high head carriage, and they range in height from 15 to 17 hands. They have become popular worldwide for their docile, calm temperaments, which make them suitable as riding, driving, and dressage horses. ❶

Opposite:
The Fell Pony stallion shown here actually lives in Gloucestershire in the UK near the River Severn, just a stone's throw from Bob's home. Fells share some early ancestry with the Friesian, hence their predominantly dark brown or black colouring. Traditionally they live in the north of England, where they were used as pack horses. Incredibly strong for their size, they are usually just 13.2 to 14 hands high. Nowadays, they make great riding, driving, and trekking ponies. ❷

❷

❶

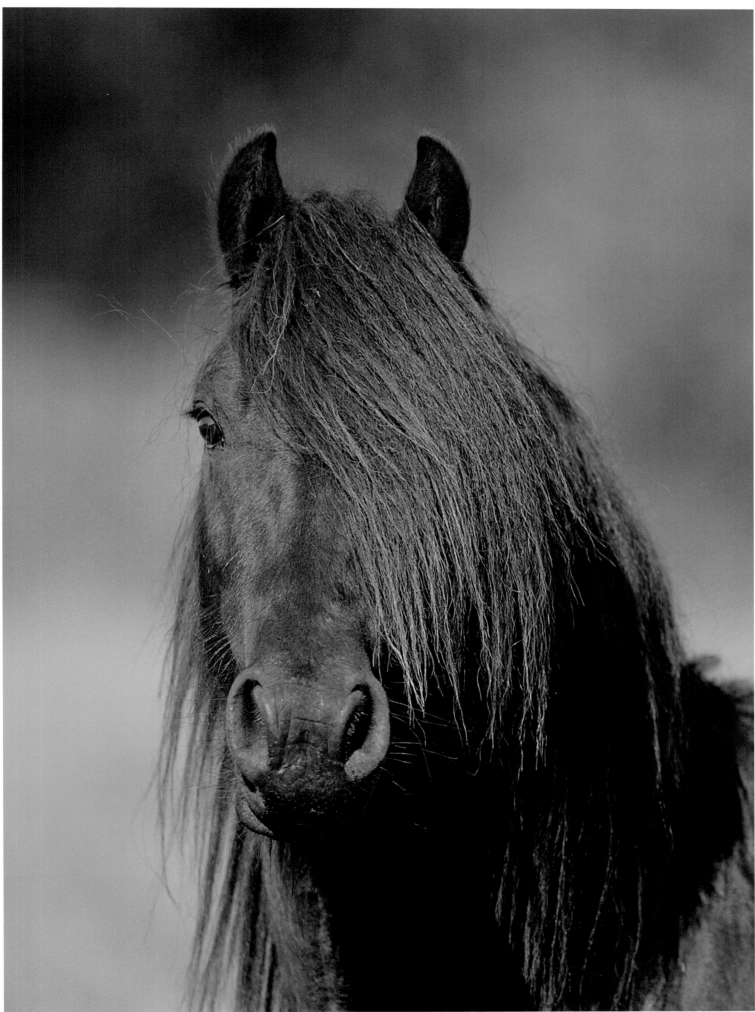

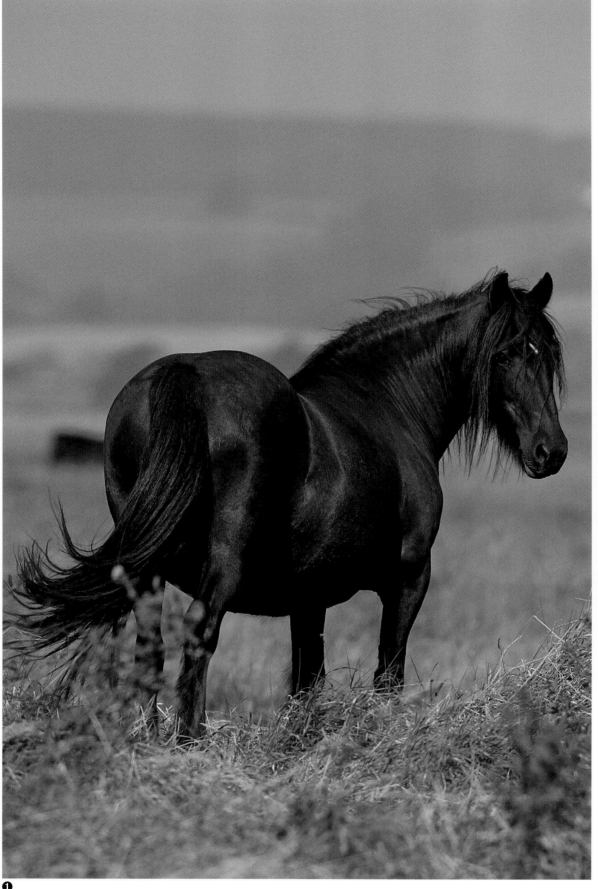

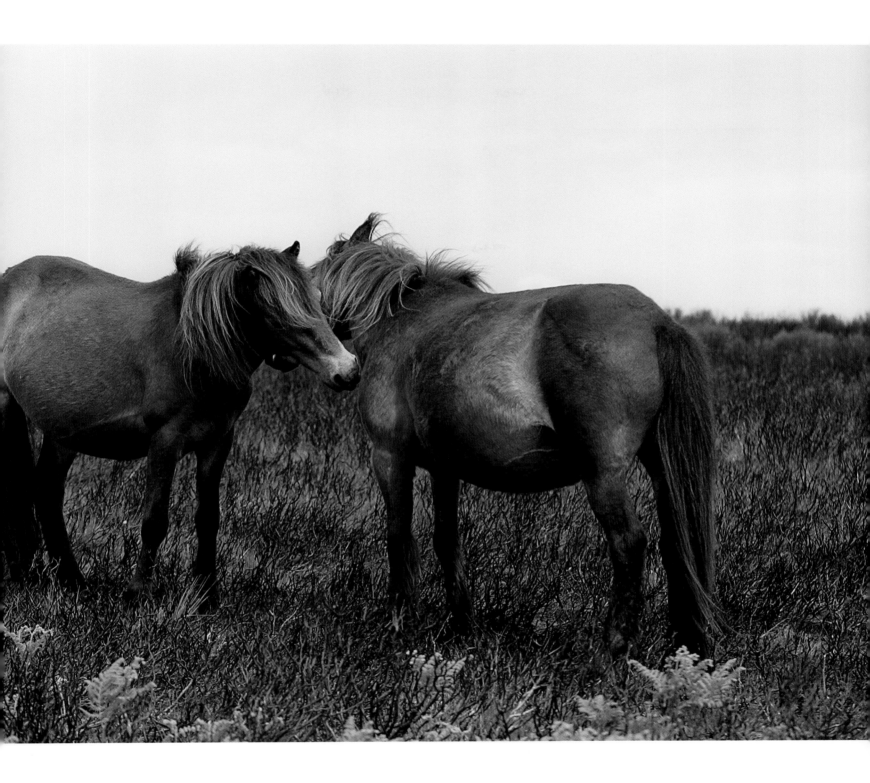

Opposite:
This smart Fell mare is very typical of her breed: small head, and solid, muscular shoulder. To take her picture, Bob placed himself in a semi-blind position and made noises to get the mare to look over her shoulder in this puzzled way, as if she were saying, "Are you something I should be concerned about or just a bit mad?" Fells are closely related to their larger neighbour, the Dales, and both breeds live on either side of the Pennine Hills in the north of England. ❶

Above:
This charming picture of two Exmoor mares grooming each other amid typical moorland vegetation shows the dun/bay colouring of the breed as well as their distinctive pale, mealy muzzle and the ancient "toad eyes". You will often see groups of animals having a good scratch and grooming each other, especially in the early spring when they are trying to shed their thick winter coats. It is not unusual to see birds pecking away at the ponies' backs and flying off to line their nests with hair! ❷

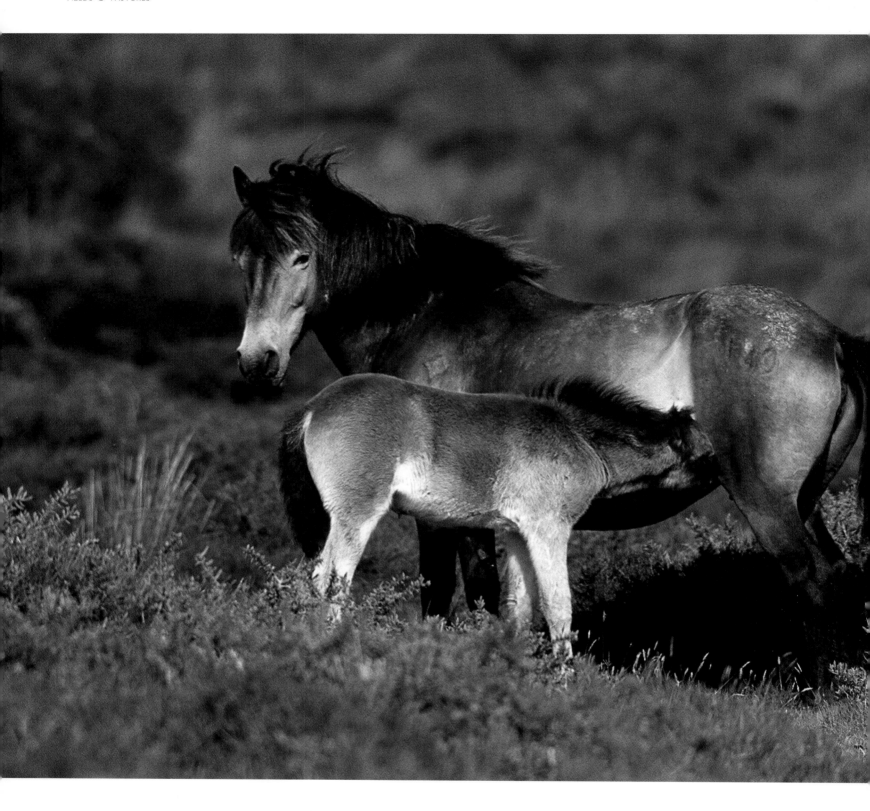

A look of motherly contentment settles on this young Exmoor mare's face as her foal guzzles hungrily at the milk bar. In nature, Exmoor foals tend to arrive in the spring when food is at its most plentiful. This mother appears to have had her tail chewed at the end, which can indicate a lack of vitamins or minerals in the diet. Most foals manage very well on their own from birth, as they have a strong instinct to get up quickly and feed, but for the few that struggle, the future is bleak unless they receive help in time. ❶

Opposite, top right:
Two young Exmoor males playfully fight playfully together—typical behaviour as testosterone levels increase. Fully mature horses and ponies can get aggressive if there are females around, and the dominant male may well fight off other males to claim the herd. In the wild, the dominant male will typically cover any female droppings with his own to show the females belong to him. ❷

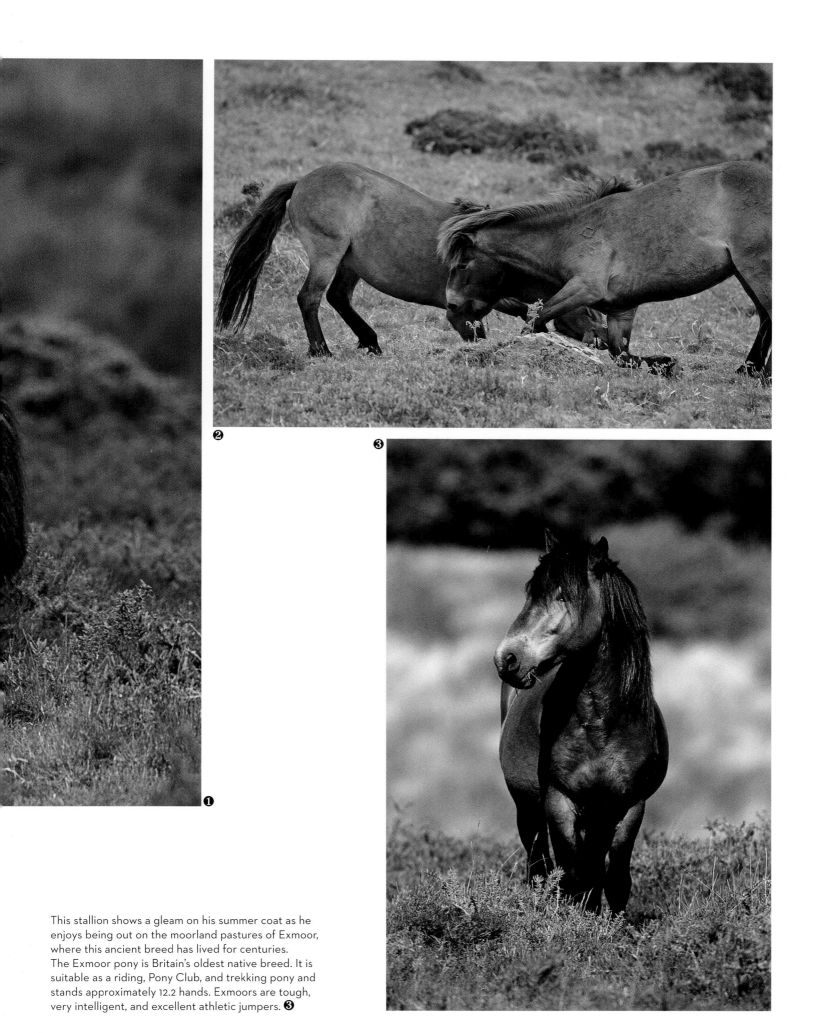

This stallion shows a gleam on his summer coat as he enjoys being out on the moorland pastures of Exmoor, where this ancient breed has lived for centuries. The Exmoor pony is Britain's oldest native breed. It is suitable as a riding, Pony Club, and trekking pony and stands approximately 12.2 hands. Exmoors are tough, very intelligent, and excellent athletic jumpers. ❸

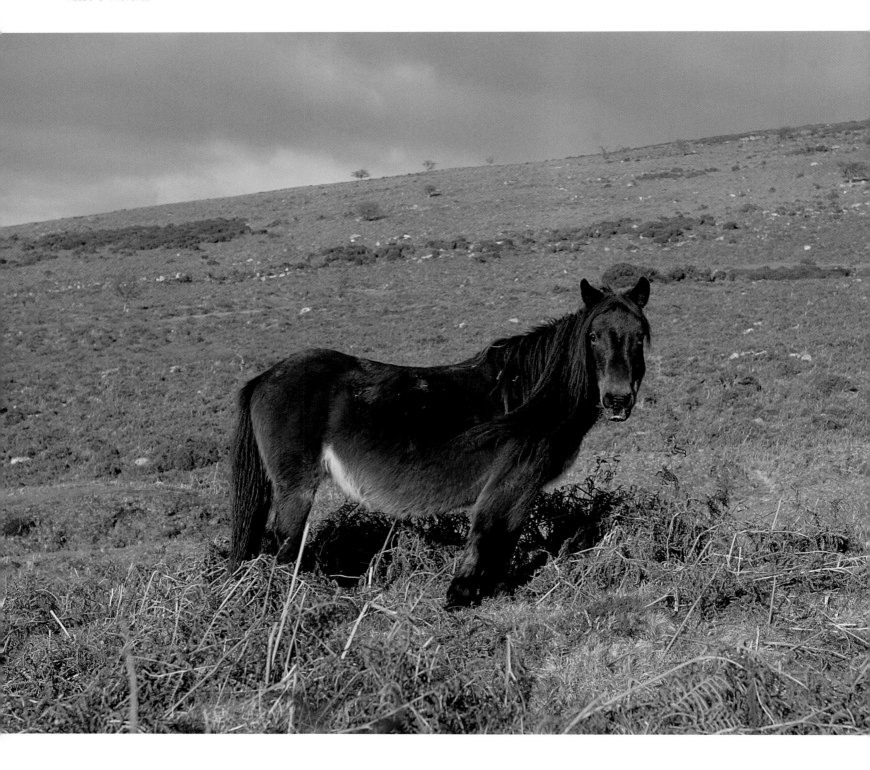

The Dartmoor ponies (and some of the Exmoor ponies) in the southwest moorlands of Britain are less likely to be purebreds, as many local people have grazing rights which allow them to turn out horses onto the moors, and some of those have mixed with the indigenous animals. Only purebreds are allowed to register with the breed society, and these must meet the breed requirements. ❶

Dartmoors make great riding ponies due to their sturdy and correct conformation; they are exported all over the world for this purpose. They are gentle and willing and have flowing paces ideal for young riders, they stand around 12 to 12.2 hands. Dartmoors are generally bay, brown, black, or grey in colour and have roamed the southern moorlands for at least a thousand years. ❷

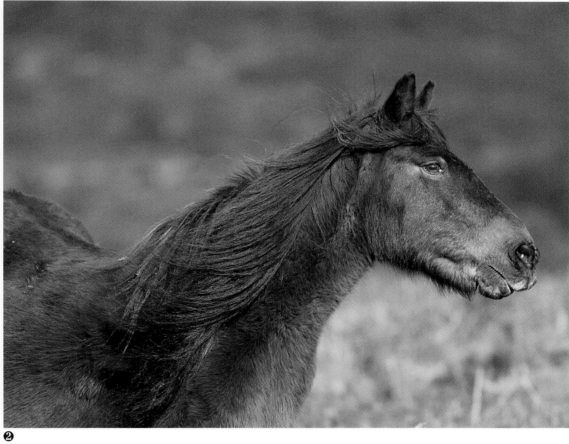

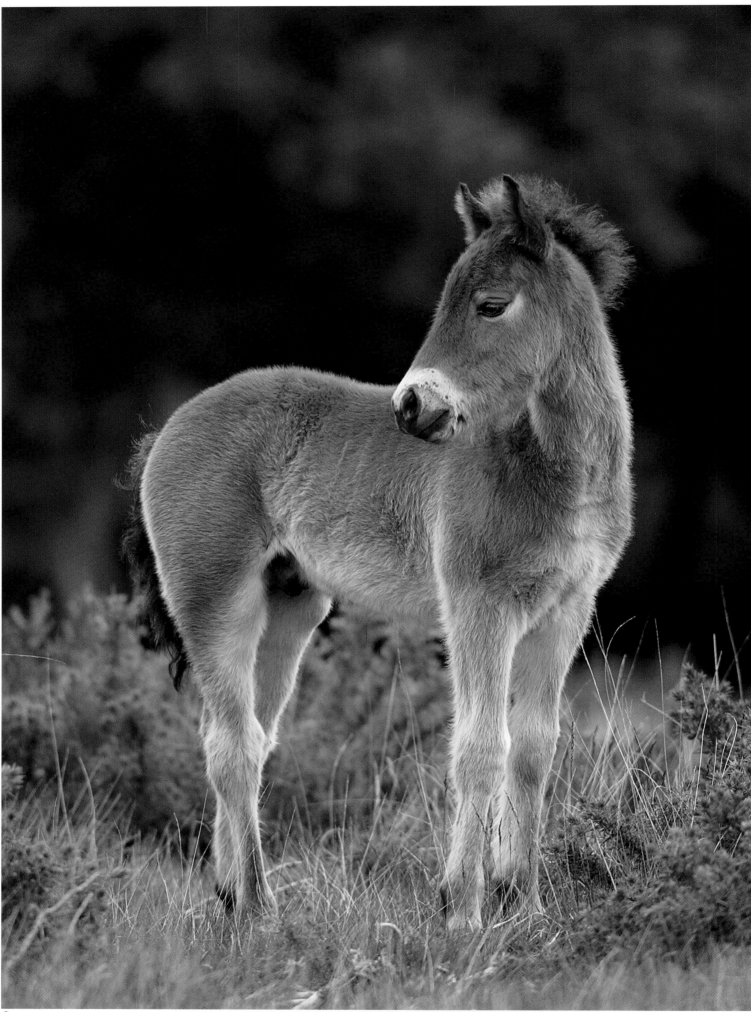

❶

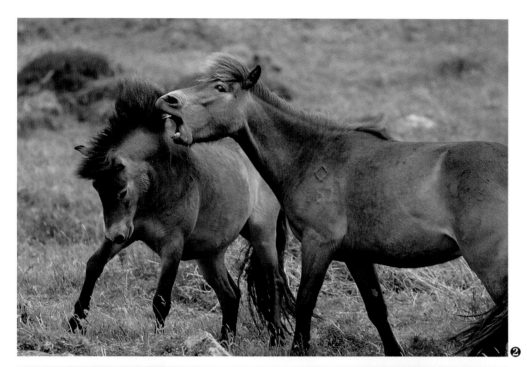

Opposite:
A little Exmoor foal surveys his new world. Even at a very young age the distinctive mealy muzzle is apparent and can be seen from some distance away. He is a strong foal with well-balanced, correct conformation and an interested expression. Foals learn the ropes from their mothers and become remarkably independent in a short space of time. ❶

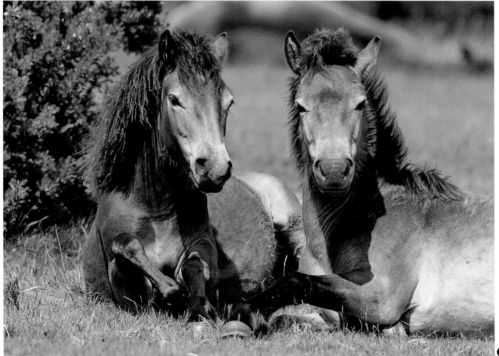

Top:
As the young grow up, their playful behaviour will become more aggressive in males. These two are enjoying a good scrap but appear to be just playing and not having a serious fight. Such antics will help to prepare them for the future by teaching them to respect each other's space and understand their place in the herd. ❷

Bottom:
Sometimes it is just too hot to do much, and these two seem content to have a lazy afternoon, enjoying the fine weather and watching the world go by. There are a lot of summer visitors to the Exmoor National Park, so none of these ponies are remotely worried by the number of people around. It is very important, however, for tourists not to feed them, as this has led to serious injuries when the ponies get spoilt and start to expect food. They may kick or bite people in frustration. ❸

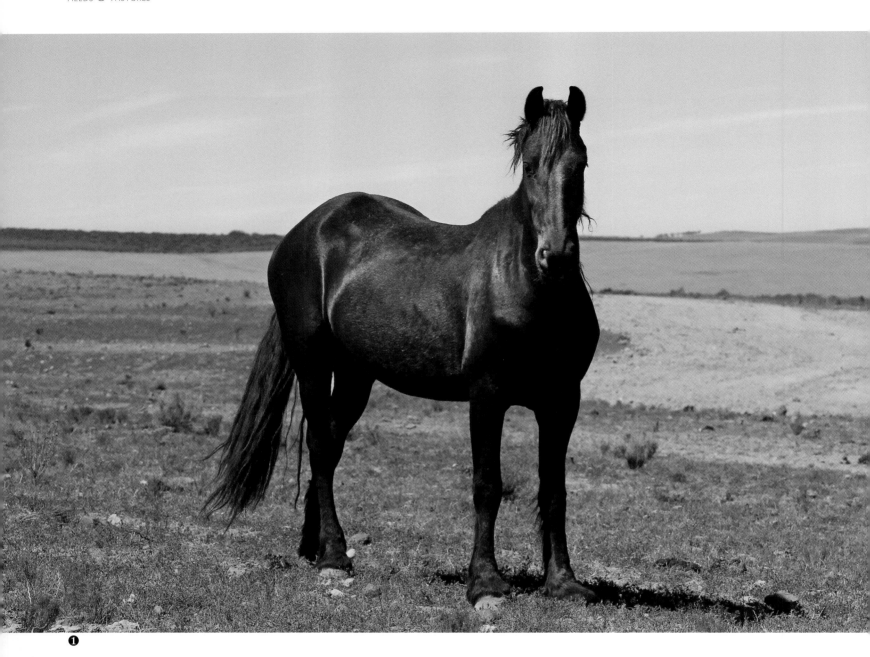

❶

Above:
Life in South Africa seems relatively easy for this nice young Friesian who looks out over the prairie. There's not much appetising forage here, but enough to nibble at in the hot months. Friesians are very popular as riding, driving, and even pack horses, especially so for riding safaris. ❶

Opposite:
A lone Mustang, guarding his herd of mares in the Pryor Mountains, USA, took no notice of Bob as he apparently did not pose a threat. The heavy head typical of the Mustang can be clearly seen in this image. ❷

❷

❶

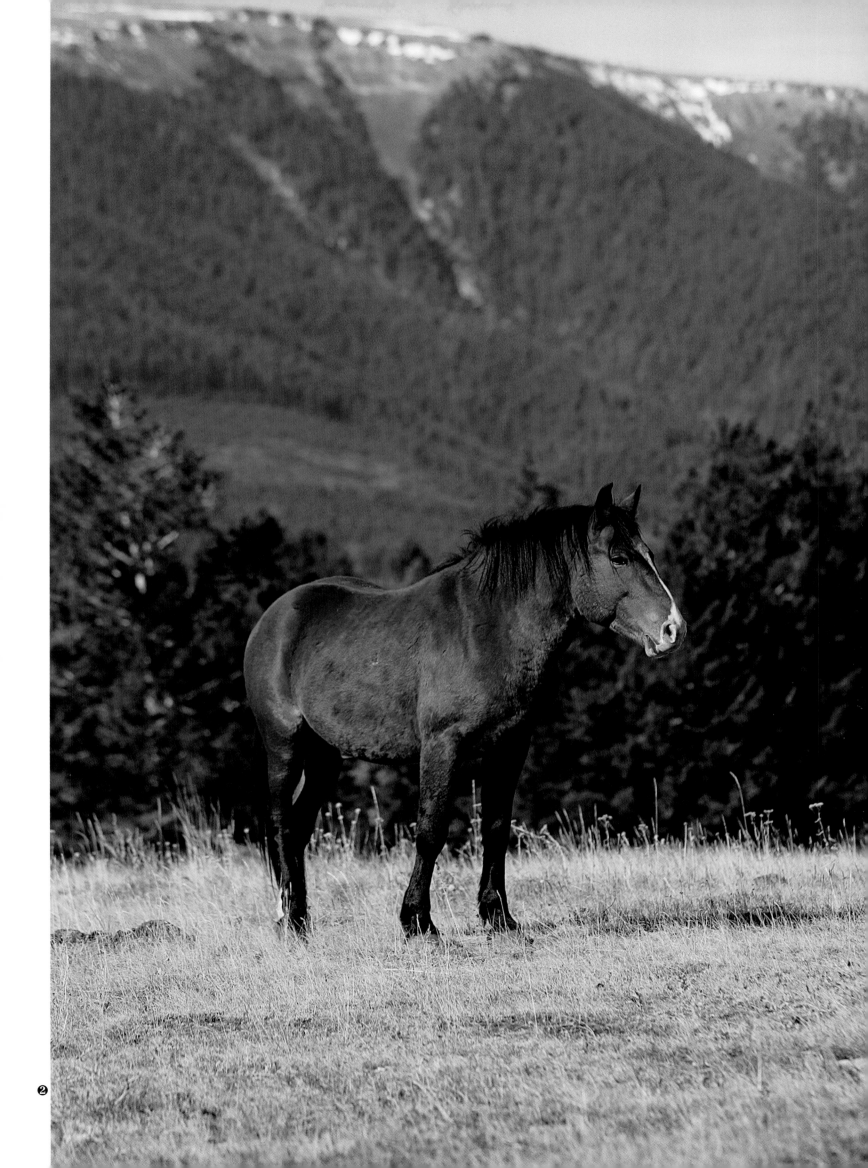

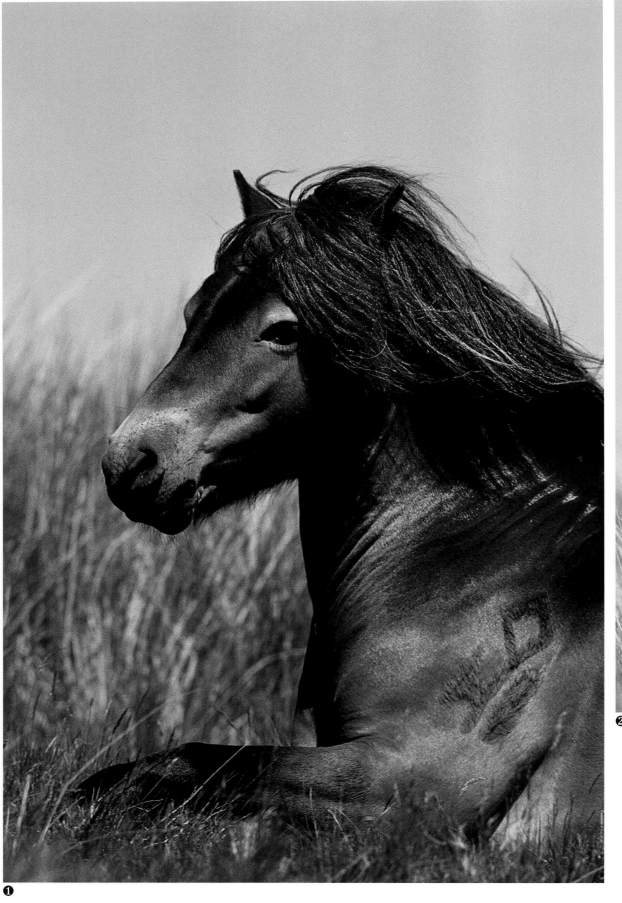

❶

❷

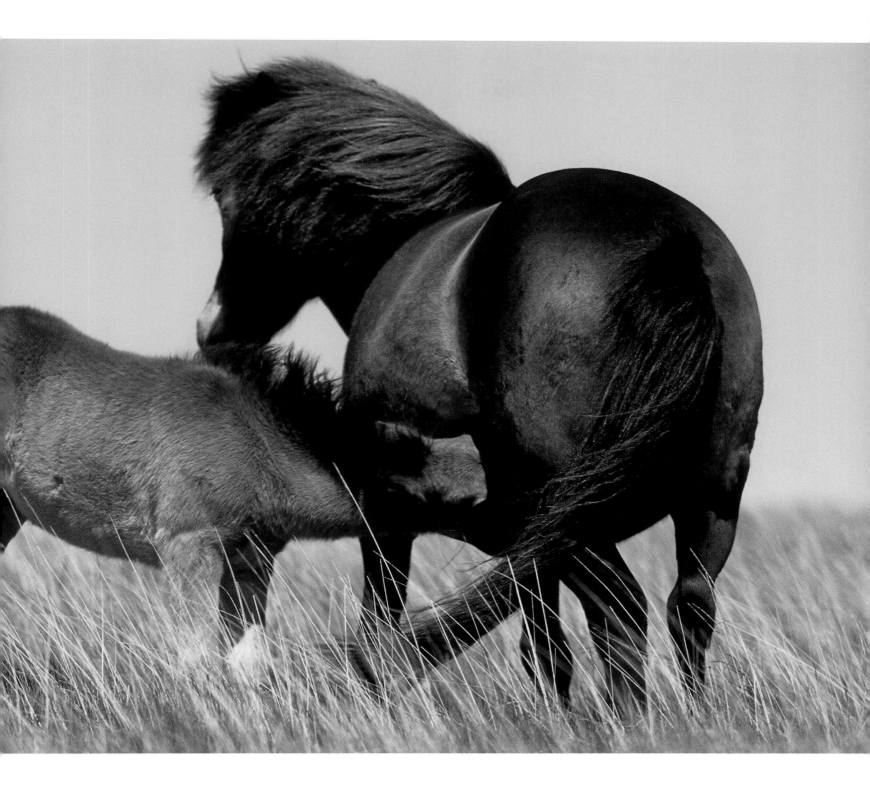

Opposite:
A beautiful intelligent head showing the mealy nose and pale ringed "toad eye" of the ancient Exmoor breed as it lies in the grass. Horses and ponies have the ability to sleep standing up, thanks to a special "locking" system in their joints designed to help them make a quick get away from predators. However, one may often see a herd at rest lying down while the one on "look-out duty" will be standing to oversee the safety of his charges. ❶

Above:
Learning to nurse, a vital part of a young foal's life, is one of the most difficult tasks for a new born. It has to learn how to balance on its legs while bending down, twisting its head and latching onto one of the two teats. Quite a lot to take in at less than an hour old! Foals have an advanced sense of smell at birth, and the sticky, sweet smell of colostrum, packed with essential nutrients, draws the foal in the right direction. A few well-placed nudges from mother will usually solve any problems. ❷

❶❷

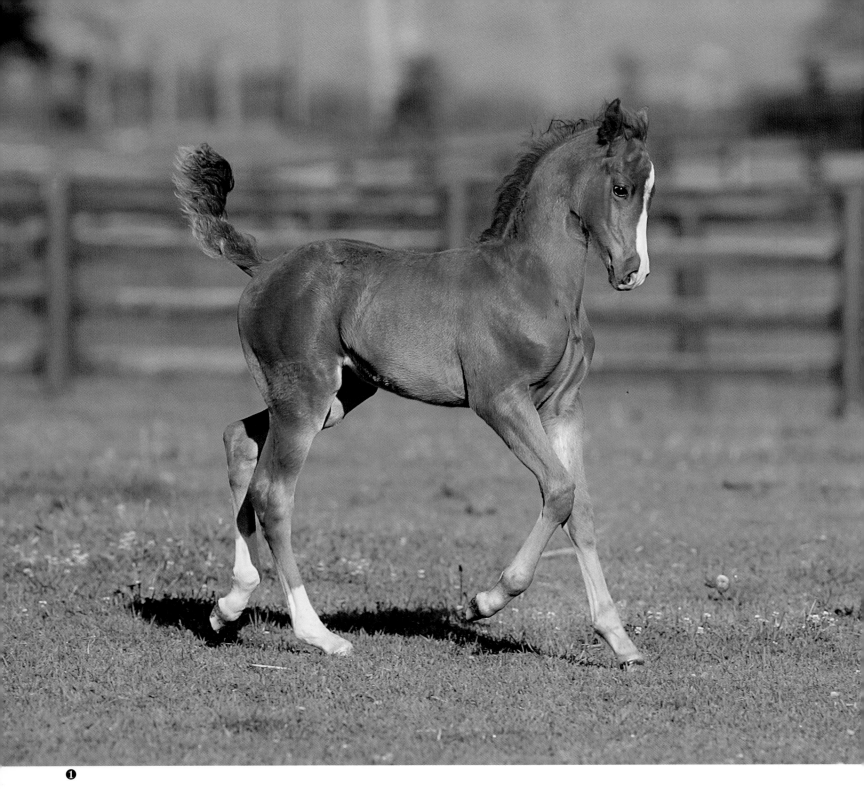

❶

A charming selection of photos of a young Morgan foal
playing in the sunshine in a Kentucky paddock. Bob
comments that the joys of a motor-driven camera is that
it lets you capture ten pictures per second—a fabulous
opportunity to catch foals at play. In this first picture, the
foal is demonstrating a perfect two-beat trot with excellent
head carriage for a Grand Prix dressage movement. ❶

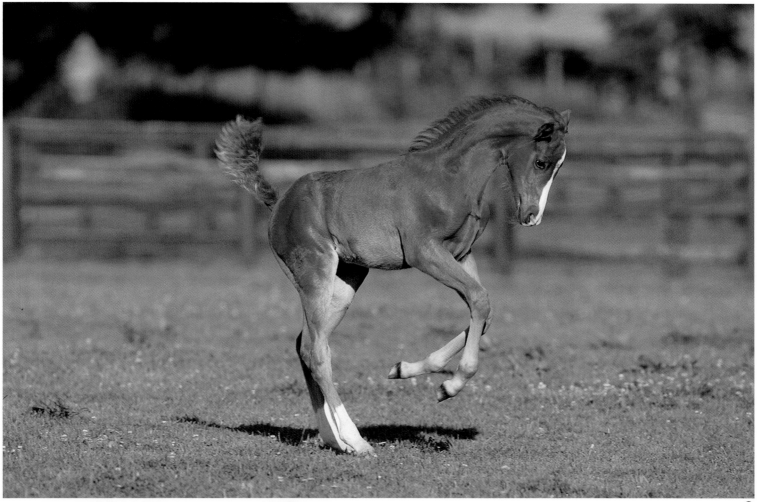

In this picture, he is showing perfect balance with his hocks well underneath him and appears to be in the right position to perform an excellent flying change. It is important for young foals to be turned out for as long as possible, preferably in company, so they have a chance to interact with others and learn social skills as well as balance and elasticity in movement. ❷

All four legs off the ground and a twist in the air too! This lovely foal is really enjoying himself and shows so much talent that he is likely to have a bright future in the competition world. The spectacular evenly spaced blaze down his head and equally marked white socks on his hind legs are perfect for a future show or dressage horse, not to mention the athleticism that will make him a successful jumper. ❸

Above:
Bill Robinson's farm in Idaho is home to about one hundred Lusitano horses, which are native to Portugal. Bob says, "We led the stallion out to the rapeseed field with the Teton mountains in the background." ❶

Opposite:
Flowers like these will always lead to pretty pictures, and Bob made full use of this background to show off this lovely Arabian mare. Perhaps she was on a mission to find her recalcitrant foal, who had ventured out of her view. Arabians at speed are always a spectacular sight with their bright eyes, flaring nostrils, and high tail carriage, attributes that could hardly be better demonstrated than in this picture. ❷

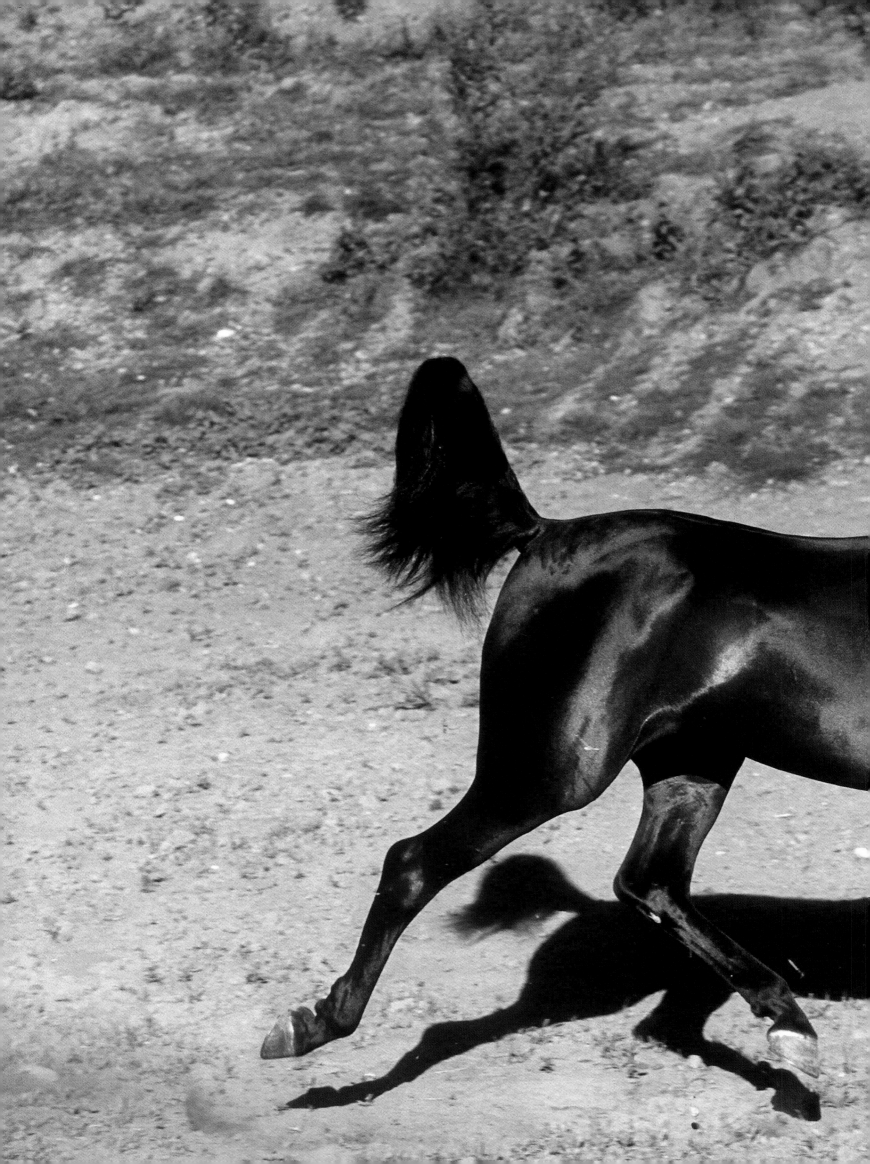

DESERTS, SAVANNAHS & DRY PLAINS

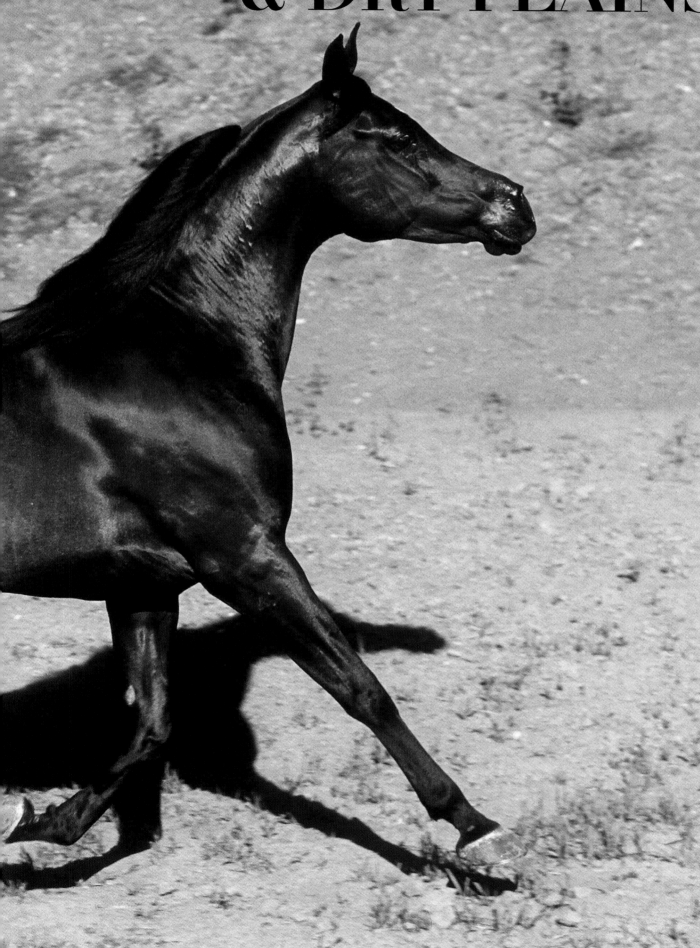

Many horses live in deserts both hot and cold, on the savannah and on the plains and steppes of Asia and Australia. Some of these vast areas are extremely hot; others can be freezing cold. Most are short of fodder at certain times of the year in particular, and the animals that roam them need to be hardy, tough, able to withstand the weather conditions, and adaptable enough to cope with food and water shortages.

The Sahara Desert is the largest hot desert and the biggest desert of any type outside of the Antarctic and Arctic. It has a generally Mediterranean type of climate with wintry seasons, north-easterly winds and sandstorms that can reach hurricane intensity. Different areas receive one to four inches of rain per year. The Nile crosses the Sahara from central Africa to the Mediterranean; therefore, there is little fertile ground, except for a few kilometres on either side of this great river. Thousands of years ago, the riverbanks were lush areas where cattle, elephants, giraffes and lions thrived, as so often depicted in many prehistoric rock paintings found in the region. The horses that roam these landscapes today are tough and generally fairly small, ranging from around 12.2 to 15 hands high. Feeding grounds are few and far between, and in certain desert areas water is hard to find. These horses have adapted and require less water to survive. The Namibian horse from southern Africa, for instance, can go for up to forty-eight hours without water, coming in herds to watering holes infrequently. The feet of roaming horses are extremely hard, to cope with the harsh terrain and the distances they travel, which are often up to thirty kilometres daily. In the colder climates, they change their coats, growing very thick ones in the winter months to withstand the cold winds. The natural oils in their coats create a waterproof barrier, and some very ancient breeds have developed a "double" coat to cope even more effectively with the elements. Savannah comes from the Spanish word zavana, which means "treeless plain." These "tropical grasslands" are usually without trees except near rivers and lakes. There are huge grasslands in Eurasia and the large open spaces of Africa, the Americas, and Australia. These can be cold or warm depending where they are, but they range from Siberia in the east to Mexico in the west. Central Asia served as a land bridge over which the horse travelled from India and Iran to Europe. It was from here that the true wild horse, the Przewalski – now extinct in the wild – was thought to originate.

Nature being what it is has enabled the horse to adapt to many different conditions and learn to forage for what is available to eat and cope well enough when there is nothing. Many horses have evolved to survive with very little food and water for astonishingly long periods. Bob's travels have taken him to some interesting places and situations where local customs, politics, or religious frictions have affected his journeys.

Previous double page:
The Arabian is ideally adapted to hot desert climates. This magnificent black stallion is at stud in New South Wales in Australia, running free in one of the dirt paddocks common in the region. Bob has captured the agility of this breed as the stallion copies his Warmblood friends doing a spectacular extended trot. There is little doubt this animal is a true Arabian; he displays the typical fine dished head and high-flowing tail carriage. ❶

Opposite:
Working with the Bureau of Land Management in Nevada, USA, which now manages the Mustangs there, Bob travelled for two days to get this picture of a semi-wild Mustang and his band of mares. Mustangs have had a rather chequered history — they have overbred and run wild for a long period. Bob could not get too close to this herd but a long lens enabled him to capture this shot. America is home to several types of Mustang. ❷

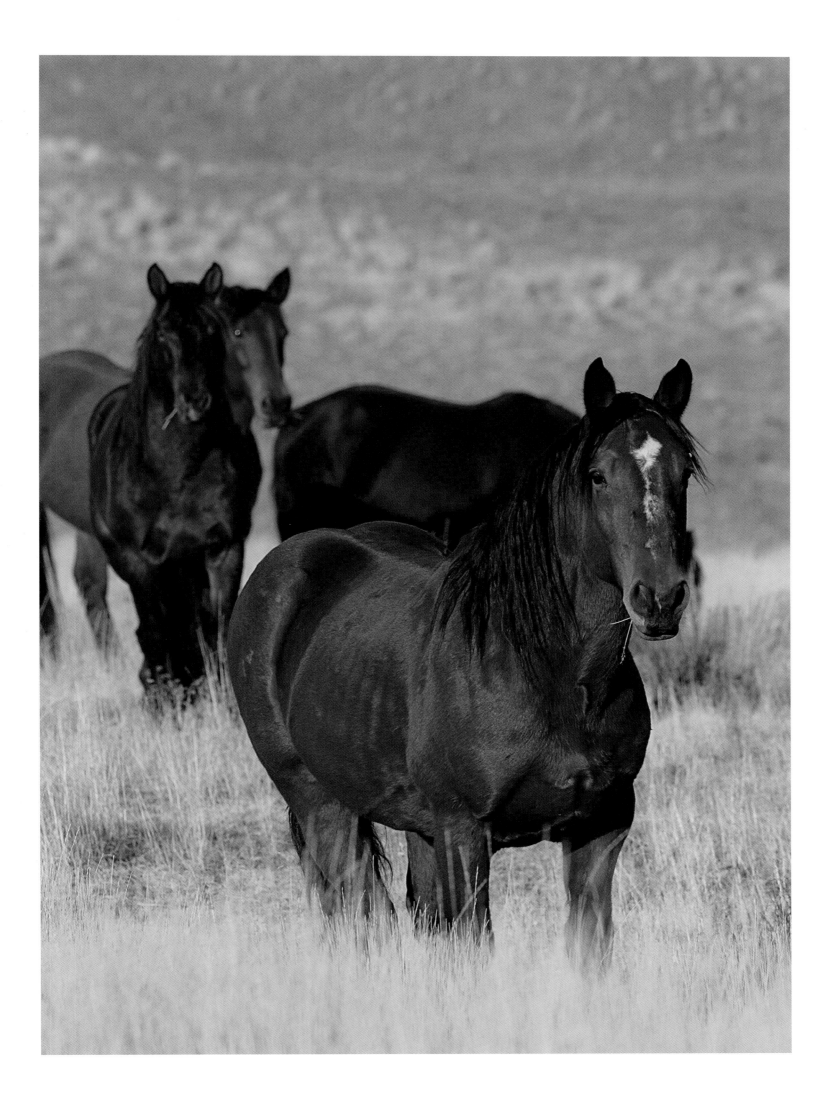

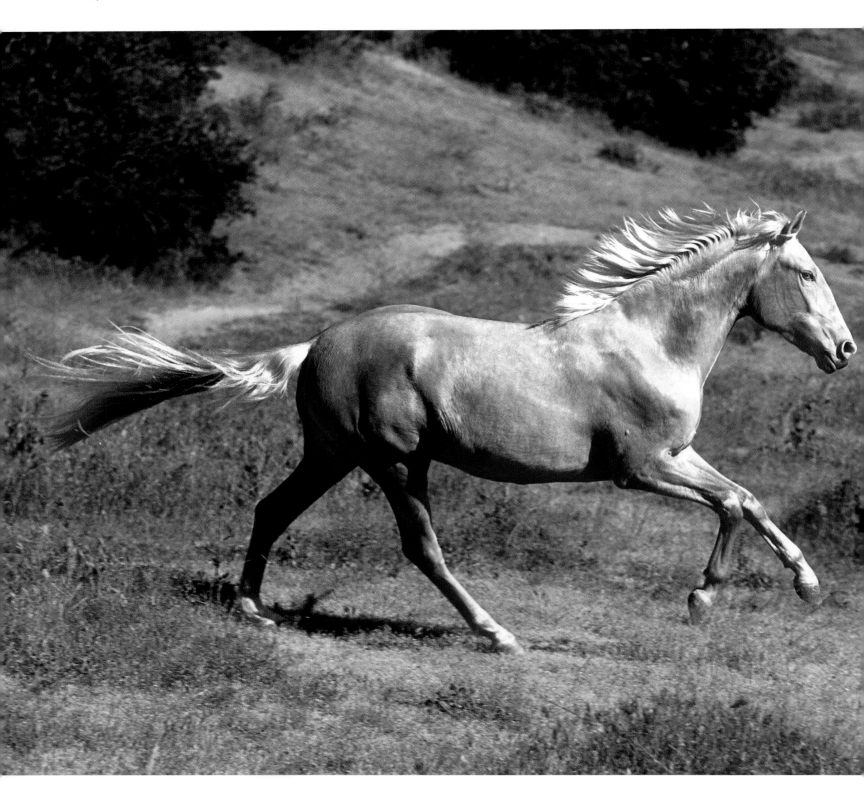

This spectacular golden Andalusian mare with white mane and tail is technically of Palomino colouring. She was photographed at a ranch in California. To get the picture, Bob had to take individual horses away from their group and then let them loose to gallop back toward food and friends. ❶

A Kiger Mustang stands in an Oregon early morning against a misty background. This particular herd was discovered in the 1970s in the Pacific Northwest, far away from the Southwest where Mustangs have more often been found. These animals seem more likely to have escaped from the Spanish settlers as they have dun coats with black manes and tails and the prettier look of the Spanish horse. ❷

①

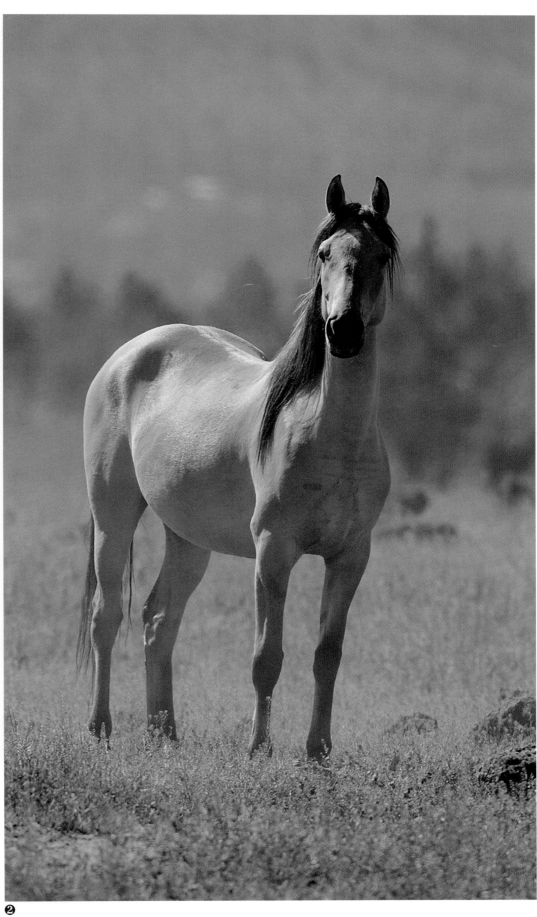

②

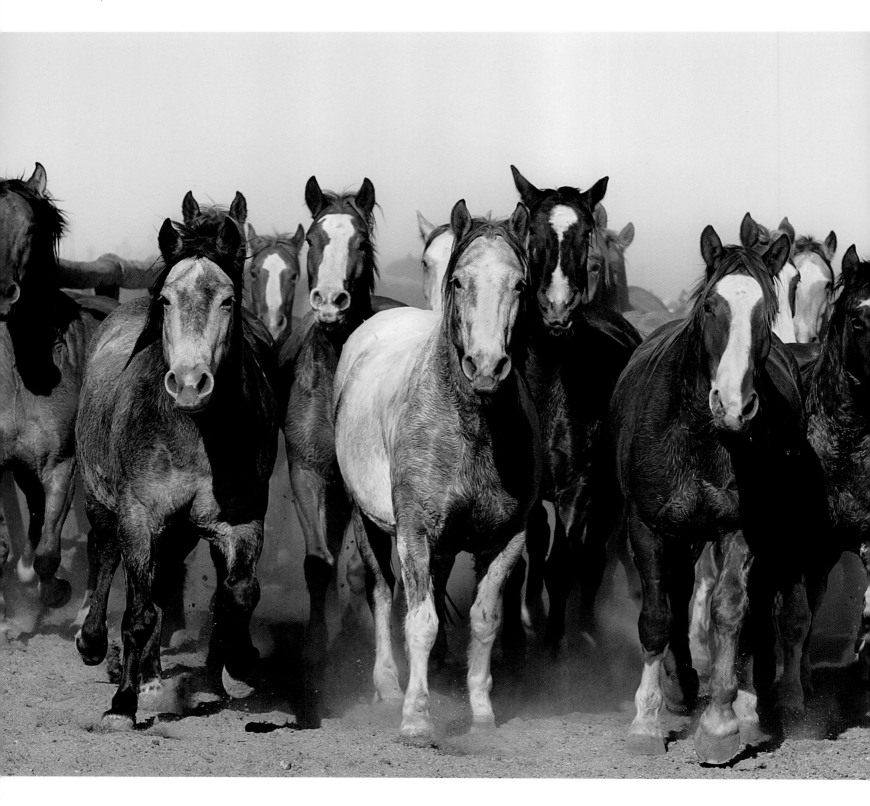

These Mustangs at a holding station in Nevada were chased from one corral to another, hence their flared nostrils and sweaty wet coats. Bob positioned himself in a corner so that the horses had to go around him, but it was still a very vulnerable placement for him. The mustangs were then chased from behind toward the corral. "Luckily, they all avoided me as I think they were more scared of me than I of them," he joked afterward. ❶

The Nooitgedachter is a rare South African breed developed by crossing native Basuto ponies with imported Arabians. The result was a fine, proud-looking animal like the one in this picture, but there are only about a few hundred left. Some are used as riding horses or for horseback safaris, for which they are very popular. ❷

❶

❷

Top:
The noble head of this Namib stallion belies the toughness of the breed. These feral horses of Africa are legendary for their stamina and ability to survive in the Namib Desert on little food and water. Namibs are usually bay brown in colour, or sometimes chestnut, and stand around 14 to 15 hands. ❶

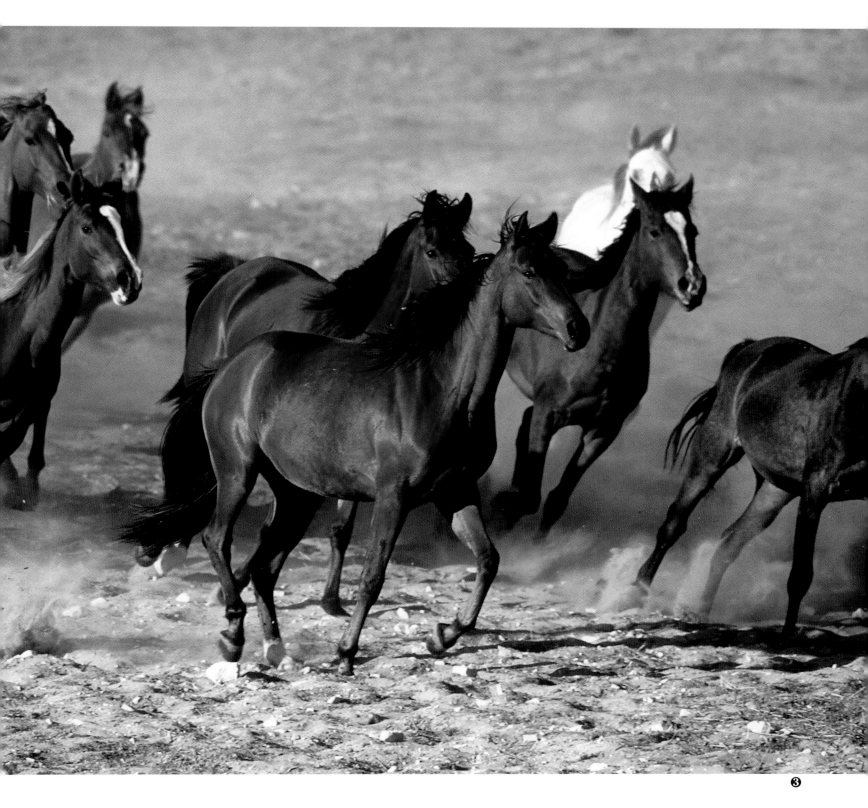

❸

Opposite bottom:
Giara horses come from Sardinia, just off the toe of Italy. Although very small at around 11 hands high, they are still about the same size as they were around 10,000 years ago and are genetically categorised as horses. They have very thick manes and jaws with rather short necks. They are very agile with sensitive temperaments. Recently, they have been crossed with Arabians to help introduce a more docile riding horse. ❷

Above:
Chasing two- and three-year-olds around the large paddock at the Royal Stables in Abu Dhabi enabled Bob to get some shots of Arabians in action. The Arabian's tough limbs and feet have adapted to cope with harsh sand and stony terrain. It is vital that the young get plenty of exercise to allow them to grow strong and healthy and to develop to their true potential. ❸

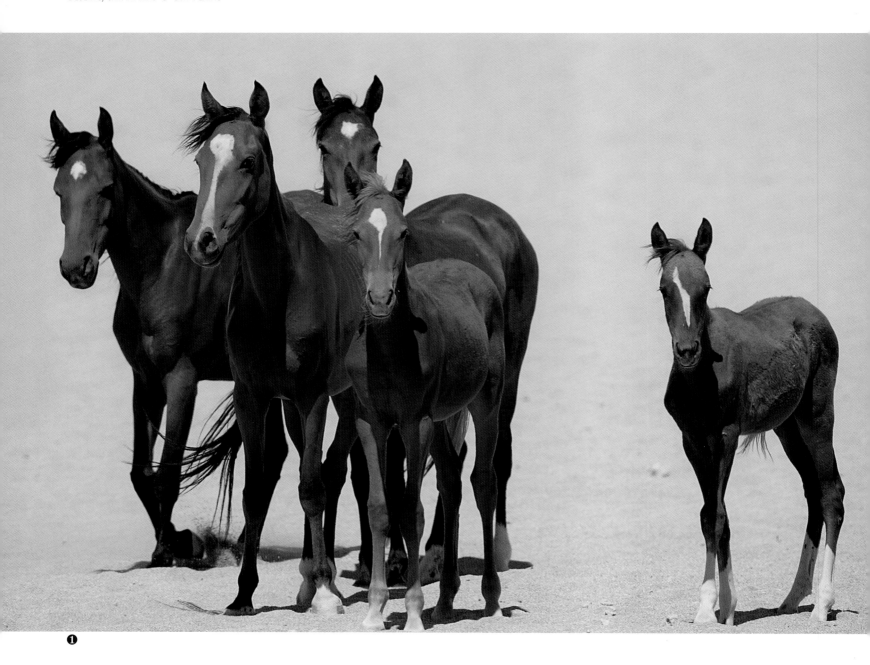

These Namibian mares and foals were photographed in the desert near Garub, where most of these horses originate. After the droughts of the 1990s, many were moved nearer to Aus, which became a tourist attraction after photographs appeared showing the desperate plight of the breed when the water virtually dried up. ❶

These two Kiger Mustangs seem to have become close friends. Another endangered breed, they hail from the Pacific side of North America and show all the attributes of ancient Spanish blood. Their colour, profile, and expression differ from other strains of Mustang, which are generally many colours with large heads and short legs. ❷

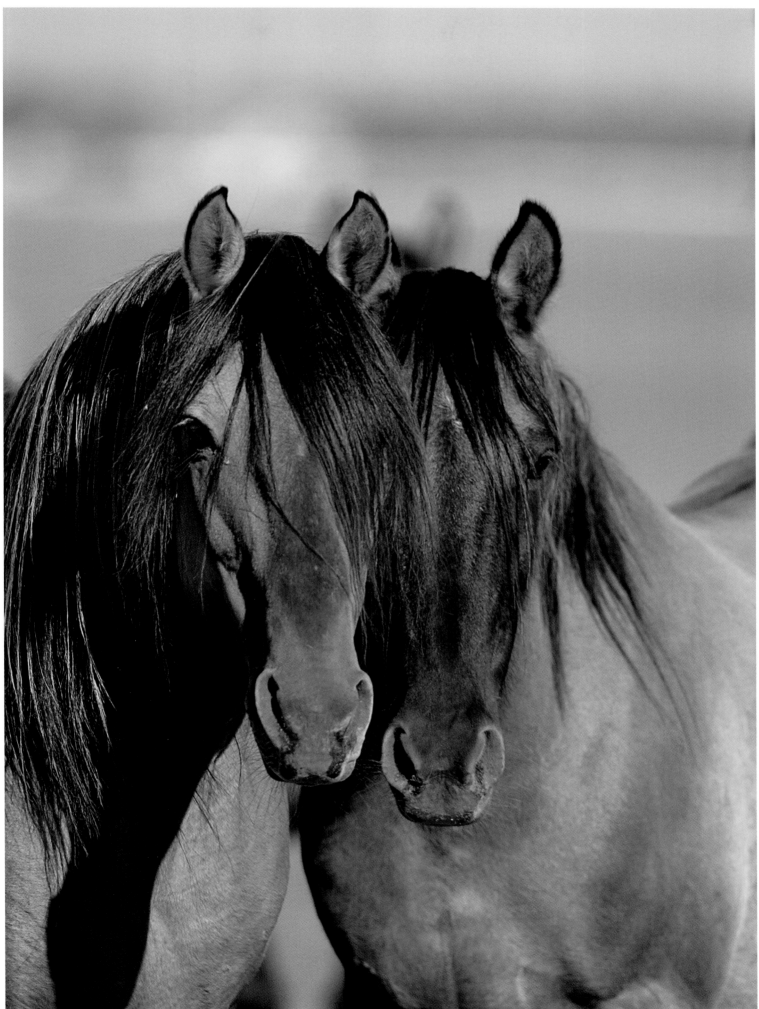

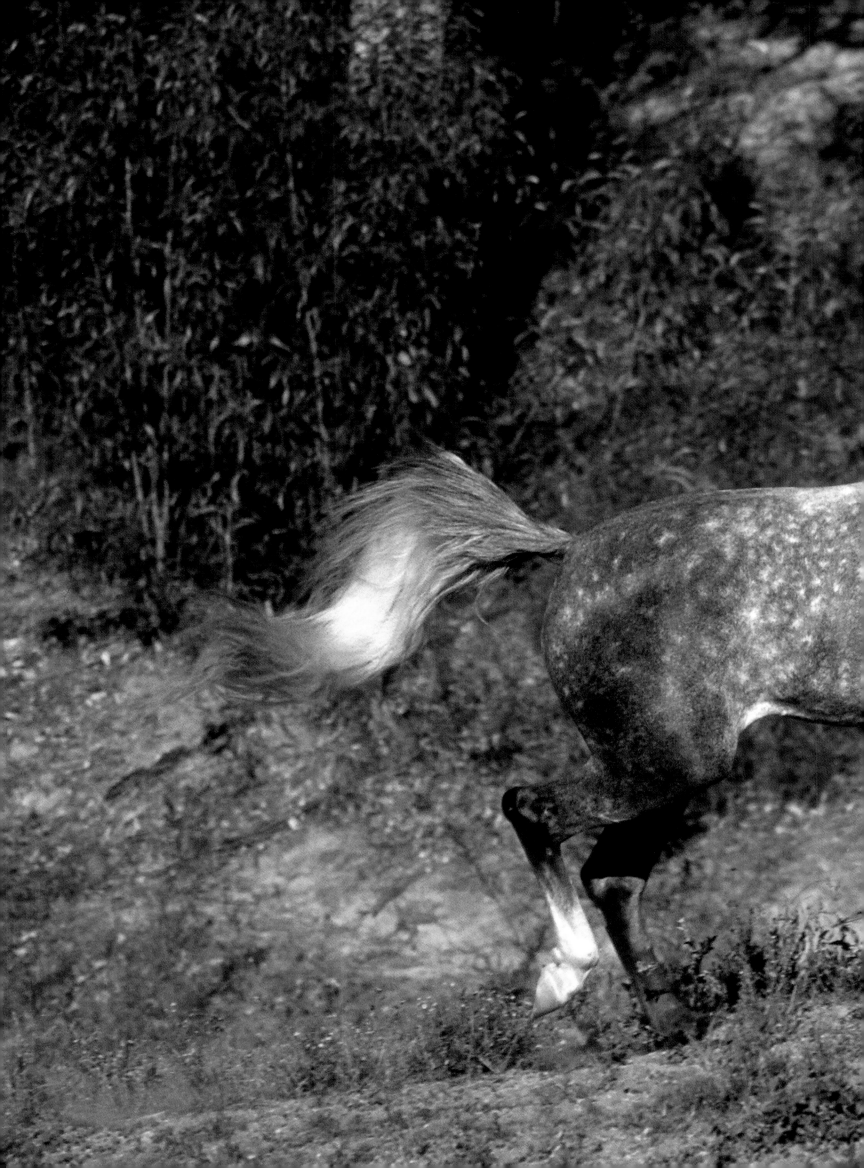

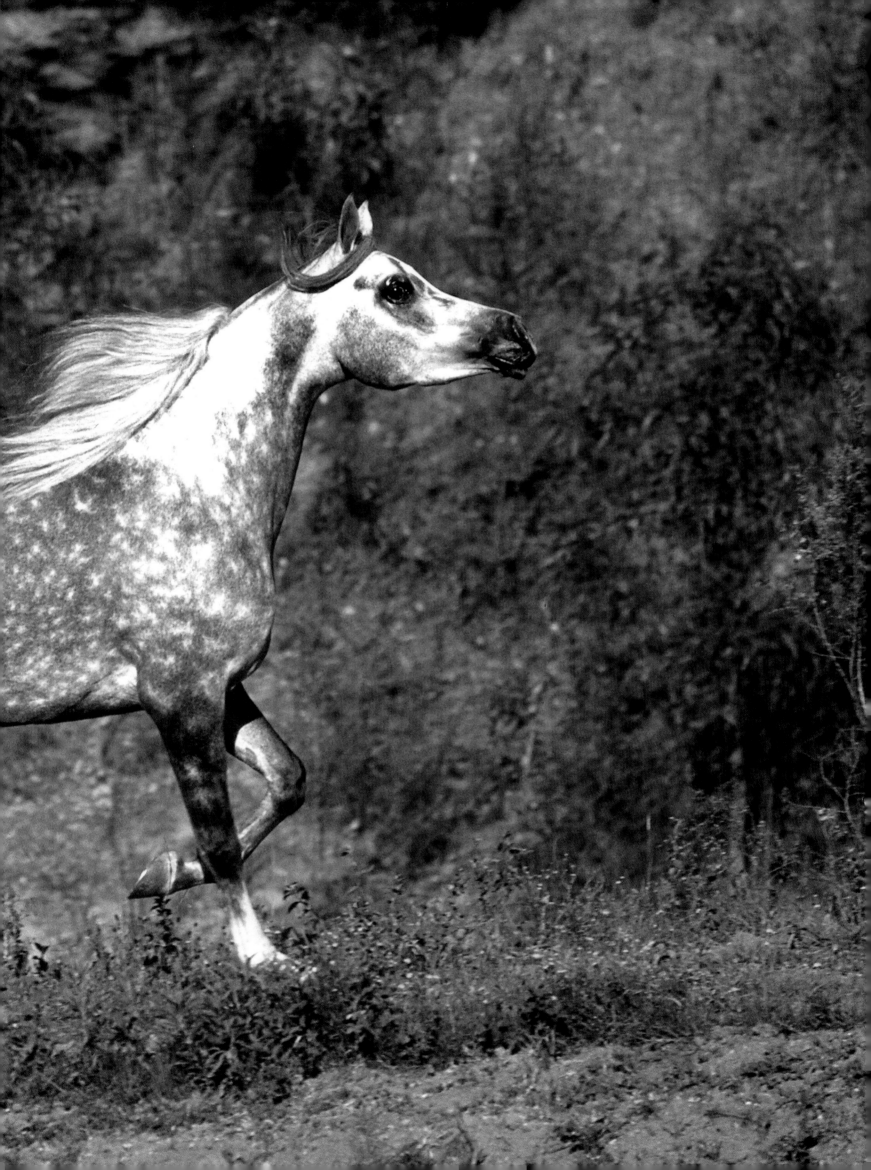

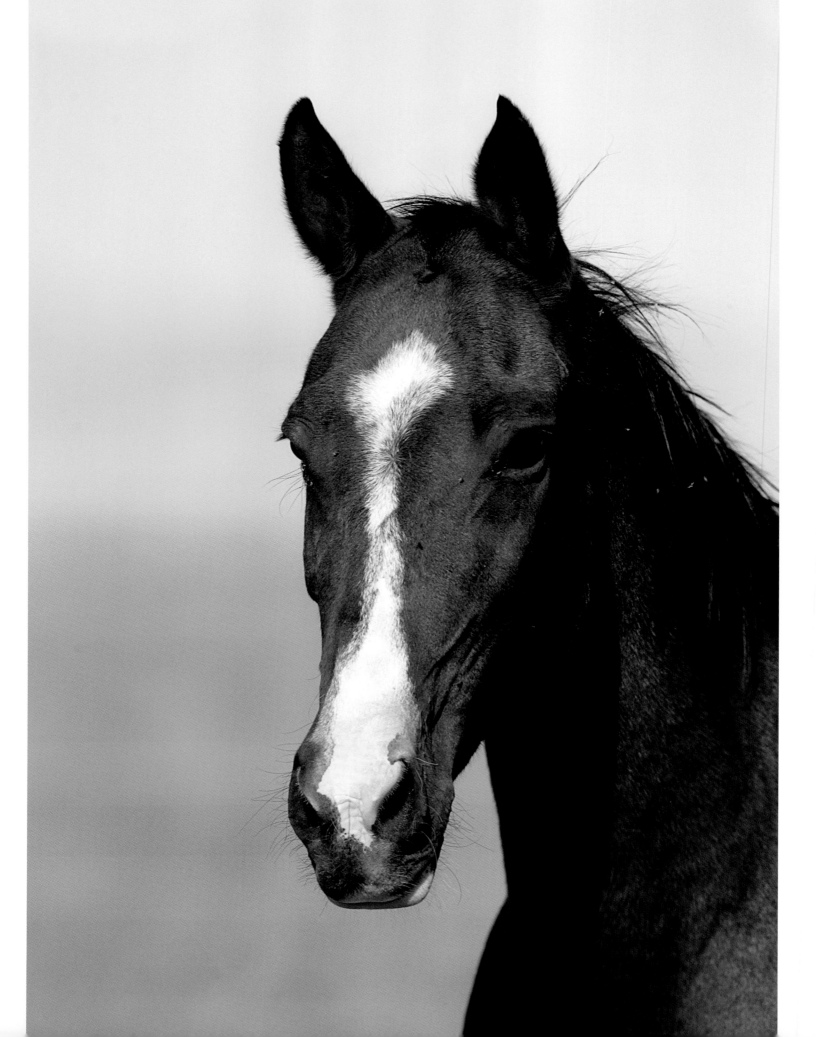

Previous double page:
A dappled grey Arabian runs loose in a large paddock in New South Wales in Australia. Greys usually start off dark, as this one did, but they grow lighter with age and may well end up completely white. The dapples on this mare are exceptionally distinct, and with such dramatic colouring, she would be bound to catch the judge's eye in the show ring. ❶

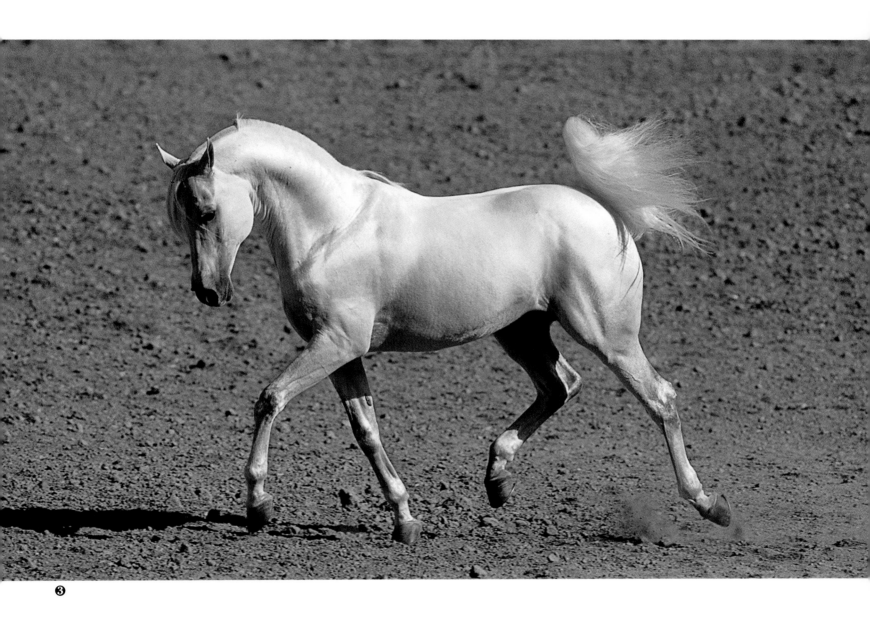

❸

Opposite:
The docile head and expressive face are hallmarks of the sparse-maned Yomud, a rare breed from Turkmenistan. Their comfortable and fluid gaits make them good riding horses, and they are great jumpers. As their numbers declined in the early 1980s, some studs were set up in the country to preserve the best of the breed from extinction. This photo was taken in Iran at the farm of the late Louise Firouz, who is credited with the rediscovery of the very ancient Caspian Horse breed. She was interested in all endangered breeds. ❷

Above:
The Arabian stallion Poison performs on command, so Bob went to a stud just outside Los Angeles, California, where he was able to pose the horse against various backgrounds to capture some really good images. His gleaming silver coat is every photographer's dream, and his look of power and pride has been immortalised in numerous pictures by Bob. ❸

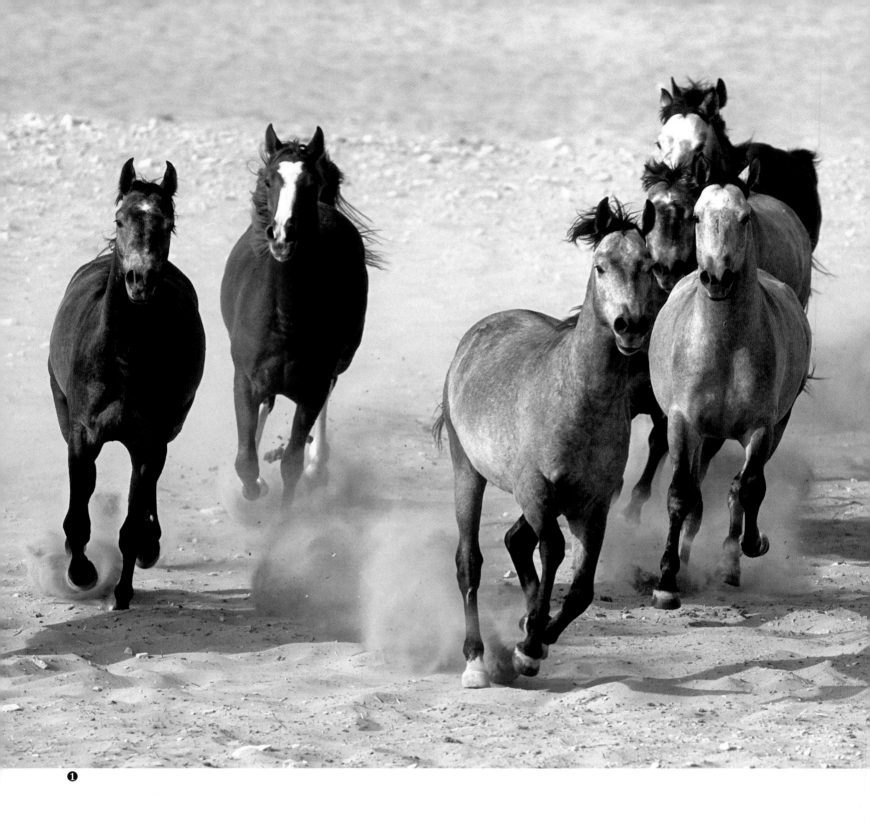

❶

Bob visited the Royal Studs of the United Arab Emirates
on several occasions and persuaded the staff to chase
small groups of young stock to get some good action
shots. Sometimes they would take a lone horse away
from the group and then release it back to its friends.
As herd animals, horses are always keen to catch up
with friends and move together in a group. ❶

❸

❶
❷

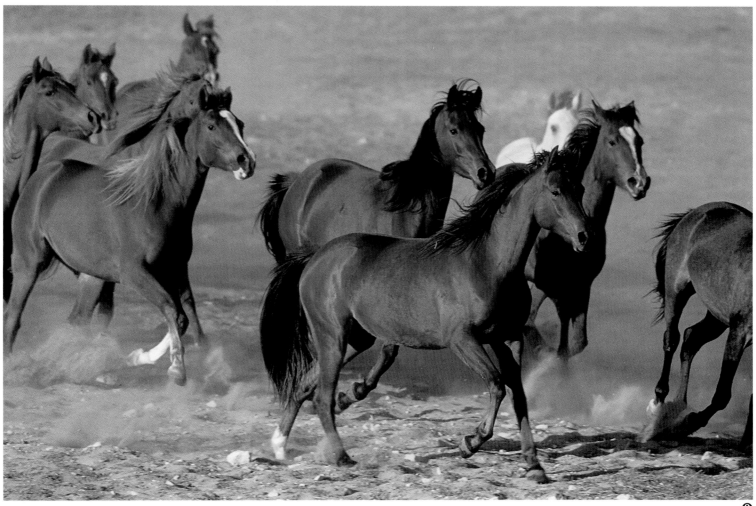

❷

❸

Above:
Arabian youngsters enjoy their freedom in a desert enclosure. Arabians come in most full colours and are generally around 14.2 to 15.2 hands high at maturity. The Arabian is one of the oldest breeds and has been known to exist for the last five thousand years. There were huge armies of Arabian horses in the ancient world, and Solomon's army around 970 B.C.E. is reputed to have included up to four thousand chariot horses and twelve hundred riding horses. Many of these had been captured from Egypt and the Arabian deserts. ❷

Left:
The Yomud from Turkmenistan is a rare breed whose stamina and fine features once made them popular in the region for military and transport use. As with many breeds today, modern practises and mechanisation have made them less popular, but in certain areas they are the conveyance of choice when machines are inappropriate. ❸

Top:
This Caspian mare and foal were photographed at Texana Farm in Texas, which has a breeding programme and a herd of about sixty horses to help promote this rare, diminutive breed from Iran. Although genetically horses rather than ponies, Caspians are tiny at between 10 and 11 hands; they were believed to be the original chariot horses used by Darius. Caspians were thought to be extinct until a few were rediscovered by Louise Firouz in the 1930s in the foothills of the Caspian Mountains. ❶

Above:
A group of wild Mustangs on the desert plains of Nevada. Bob's guide in the desert was Jim Geonolla, head of the BLM in Nevada. "Each day, either in the desert or at Carson City Jail, he took with him Bones, his Bloodhound puppy, who the prisoners adored. One day, something scared Bones and he ran off into the desert. We couldn't find him so, as a last resort, they sent 10 prisoners out to search for him and luckily, they were successful. Talk about a role reversal!" ❷

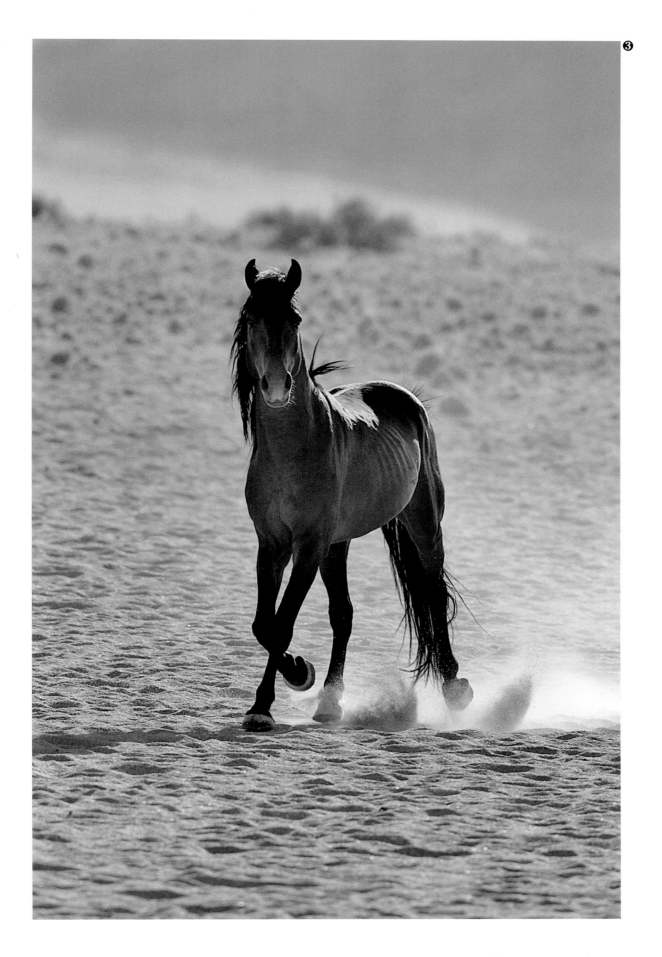

A Namibian Desert Horse lopes
in the early morning, sun glinting
on his rich dun/bay coat. ❸

Contentment shows on the faces of these young semi-wild Mustangs as they rest amid relatively lush vegetation in the plains and hills of Nevada. In some areas, the Mustang — whose name *mesteño* in Spanish means "stray" — has become a problem because of overbreeding. In the early days of the Spanish settlers, the indigenous tribes tended to take what they could catch, and Mustangs were crossed with other breeds that were brought to America. The American Indians quickly learnt to ride them, and over time the Mustang became a cavalry horse to armies in the USA, Canada, and Mexico. ❶

❶
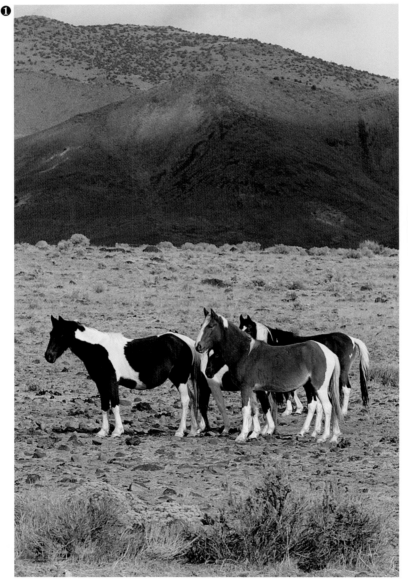

❷
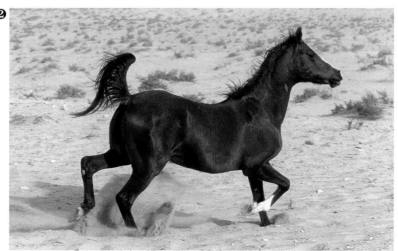

❸
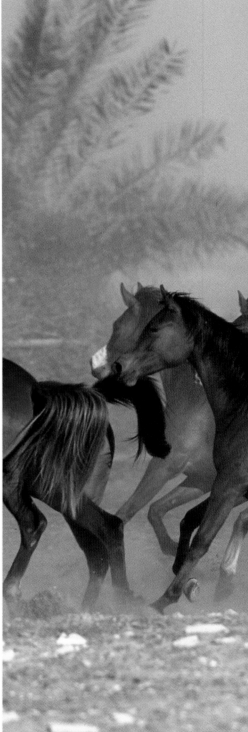

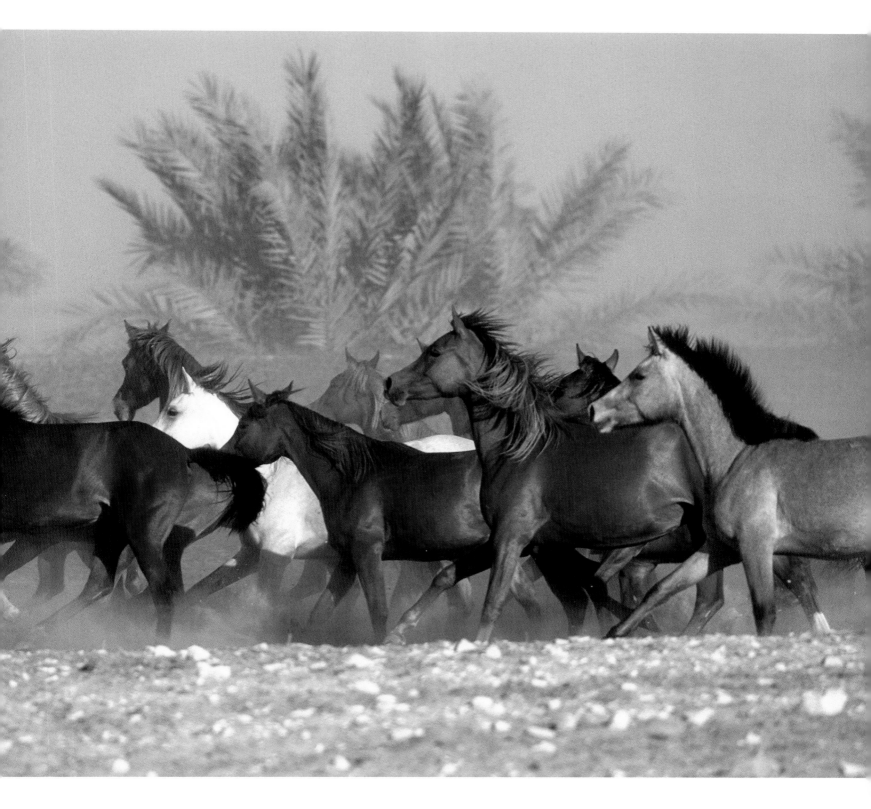

Left:
This Arabian mare in the desert near the Royal Stables in Dubai decided not to cooperate with Bob's normal tactic of taking one horse away from its friends and allowing it to gallop back. Bob had positioned himself close to the stables with the desert in the background, but she gave them all the slip and it took some time to get her back from her newfound freedom in the desert! ❷

Above:
A large herd of youngsters gallops past the palm trees in a paddock in Abu Dhabi. The stony ground does not seem to worry them, as Arabians have very tough, hard feet, and most horses cope well in hotter climates when the ground is harder and drier. Their feet are more upright than their counterparts in wetter climates, where the feet seem to grow wider and shallower to carry them across soft, muddy ground. ❸

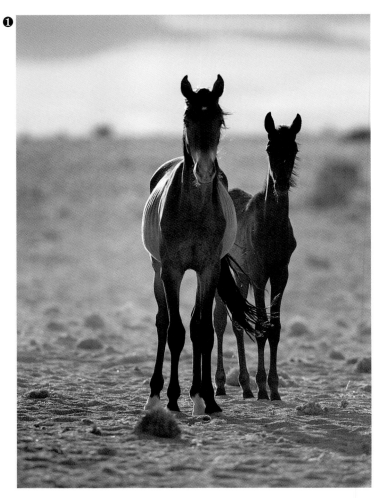

This young Namibian mare and her foal are waiting patiently for their turn to drink at the watering station in the desert near Aus in South Africa. They come every two to three days in herds of anywhere from three to ten animals, usually with one stallion and his mares and offspring. Everyone seems to know when to move forward to take their turn. If only all species were as polite! ❶

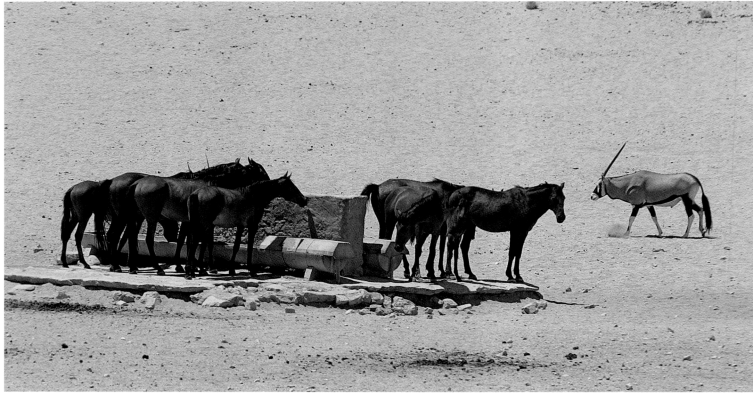

❷

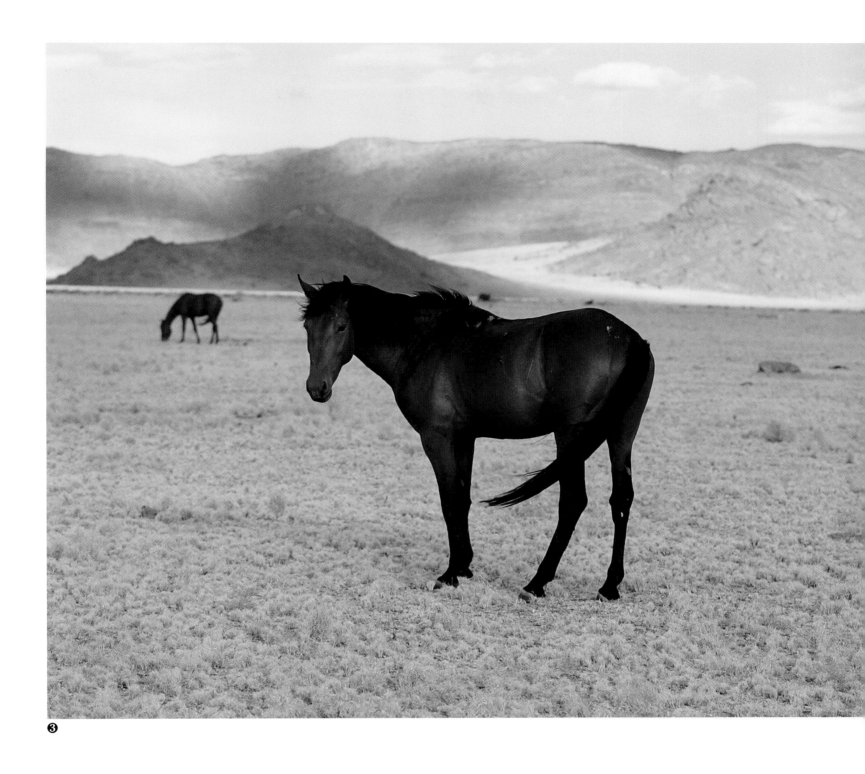

❸

Left:
Horses share the watering station with other desert animals such as oryxes, jackals, and ostriches, who also come here to drink and happily walk around until there is a space. The horses are very shy, and to get these pictures Bob had to spend three days sitting very still about a hundred yards away with his telephoto lens before they accepted his presence. **❷**

Above:
With the watering over, the horses return to the arid desert or go up into the hills until the same ritual happens again in thirty-six to forty-eight hours. The installation of the troughs has made a huge difference to the wildlife in the area, and with the resulting tourism, the future of these animals now looks bright. Current estimates are that around 25,000 visitors come annually to watch the animals at the watering holes. **❸**

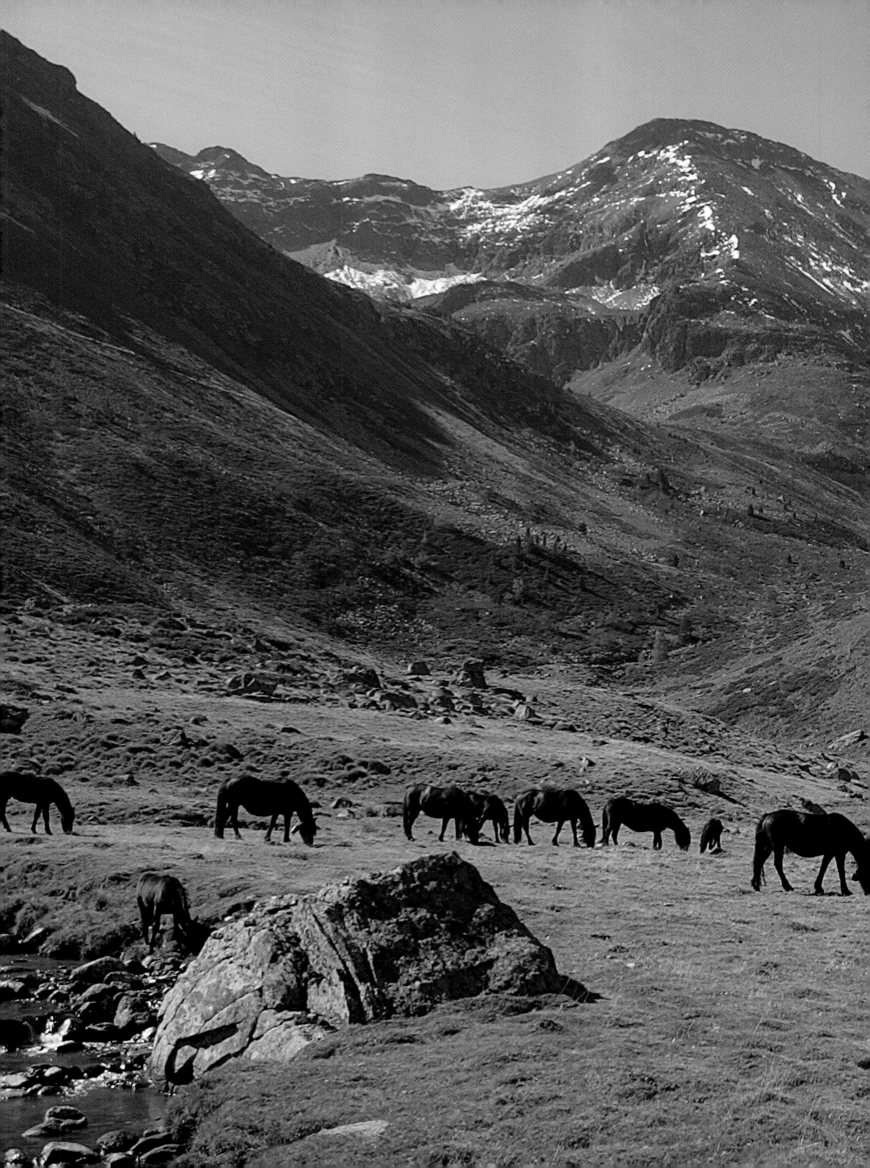

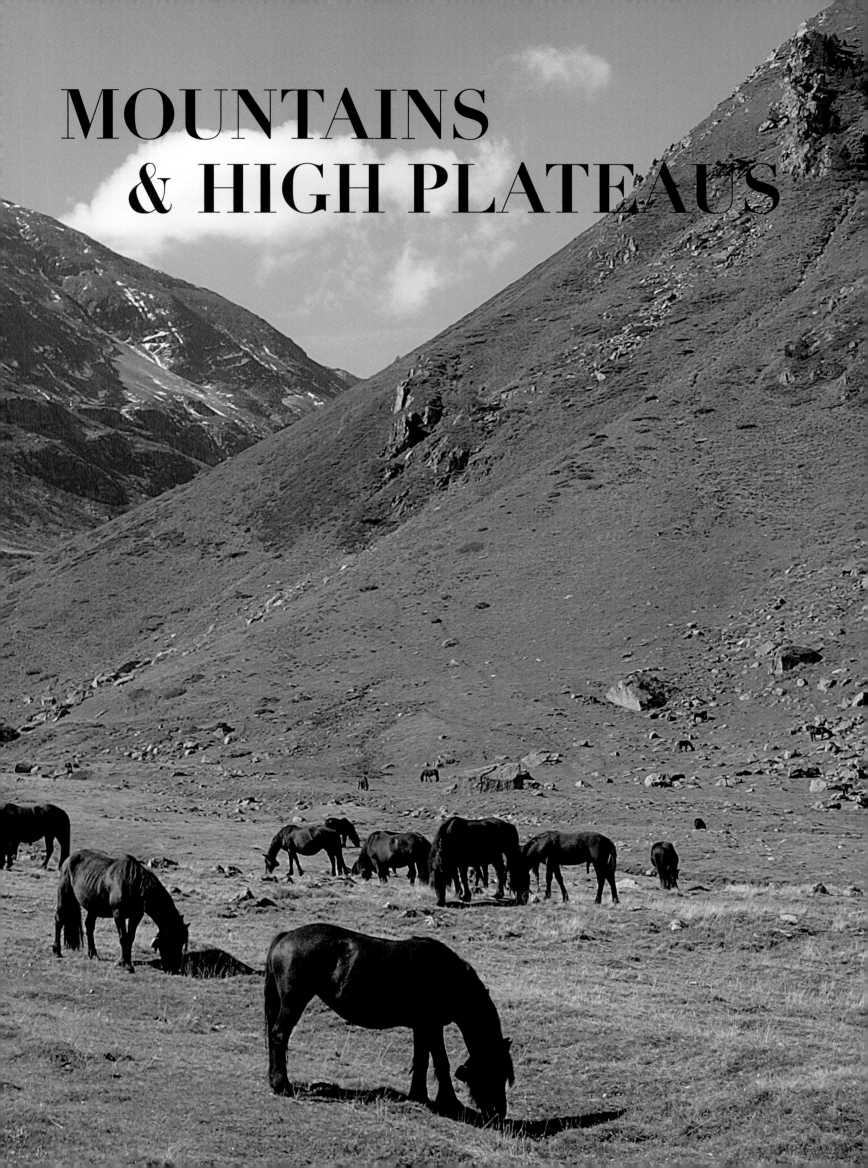

MOUNTAINS
& HIGH PLATEAUS

Many of the horses in this section were photographed in or near the Pyrenees, such as the Mérens and Pottoks in France, Asturcón in Spain, and the Karabakh and Kabardin horses in the Caucasus Mountains, which Bob has visited on two occasions. Some were taken in the Nevada desert in the USA. Generally, it was best to get these photographs during the warmer months when the snow had melted enough to see the vegetation on which the animals subsist. Carrying heavy equipment and cameras to these very remote areas demanded concentration and a lot of stamina from all concerned in order to avoid accidents.

Bob contrasts his first visit during the time of Communist Russia with a second visit after the Berlin Wall had come down. Nothing had changed in the countryside, but in Moscow everyone was driving BMWs and Mercedes, and much of the city appeared to be run by Russian mafia. Bob's guide, a veterinarian named Mikhail, carried a concealed handgun on the second visit. Many of the photographs from this trip were taken at stables around the Moscow Hippodrome, the race track for the Orlov trotters. Bob was also warned not to speak when in public for safety's sake because he was foreign and carrying a lot of cameras.

On the second occasion, Bob was working on Nicola Jane Swinney's book, *Horse Breeds of the World*, and the publisher wanted all of the horses photographed on a white background and base. Not many of the horses were too keen on this idea! One of them kicked, catching Mikhail just above the eye. His veterinary practice was just around the corner, so he went there and put three stitches in himself, insisting that Bob finish the photo shoot before he would consent to be taken to hospital! The doctor there came to Bob saying, "We can use Russian sutures which will leave a scar, or for twenty US dollars we can use US stitches, which will leave no scar." Bob quickly reached into his pocket to find the $20, and all was well.

Most of the breeds living in mountainous areas are small and tough with good strong feet and an agile physique. Their coats tend to be thick and dense to withstand the cold and often windy conditions. When taking some of the photos of Russian breeds in the Caucasus Mountains, Bob encountered one slight problem with Russian hospitality. Whenever visiting a farm, it was customary to finish the visit with a large swig of vodka. Mikail the guide saved Bob from this well-meant gesture by saying his liver was bad and a drink might kill him! They would never have managed to continue to other venues had they given in to this custom early in the day.

Previous double page:
A group of Merrens ponies is a long way up the foothills of the French mountains. This tough ancient breed has adapted well to its environment, being extremely versatile with a tough constitution, hardy feet and attractive appearance. ❶

Opposite:
The Peruvian Paso is a spectacular gaited horse. This one, photographed in the Santa Ynez Valley in California, has Palomino colouring. Originally from Peru, the breed is known for its endurance, elegance, easy temperament, and comfort. The legs and body are usually about the same depth. The first horses were recorded in Peru around the early 1500s, when the Spanish appeared, and because of the poor roads at that time these horses were prized for their comfortable stride. Peruvian Pasos have suffered from indiscriminate breeding over the years, but this has now been rectified and the breed is carefully regulated to ensure true blood lines are used. ❷

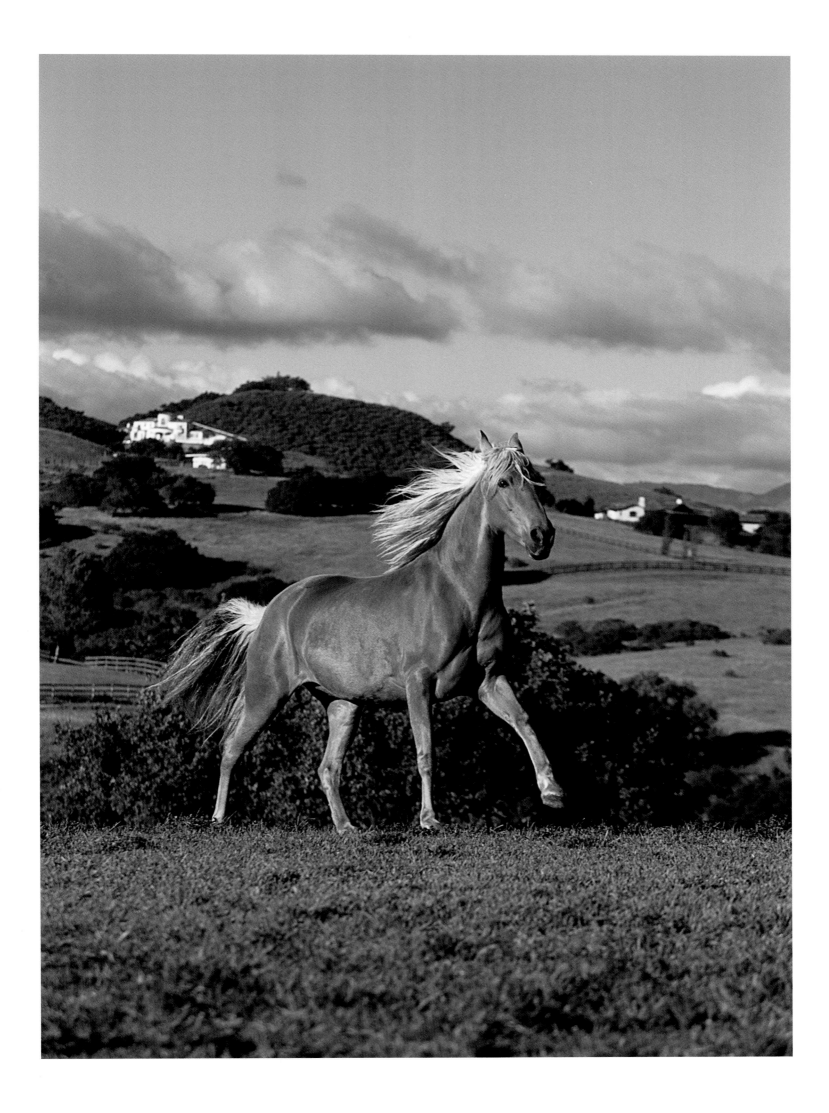

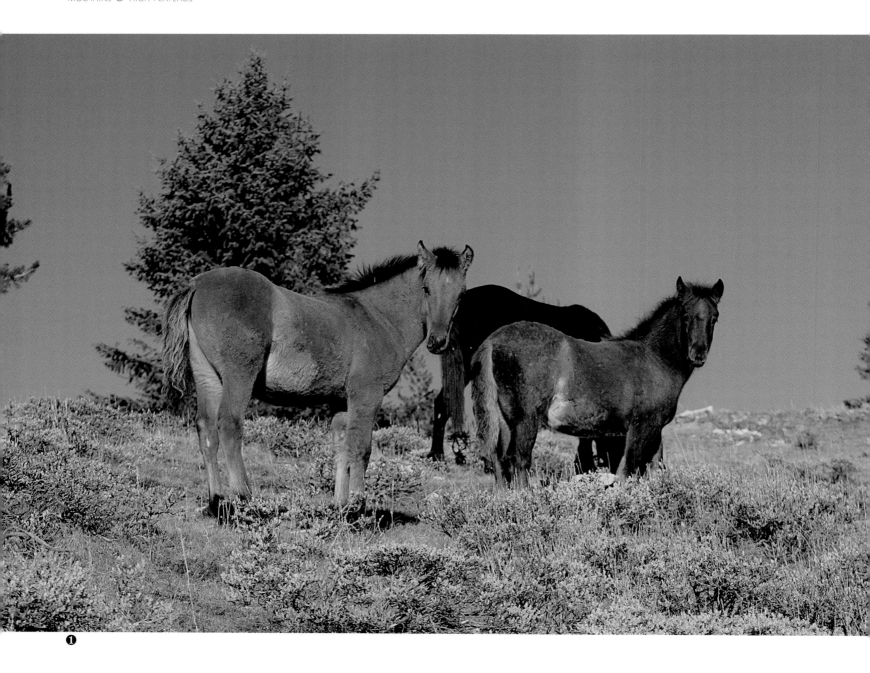

❶

Above:
Some inquisitive Mustang foals look over their shoulders at Bob as he tries to take pictures in Montana's Pryor Mountains in the USA. The foals' coat colouring against the vivid blue sky makes for a great picture as these youngsters forage amongst the prickly plants and scrubland in the area. Bob was concerned to find his guide was carrying a gun, and when he asked why, he was told, "In case we get between a bear and its cub!" They were joined the next day by the guide's son, who had no gun but said he preferred pepper spray. The father informed him that if the wind blew in the wrong direction, he would just flavour himself for the bear! ❶

Opposite:
This tough little Asturcón from Spain has moved up the mountain, where there appears to be plenty to eat even though it can get very windy and cold in some places. These horses have survived for centuries despite harsh conditions and are renowned for their hardiness and mild temperaments. ❷

❶ ❷

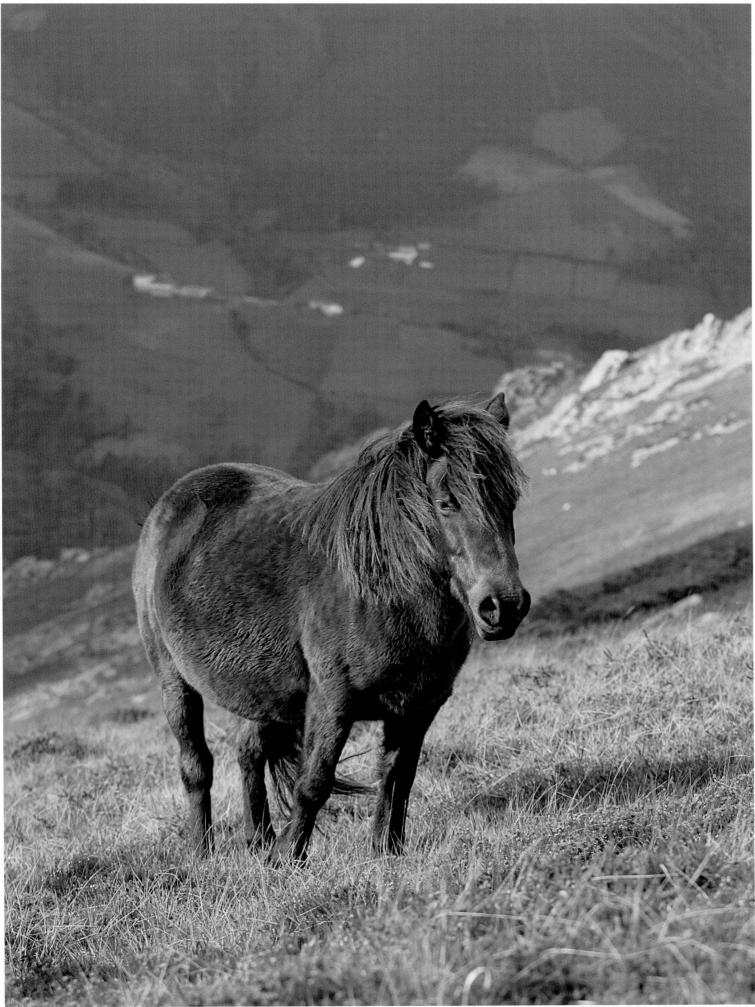

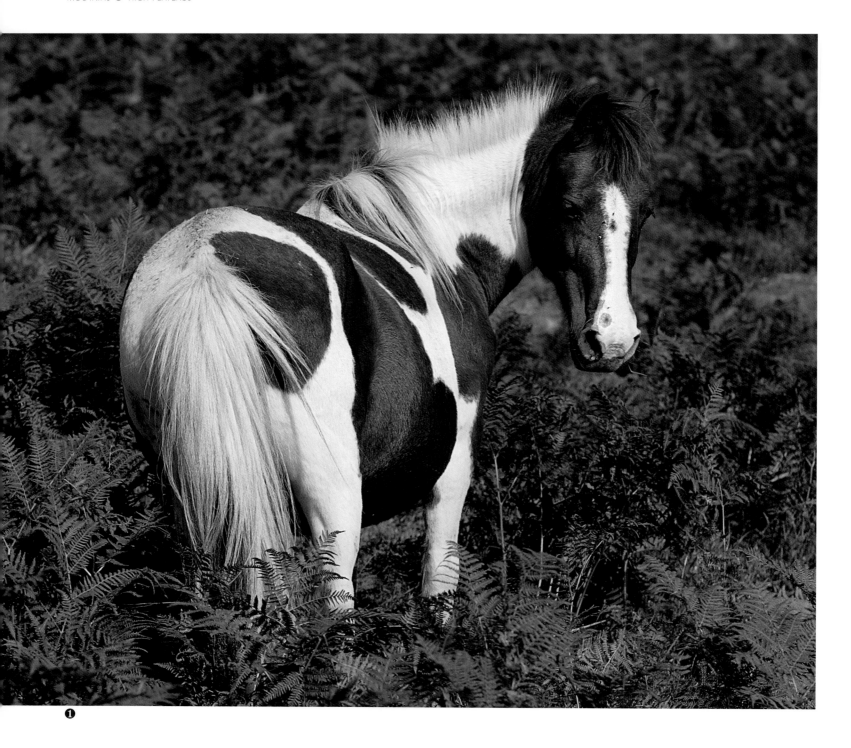

❶

The Pottok comes from the northernmost tip of
the Pyrenees and can be found on both French
and Spanish soil. A very ancient breed, it stands
about 12 to 13 hands high and has lived in the hills
and mountains for centuries. It may have derived its
name from the Basque word *pottoka*, which means
"pony" or "little horse". They have almost always
been single colours, although multicoloured Pottoks
have recently been introduced into their breeding. ❶

❷ ❶

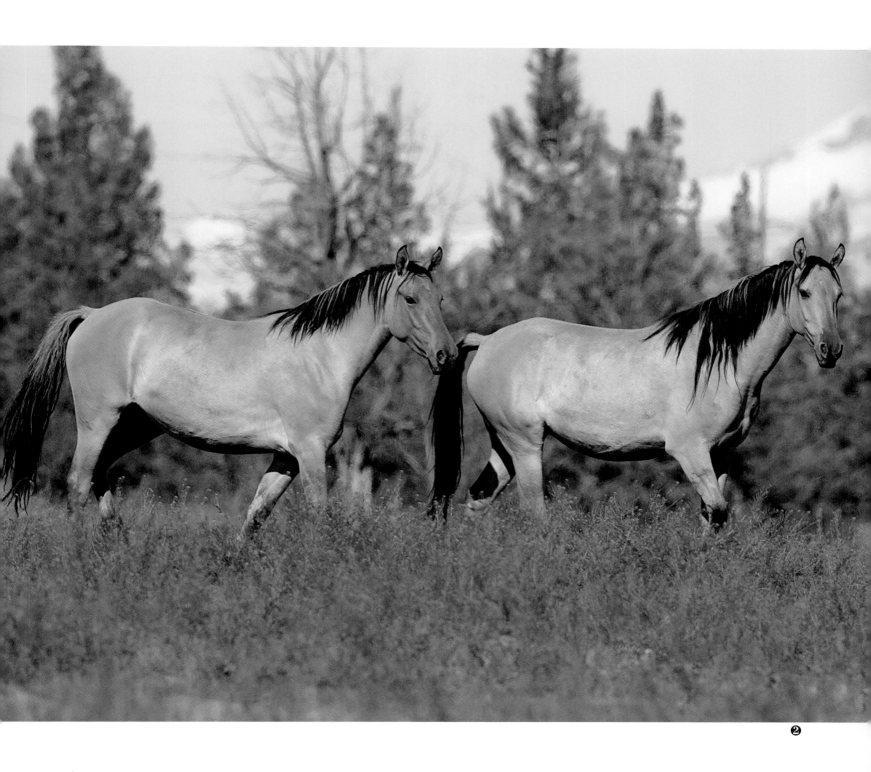

❷

The Kiger Mustang has been found to be a much
more ancient and pure breed compared to other
types of Mustangs found in America. Living in the
north western part of the USA, they appear to
have remained true to their origins in the Spanish
horses who came across in the 1500s. Photographed
in Oregon with snow-capped mountains in the
background, these two show the classic Kiger dun
colouring, which may vary considerably in tone,
with black manes and tails. ❷

Right:
This herd of Kabardin horses was photographed in the Caucasus Mountains in Russia. It is an ancient breed with sparse manes and tails and many of the attributes of strong mountain horses. They are usually bay, dark brown, or black in colour. Height is between 14.2 and 15.1 hands. Kabardin are sure-footed, docile and a good ride; more recently, they have been crossed with Thoroughbreds to create a taller and more refined sport horse known as an Anglo-Kabardin. ❶

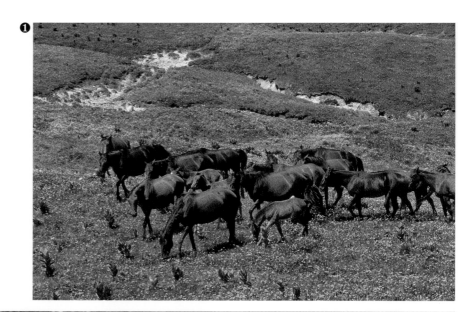

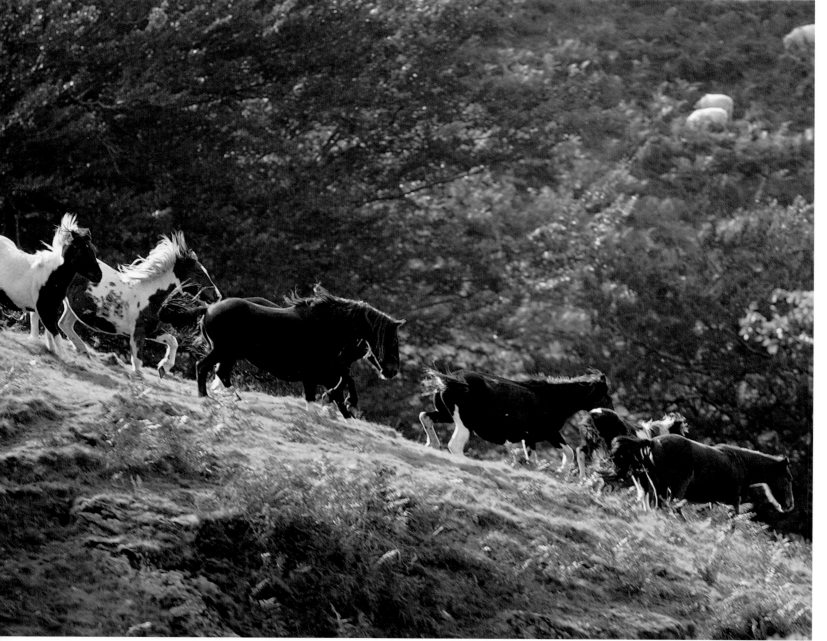

❸

Opposite:
A large herd of Pottoks tread carefully down the mountainside.
They live in a semi-feral state at the base of the Pyrenees. Owned
by the locals, they are brought down every year in late January for
identification and branding before being either sold or returned
to the hills. **❷**

Above:
French Mérens ponies live high up in the hills, and when Bob went
with a French veterinarian to photograph these, there was no sign
of them at 1000 feet. He was told they were another 1500 feet further
up! Burdened with heavy cameras and asthma, Bob persuaded the vet
to go up and herd them down toward him. Afterward, Bob and the
vet watched the England / France rugby match over a lovely bottle
of Nuits-Saint-Georges, which made it all worthwhile! **❸**

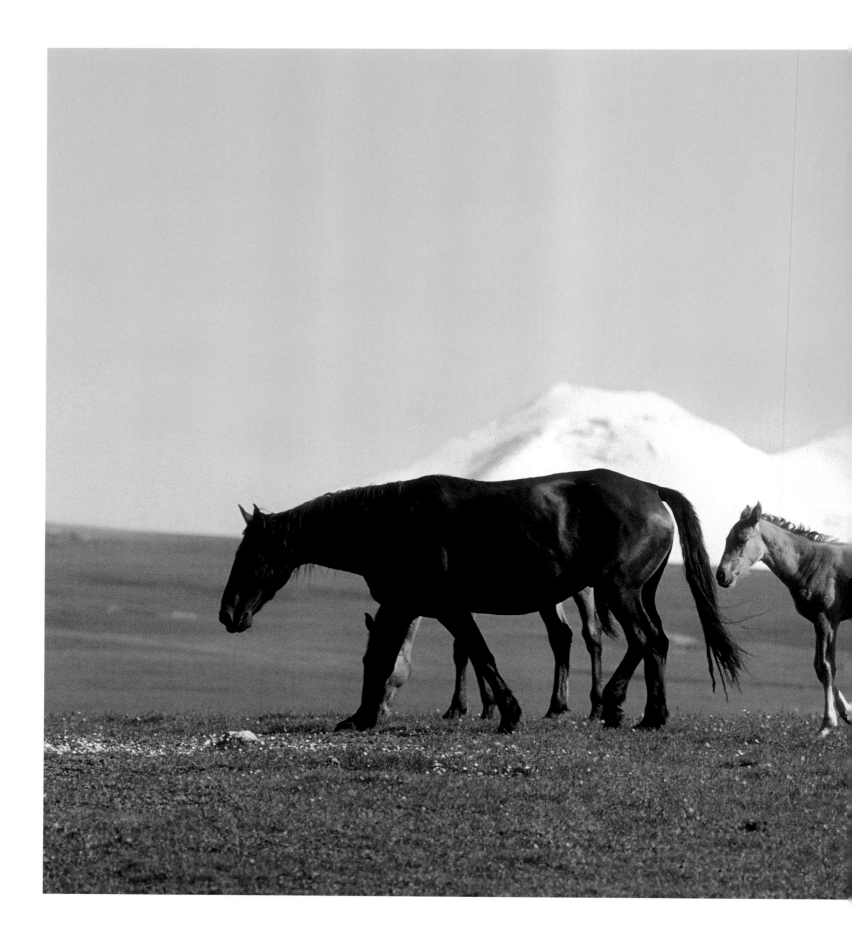

Russian Kabardin graze in front of the spectacular Caucasus Mountains. In springtime there is plenty to eat, and these animals look well fed and contented, a far cry from the harsh winter months when food is scarce and there are strong biting winds. The colouring and contrast of this photo makes for a picture-postcard image. ❶

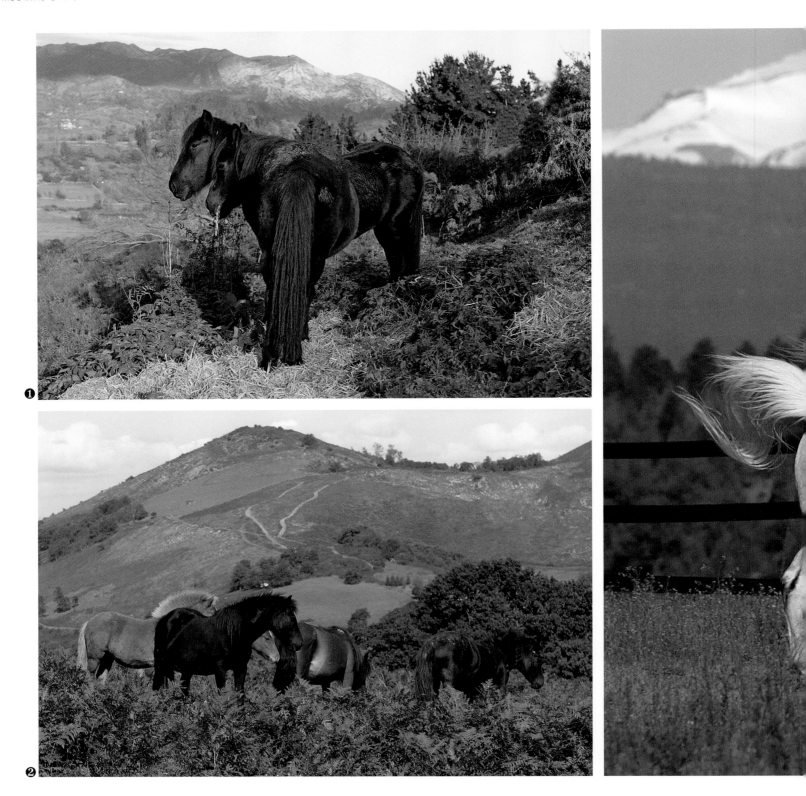

Top:
Two Asturcón ponies survey the scene in the autumn sunshine amongst the bracken and scrubland of the Pyrenees foothills near Asturias, Spain. These are very hardy horses and have survived in the mountains for generations. Their dark colouring acts as good camouflage against the trees and shadows. ❶

Above:
The ancient Pottok breed of small pony is believed to be a descendent of the Magdalenian horses that lived from around 14,000 to 7,000 B.C.E. in Western Europe; they may also be related to the Tarpan, an ancient and now-extinct breed. The Pottok roams the Pyrenees in the Basque region of southwest France and the northern part of Spain near the Bay of Biscay. ❷

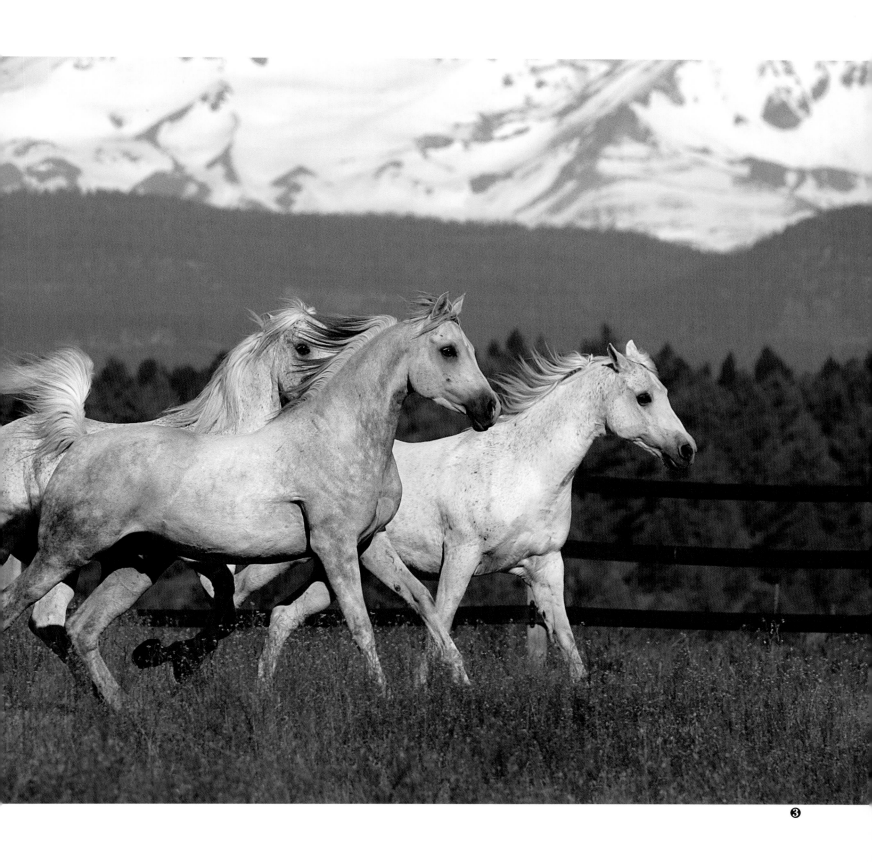

Three grey Arabians run through a meadow in Oregon. Bob was trying to get them to run in front of the snow-capped mountain, but initially they did not oblige. Finally, when he had almost given up, they cantered past this stunning background. Mission accomplished! ❸

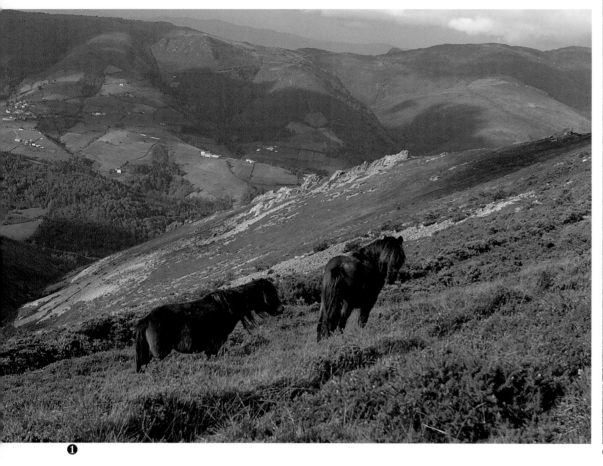

The Asturcón is a rare little pony bred in northern Spain. It is thought to have been a cross between the Sorraia, the Garrano, and the Celtic pony, and there is evidence a small pony existed in ancient times with the characteristics of the Asturcón. These hardy ponies have easy temperaments, good for packing and riding. They are usually brown or black and measure 11.2 to 12.2 hands. ❶

The Spanish Galician is a small, shy, and wary pony standing around 12 to 13 hands. It has an attractive appearance, is very strong, and is used at the annual Galician Festival in the "Capture of the Beasts," which has become a popular tourist attraction. Originally considered meat animals, Galician manes and tails were valued as materials for brushes. ❷

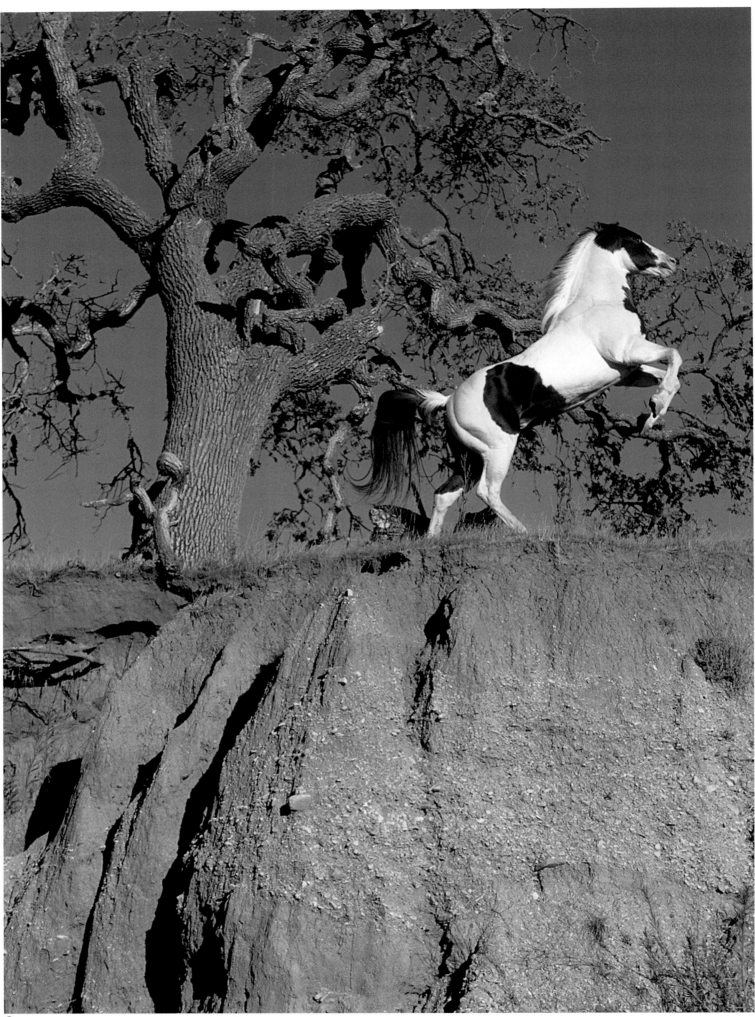

Opposite:
A Pinto strikes a classic pose. This trick horse is trained to rear on command. Bob took him to several different locations in California with various backgrounds. This is a favourite of Bob's—it reminds him of Tonto in *The Lone Ranger*! On this occasion, his method was to take a loose shot with lots of background, then use a telephoto lens and zoom in to put a different perspective on the picture. ❶

Top:
A Kabardin grazes in a valley with the snow-capped Caucasus Mountains in the background. The popular Russian breed shows the ancient trait of the bay/dun colour and is hardly enough to cope with the extreme winter conditions. Kabardins use the spring and summer months to refuel and prepare for the harshness of winter. ❷

Above:
Bob was invited to Interagro Lusitanos, a two-hour drive from São Paulo in Brazil. The stud farm started developing a breeding program in 1975 and today is the world's largest breeder of Lusitanos. With more than six hundred horses to choose from, Bob was able to set up a big group photo: "I wanted a herd of horses coming over the top of the hill. They sent out three or four gauchos to herd them toward me." ❸

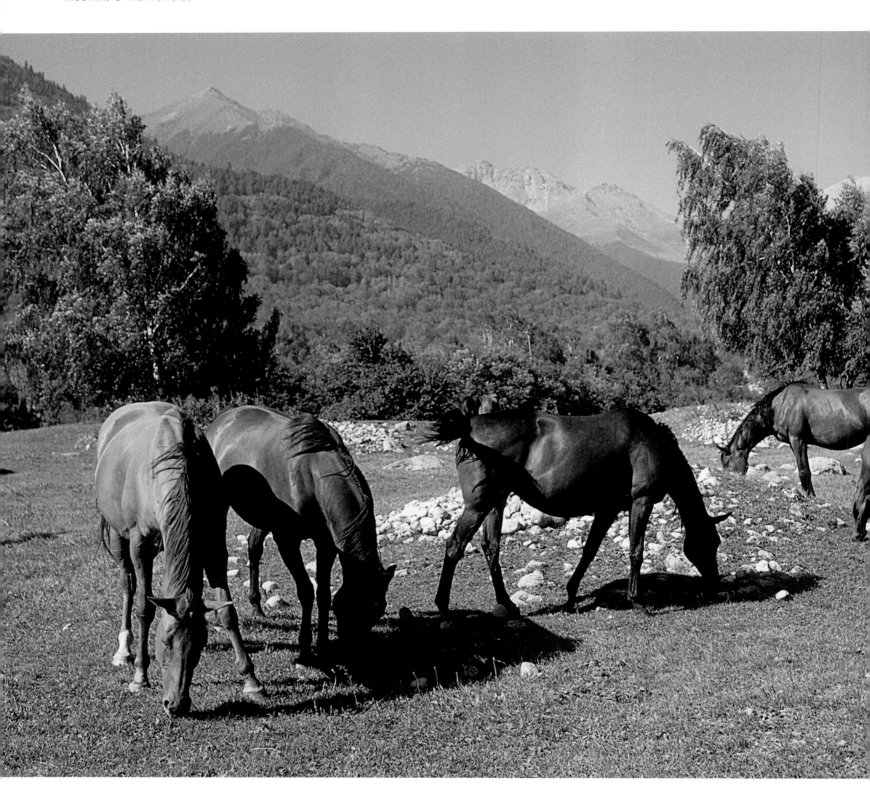

Karabakh graze in the lower spring pastures of the Caucasus Mountains. This ancient Russian breed has almost disappeared in its original form, but some can still be found, particularly in Azerbaijan. Efforts are underway to preserve this light riding horse that was once a popular military mount. ❶

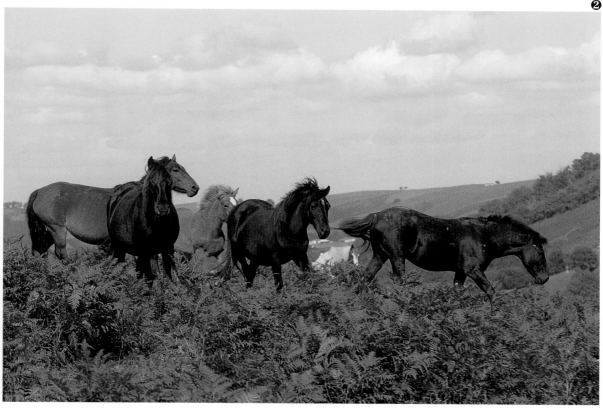

The Pottok is found in small herds high up in the Pyrenees. It is sometimes called the Basque pony and comes in almost every colour. It has an amazing ability to adapt to its habitat and makes an excellent riding pony. ❷

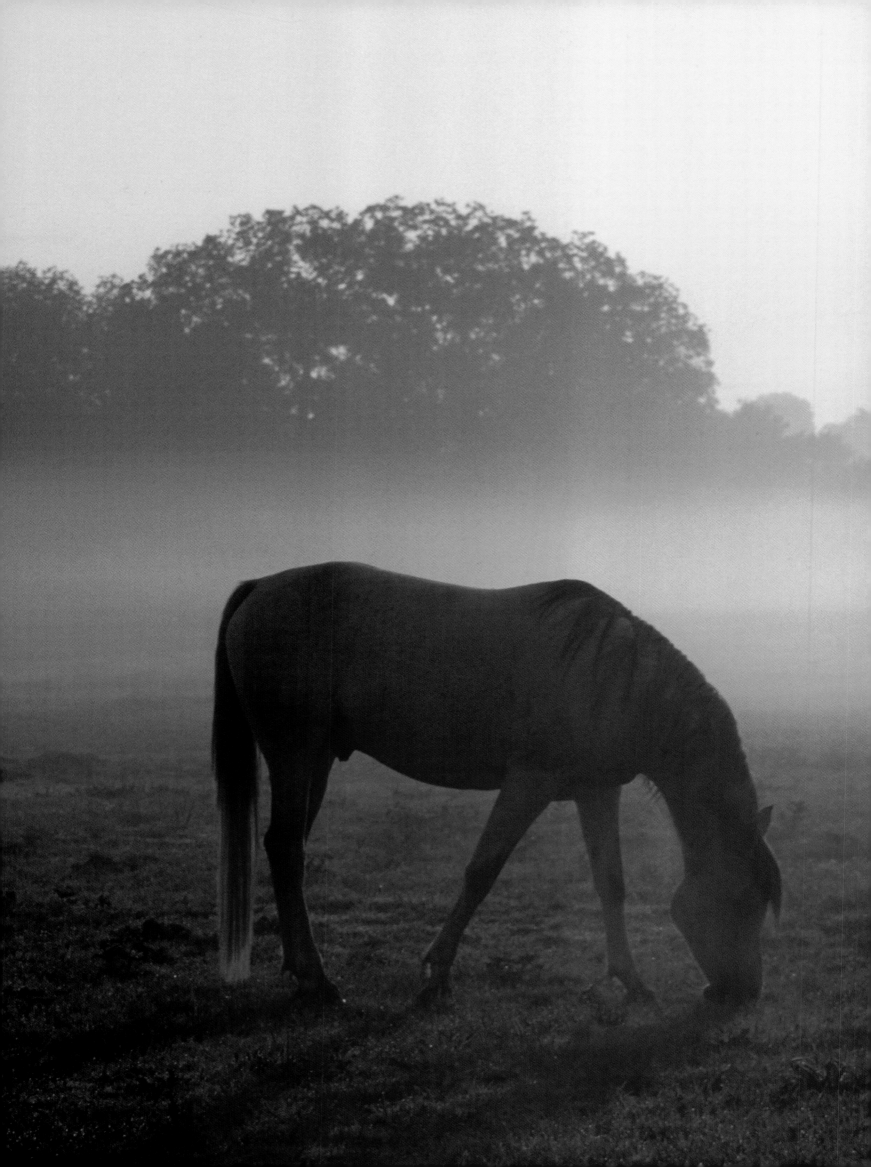

PLAINS
& WIDE-OPEN SPACES

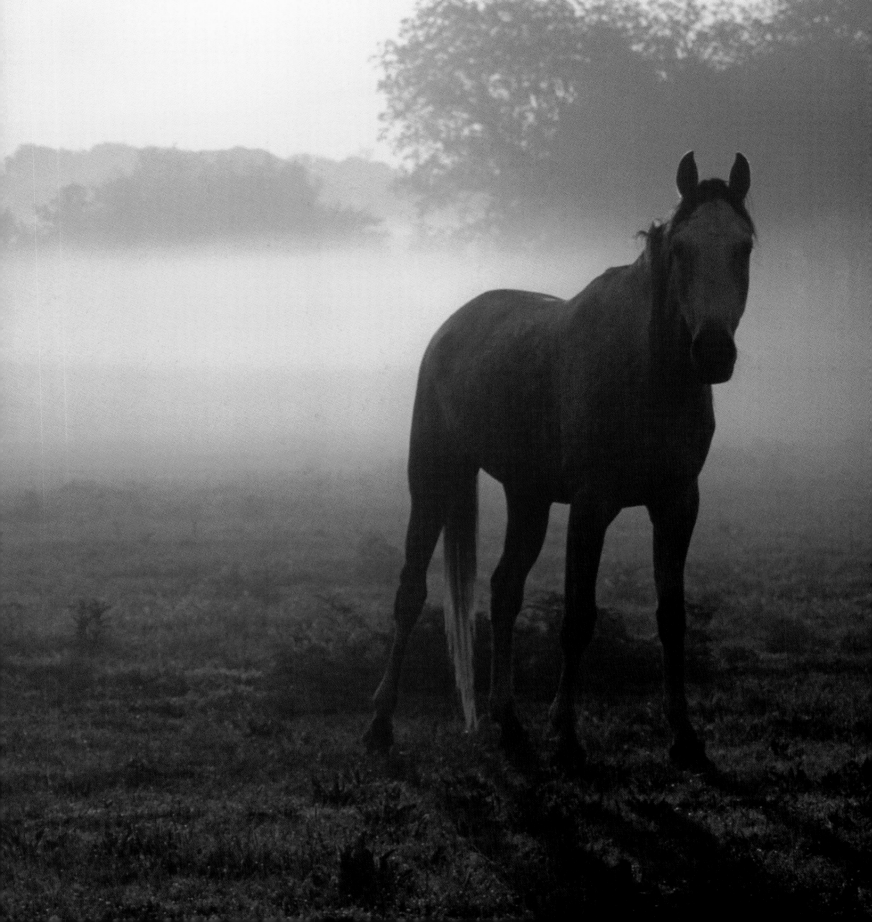

Horses are roaming animals that move from one area to another in search of food and fresh grazing grounds. They also move to find shelter and to cope with the seasons; a higher or lower elevation may be preferable with a more acceptable temperature depending on the time of year.

In open landscapes, wild horses tend to live in groups usually headed by a stallion with a band of mares and youngsters. As the youngsters grow up, the colts begin trying to take over the herd. The dominant stallion will fight off an old stallion or young impostor, who will then go off in search of his own group elsewhere or in some cases become an outcast who will end his days in solitude. In valleys and open moors, there are vast expanses of land where different breeds have lived and flourished for centuries. Britain's nine native pony breeds have flourished in such places as Dartmoor, Exmoor, the New Forest, Wales, the Dales, the Scottish Highlands, and Connemara in Northern Ireland. In the UK, Bob had to get pictures of the pony breeds in their natural habitats, so he went to all these places and even visited Her Majesty the Queen's Balmoral estate to get some Highland pony pictures.

Many of the Asian breeds, the American Mustangs, and the Australian Brumbies roam in vast open steppes, prairies, and hills and have flourished for many years. In such expansive areas, it can be difficult to locate the animals without local knowledge, and Bob usually manages to arrange for local help when visiting these places. Bob recalls traveling in South Africa in October 2017 and coming across a group of approximately 100 Friesian horses beside the road. He stopped to get permission from the owner to photograph them and spent several hours capturing the majesty of this noble breed. With horse transport no longer prohibitively difficult, many breeds of horses can now be found in countries far from their origins, traveling by land, sea, or air over the last century. This is also partly due to the successful practice of artificial insemination and the use of frozen semen virtually worldwide, which has enabled breeders to enhance the main attributes of certain breeds and make them more suitable for present-day needs and aspirations. Artificial breeding has also been the saviour of many endangered species whose best bloodlines have been preserved in this way.

There is also a downside, however, as there are always a few breeds that become unpopular when their unique traits become less necessary to the modern world. Many of the heavier breeds in particular no longer play their formerly important roles since the rise of mechanized transport. Some, such as Britain's uniquely chestnut Suffolk Punch, are on the critical list. Efforts to save this magnificent animal are in place, but that is not always the case for all species.

Previous double page:
The early morning mist at sunrise in Texas captures a peaceful picture of these two Arabians. For Bob, this is one of the best times to take photographs, but it involves some very early starts! ❶

Opposite:
This grey Andalusian stallion with a long, thick mane seems in quite a hurry as he canters toward the camera in Florida. Perhaps he has just caught sight of himself in a mirror, as he seems to be having a bad hair day! With three feet off the ground, it is easy to see which pace he is in. ❷

❶

❷

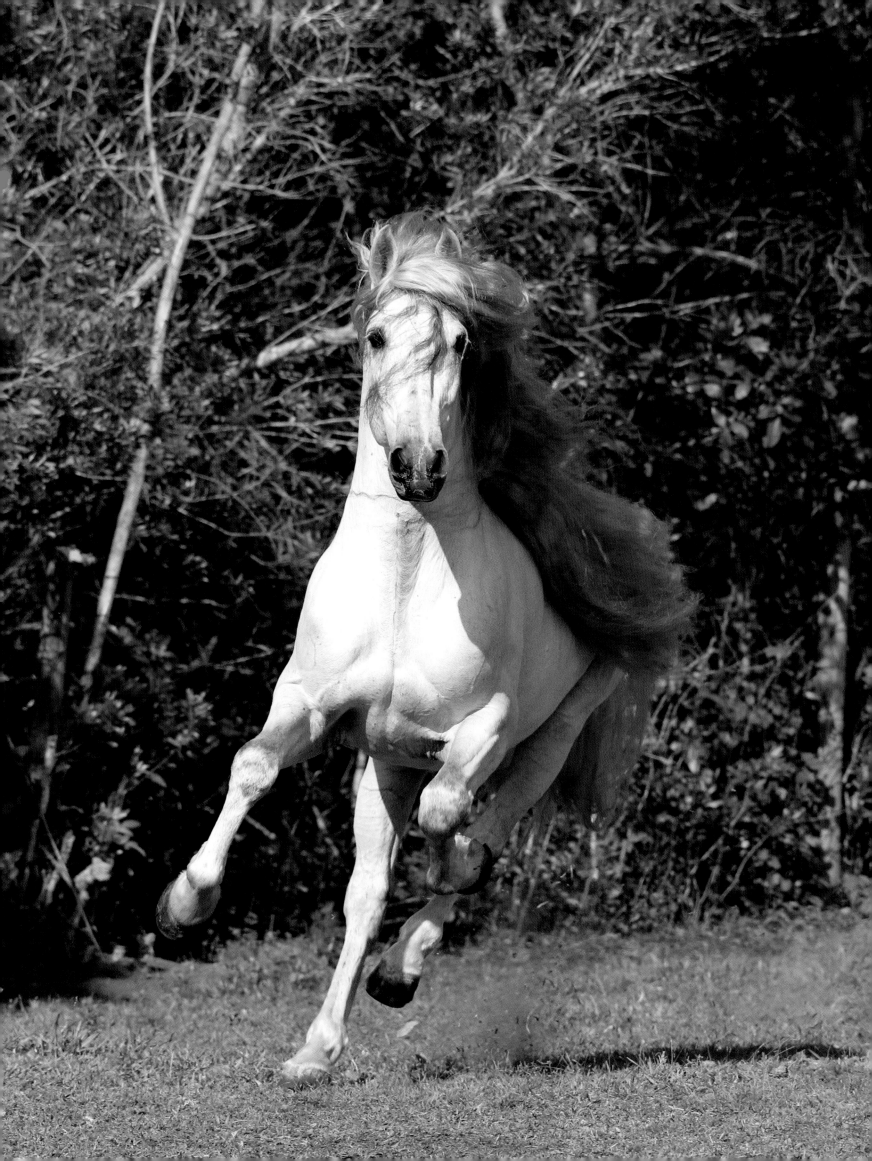

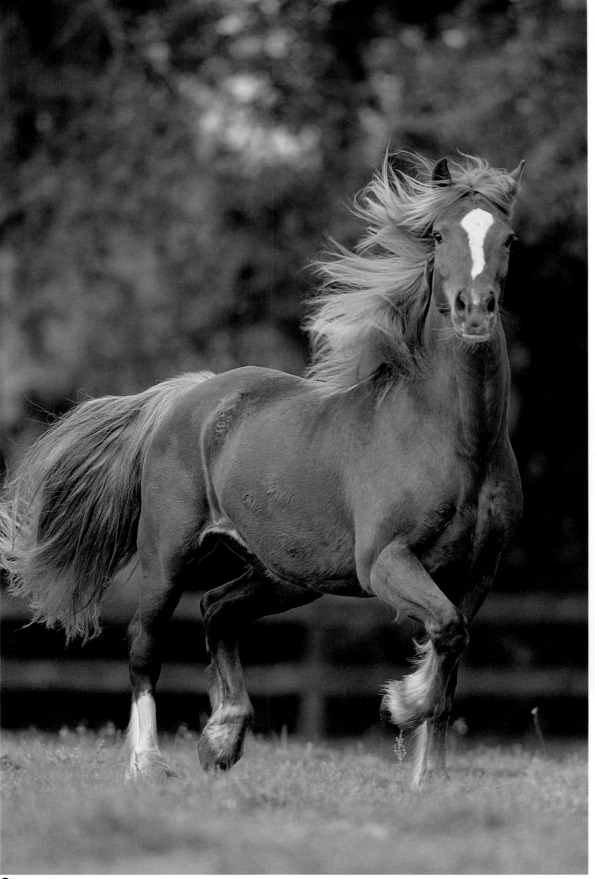

❶

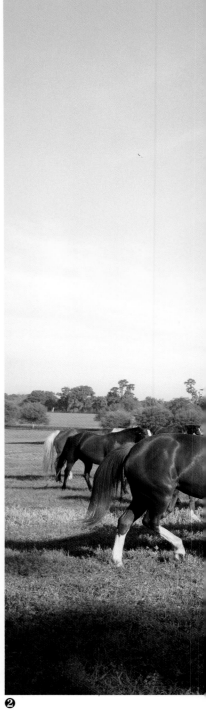

❷

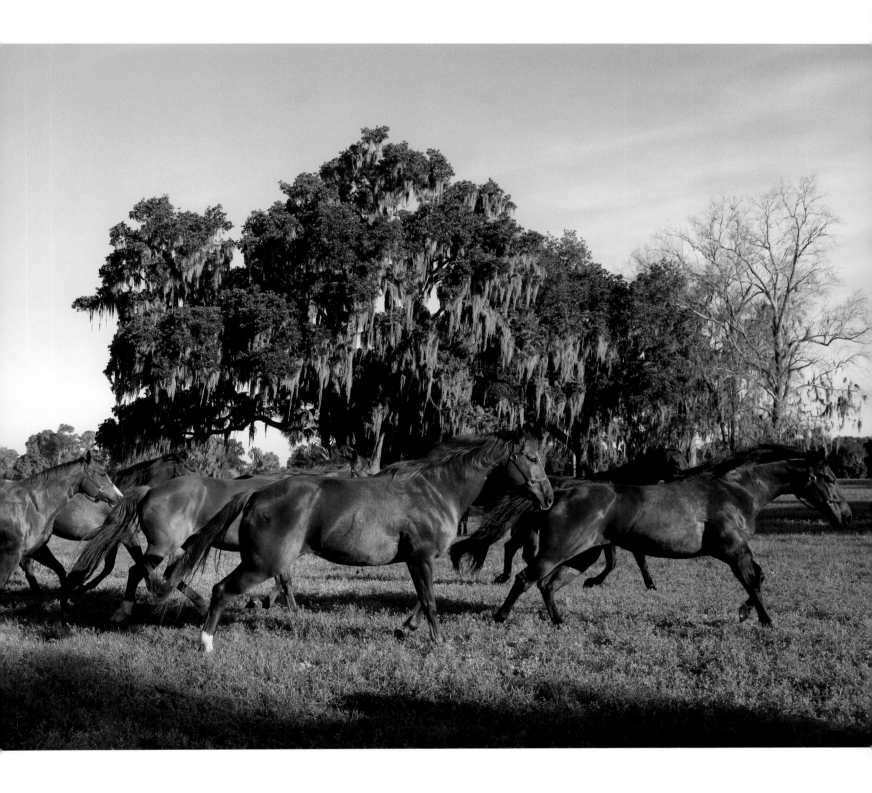

Opposite:
A Section D Welsh Cob trots around the camera showing off his expressive paces. The Welsh Cob is the strongest and largest of the four types of the breed. The As and Bs are much more refined and make ideal children's ponies; the Cs and Ds are stronger and more substantial. Visitors to the Royal Welsh Show in Wales are often captivated by the methods used to show off this spectacular native breed. ❶

These are all retired competition Quarter Horses turned out to enjoy some down time in Florida. This was one of the very few times Bob has used a wide-angle lens. He wanted to complete the scene by including the tree covered in Spanish moss behind the herd of horses. ❷

❶❷

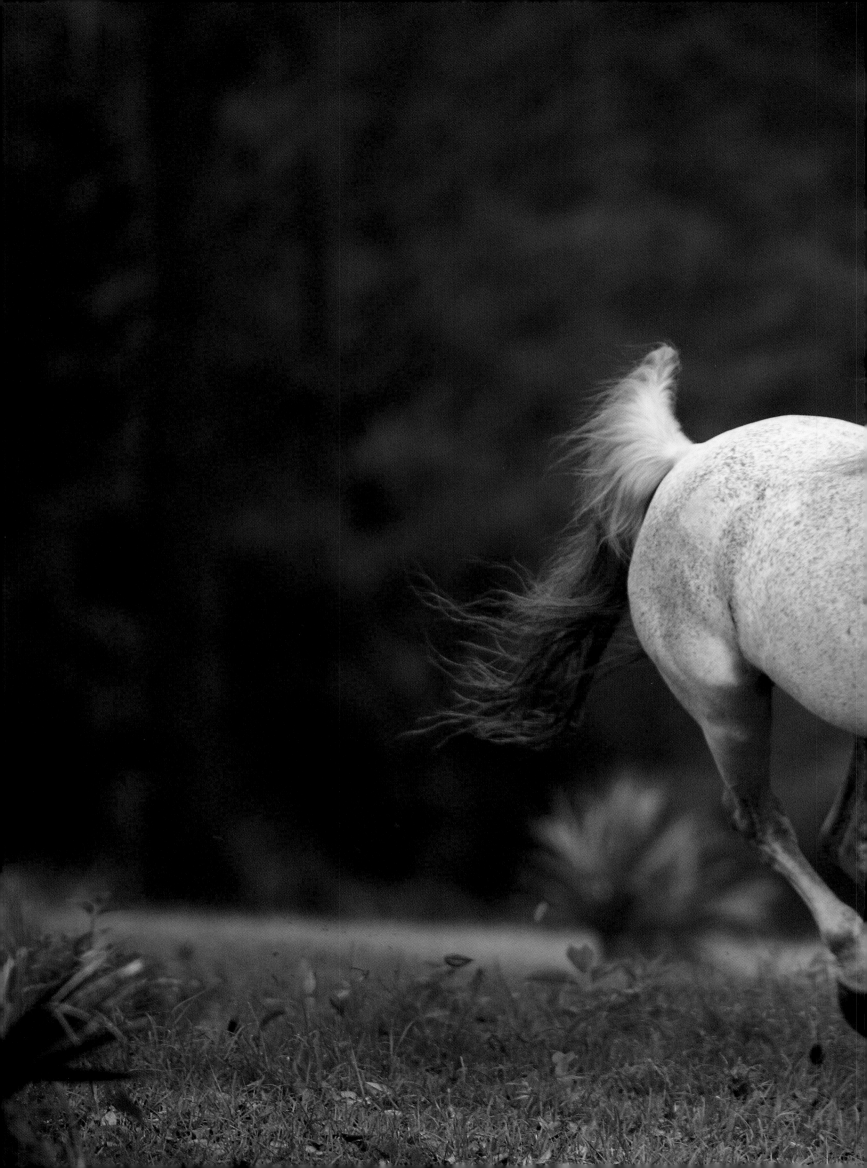

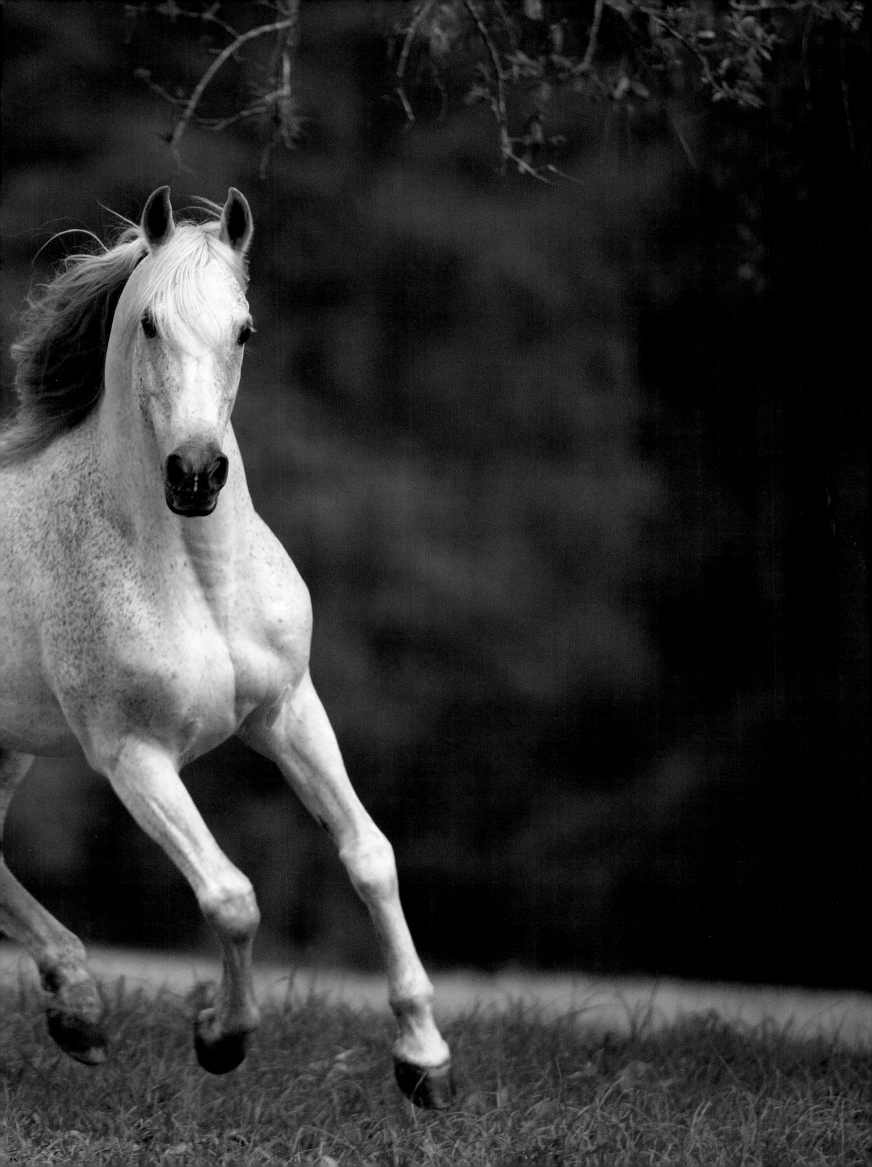

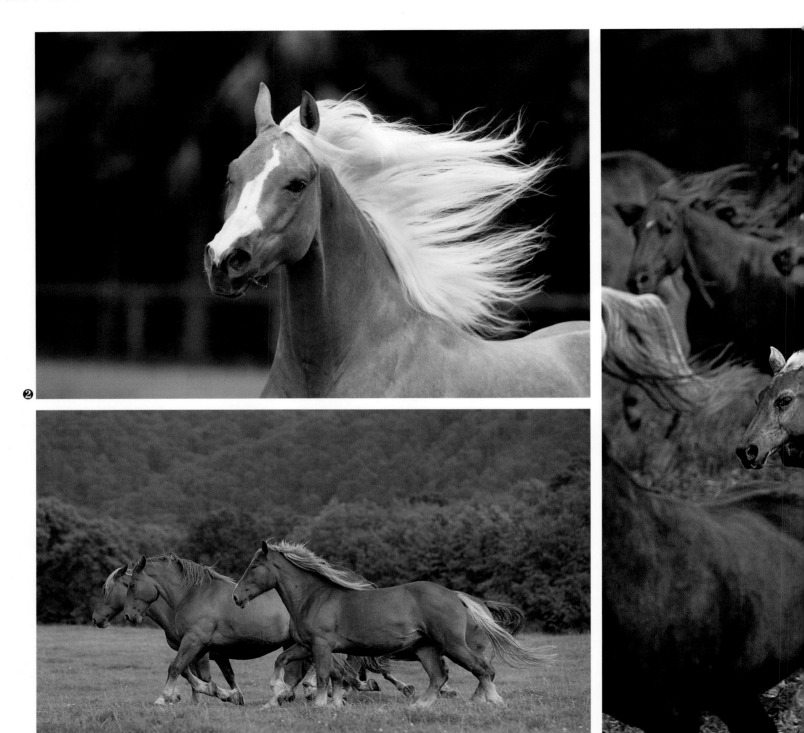

Previous double page:
This galloping Arabian with all four feet off the ground was photographed in Florida. Bob worked there for about twenty years and it was possible to work every morning and afternoon on a different farm. ❶

Top:
Beautiful palomino colouring is an eye-catching trait of this Quarter Horse in Ocala, Florida. The most prolific breed in the USA, Quarter Horses excel in quarter-mile races. The tremendous power in their hindquarters makes for excellent acceleration. They are used for ranch work of all kinds as well as the many different competitive events for which they are famous. ❷

Above:
This impressive group of Suffolk horses was photographed just thirty miles from Bob's home in Worcestershire. Holbeache Farm was breeding the endangered British heavy horse and had a herd of around thirty horses. Originating in Suffolk in the east of England, they are always chestnut in colour and were traditionally used for all types of farm work and logging. ❸

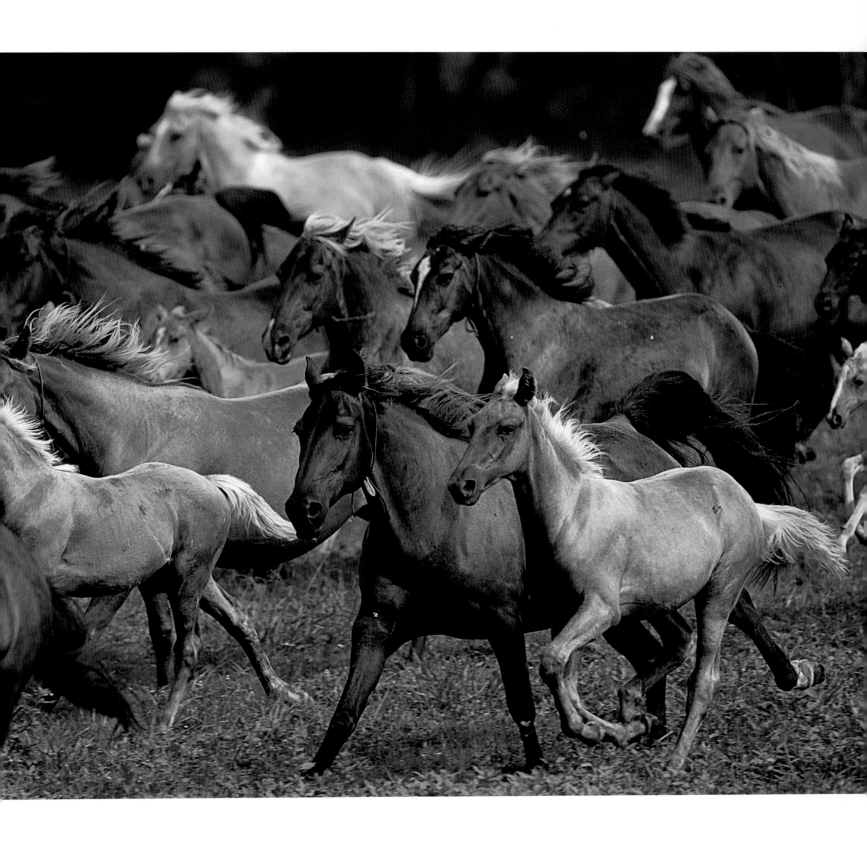

Sunlight glints off the golden coats of young Kentucky Mountain Pleasure Horse foals as they run with their mothers at a large farm in Kentucky. Originally named the Rocky Mountain Horse, this is a gaited breed. The mares and foals in this picture were photographed as they were chased from one area to another. ❹

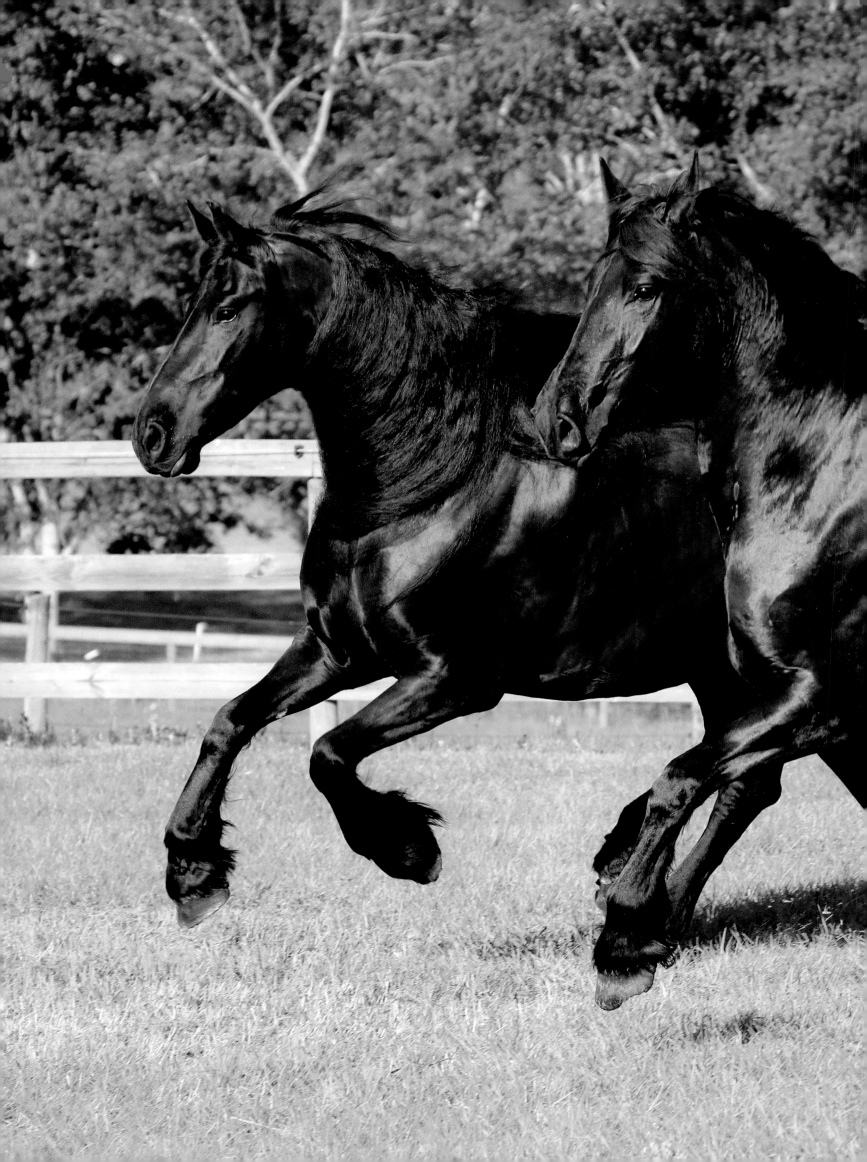

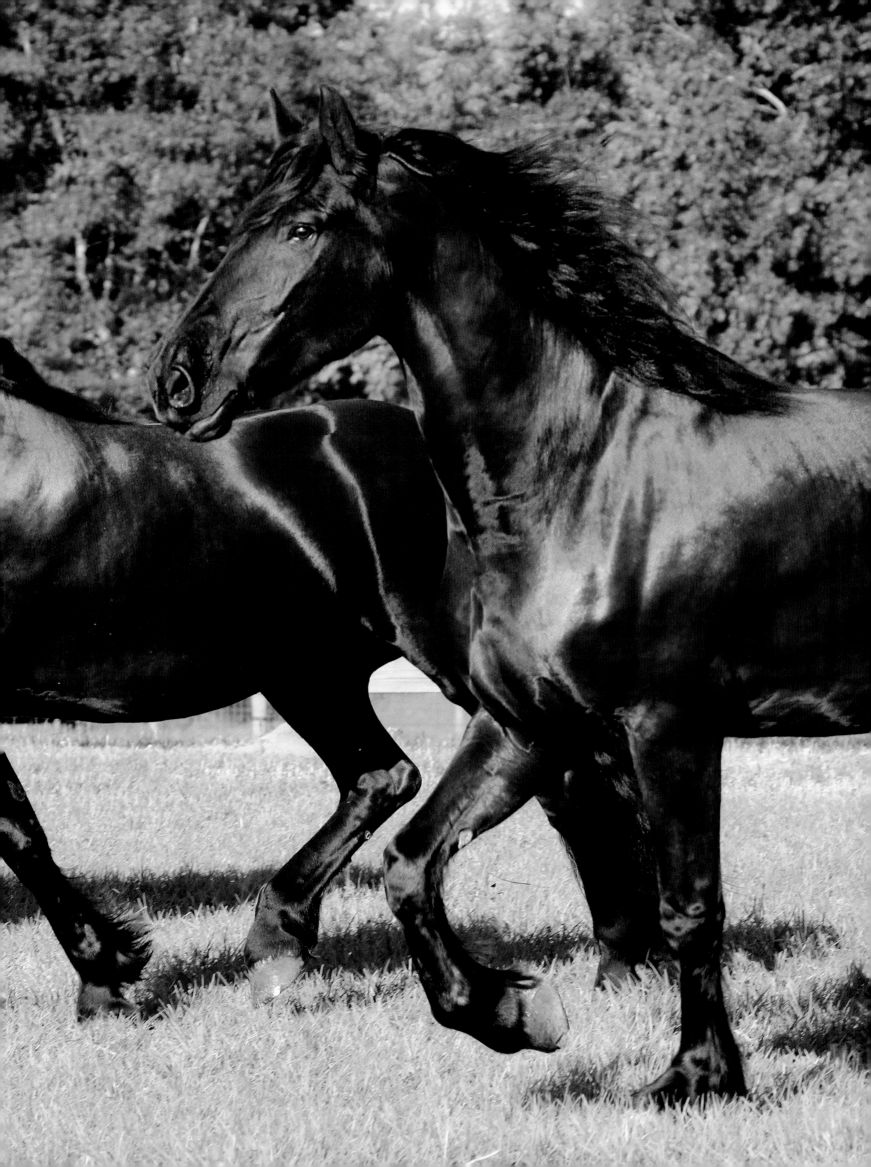

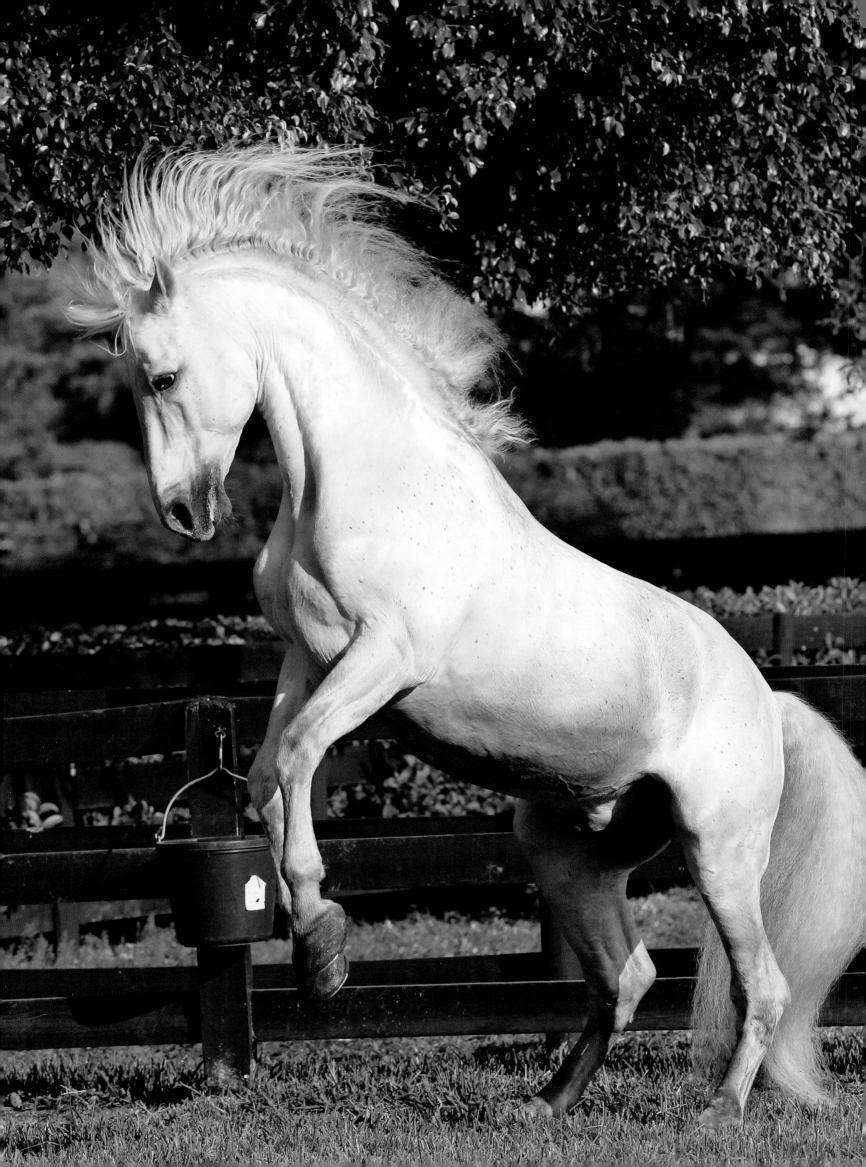

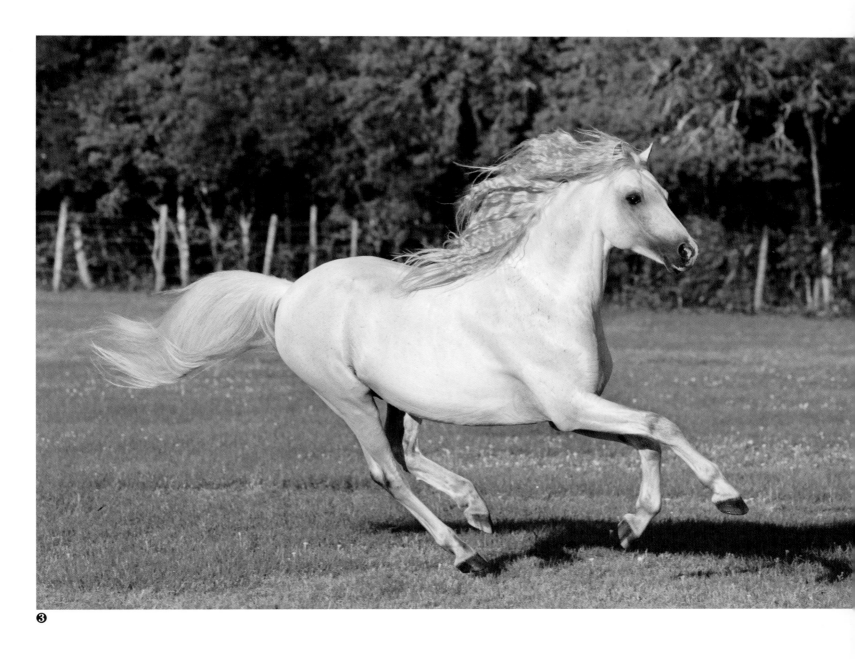

❸

Above:
A grey Welsh crossbred pony is having a great time letting off steam in the Florida sunshine. When galloping, the animal will usually keep in balance by taking his head to the outside as he moves in the opposite direction. It is easy to see in this photo how far the pony brings his hind legs under him before propelling himself onto the next stride. **❸**

Previous double page:
Three fine Friesian/Clydesdale crosses move together in Ocala, Florida. Bob said that fortune smiled to get them lined up like this. "It was obviously my lucky day!" **❶**

Opposite:
A fine Andalusian stallion had just been let loose in his paddock when he reared up in a playful way before settling down to eat. Bob says it is often a very good time to get action shots when the animals taste their first moment of freedom. They exhibit pleasure through all kinds of antics such as rearing, bucking, and galloping around. **❷**

❶❷❸

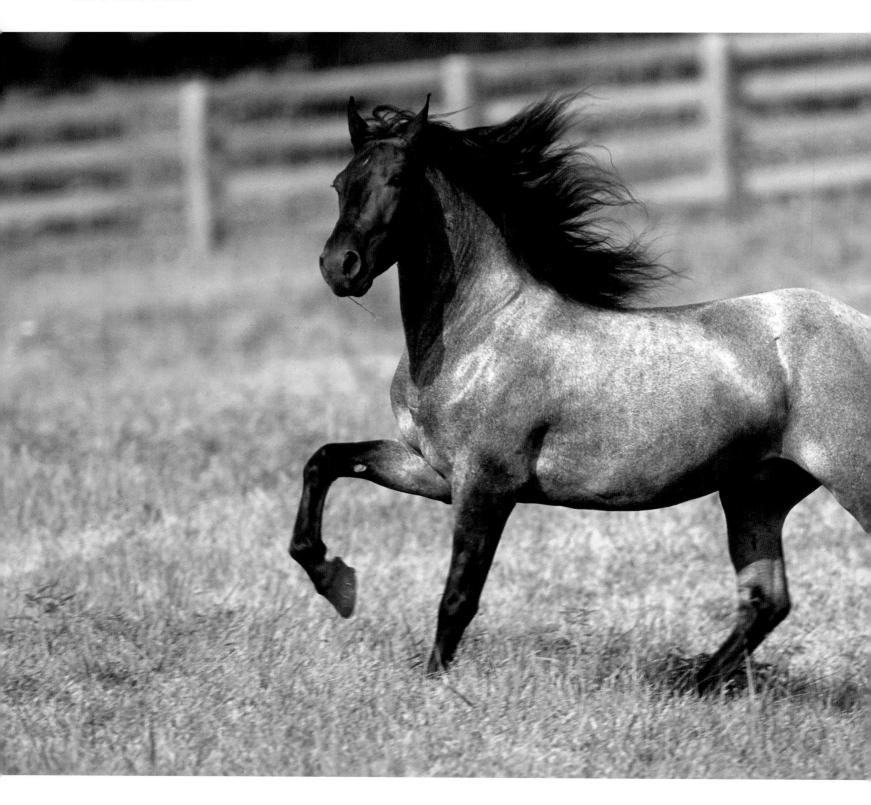

The unusual roan colouring sometimes seen on the Kentucky Mountain Pleasure Horse gleams in the sunshine as he is enjoys cavorting round the paddock. With his dark mane, tail, head, and legs he is certainly a magnificent specimen. ❶

Arabian stallion Shah Azim rearing is one of Bob's very special models. Obviously a real show off, this horse demonstrates all the power, glory, and majesty of the Arabian horse. He may have been performing for the horses in the background more than the photographer, but in any case, he helped produce an iconic picture. ❷

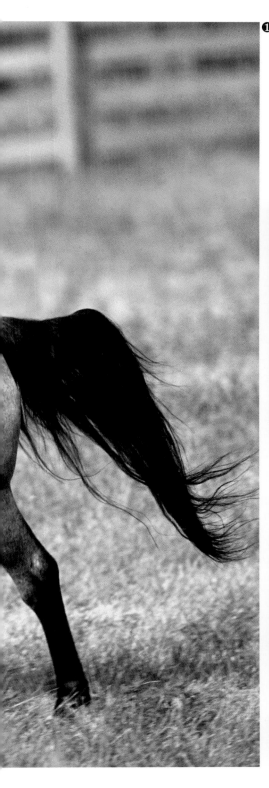

❶

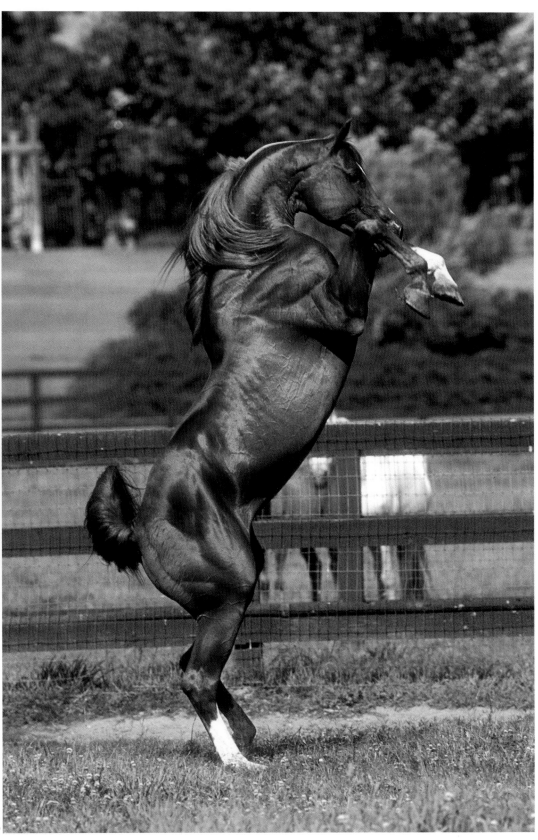

❷

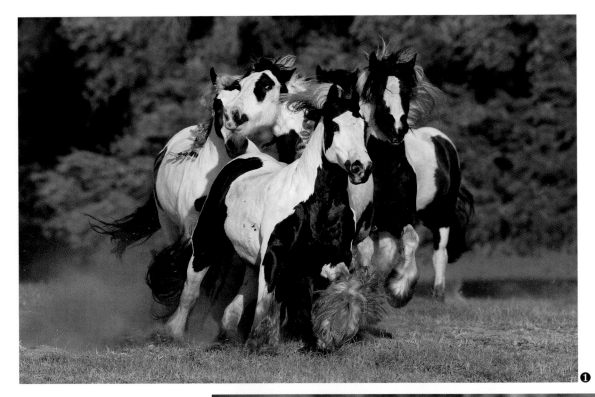

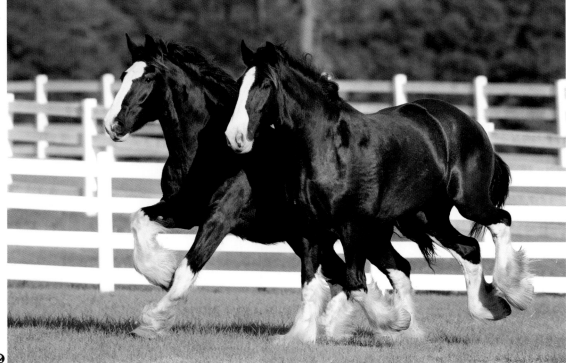

Top:
These Gypsy Vanners display all the characteristics of this English breed. Strong cobs, they are often coloured pintos, with plenty of feather, mane, and tail. In 1994, Dennis and Cindy Thompson from the USA realised their potential and worked closely with the Romani in the UK to establish the horses as a recognized breed. They are now extremely popular and highly sought after on both sides of the Atlantic and worldwide. ❶

Above:
A pair of Shires in New England is well matched, working together in unison pulling drays and carts. Shires are usually black in colour with white feathered socks and a blaze. Bob has noticed animals that are used to working together in harness seem to find it difficult to separate in freedom and will often move around like this when free. ❷

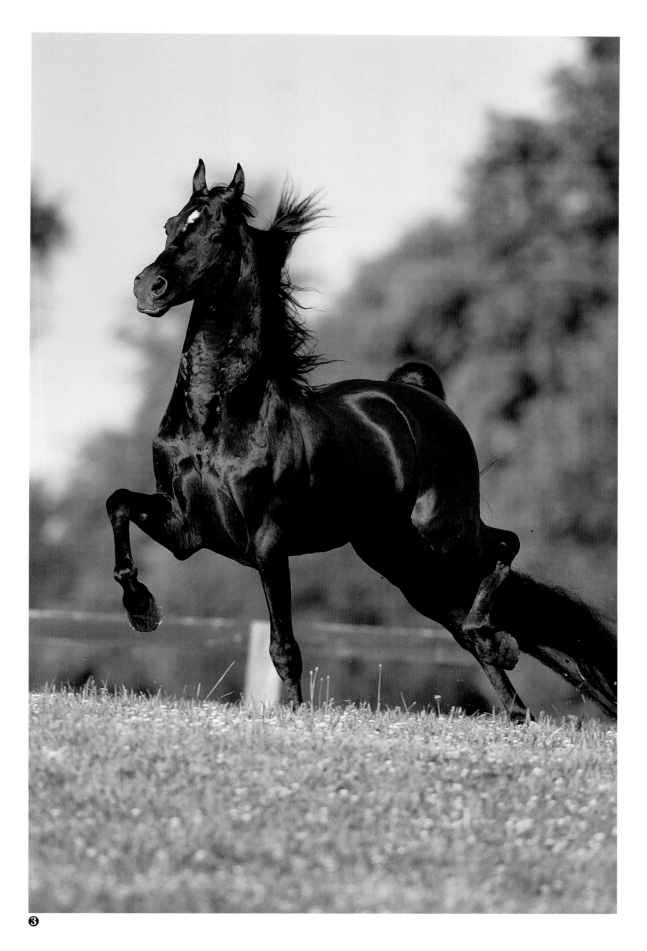

3

The powerful yet elegant Morgan is a special American breed. This is an all-around breed that excels at many disciplines. Morgans originated from one dominant stallion owned by Justin Morgan, a singing teacher from Vermont from whom the breed takes its name. **3**

This photo of two Appaloosa foals in Texas was not as easy to create as it looks! A lot of patience is sometimes required to get the "Arrr, how cute" effect of a charming chocolate box picture, and according to Bob, this one was no exception. To make it happen, he simply sat and waited the right moment to take the perfect picture. ❶

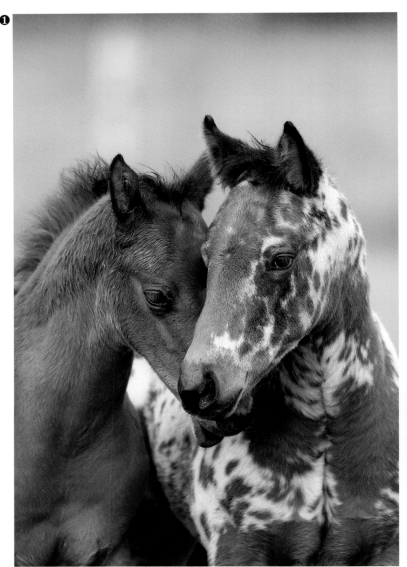

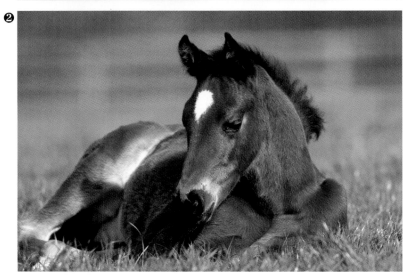

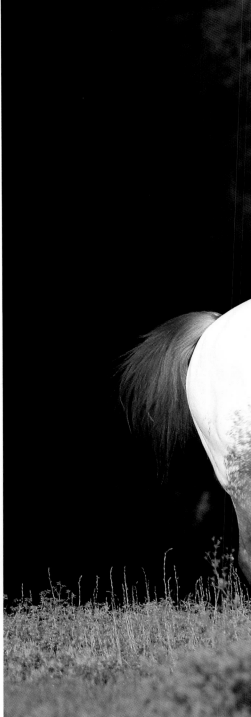

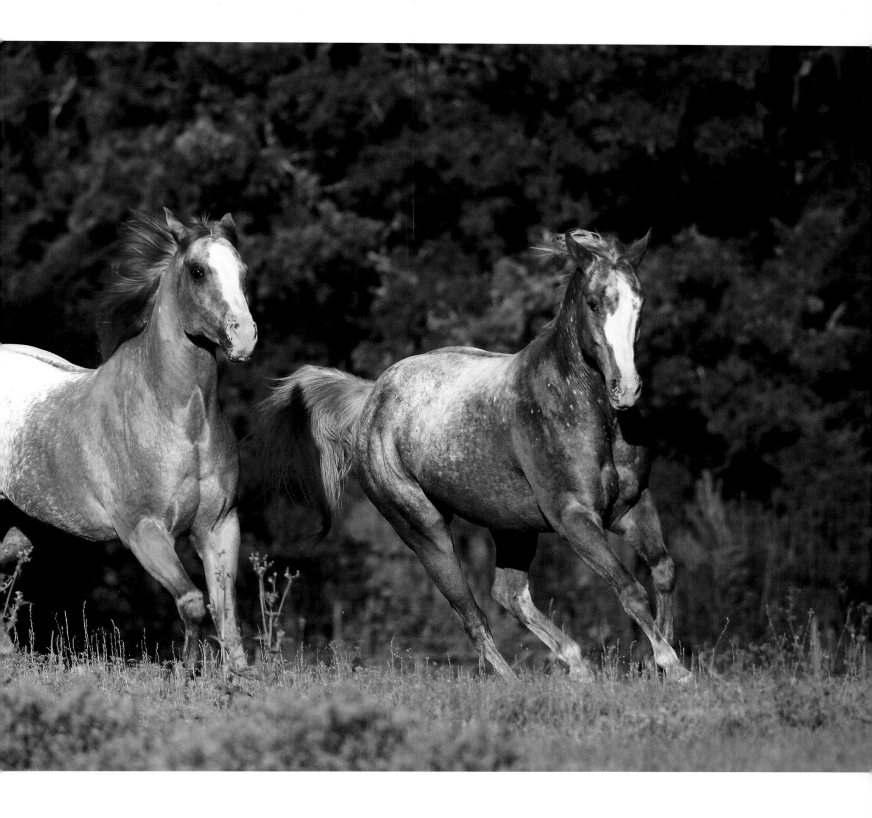

Opposite:
A Warmblood foal destined for dressage stardom, this UK animal in repose is already displaying the attributes required to help it start on the ladder to success: an eye-catching colour and a centrally placed star. Though a little wary of Bob's proximity to its resting place, it was happy to oblige! ❷

Above:
Appaloosas frolic in Ocala, where Bob always finds a great selection of breeds and horses. These two display the Blanket and Frosted patterns of the Appaloosa. There are eight different coat patterns officially recognized within the breed. ❸

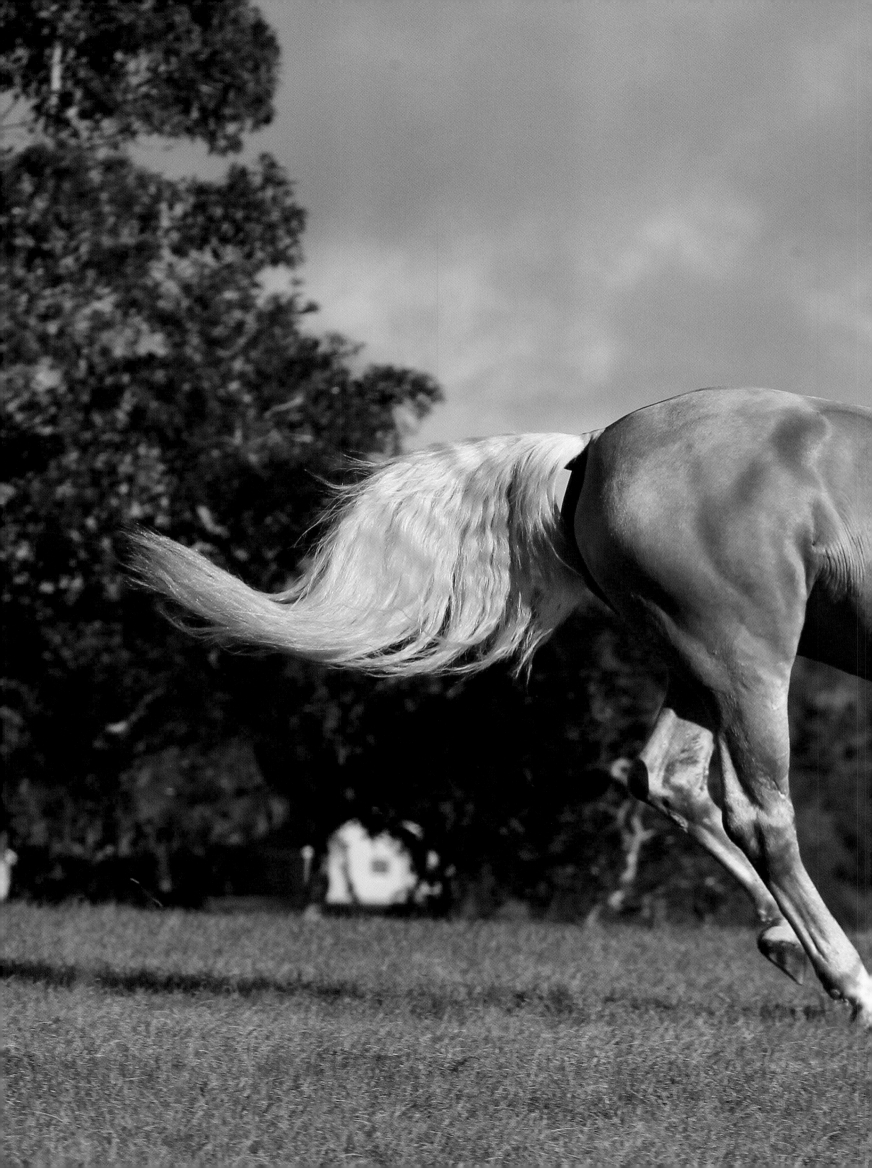

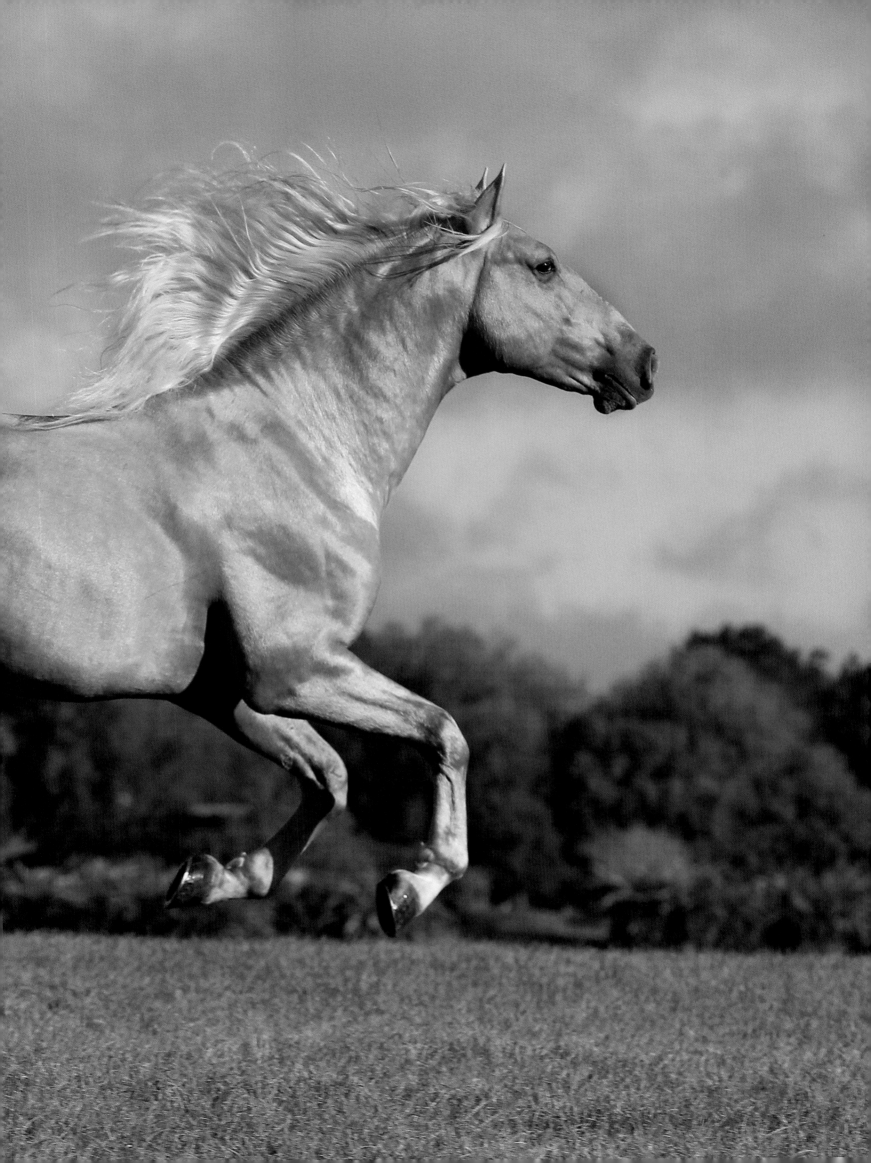

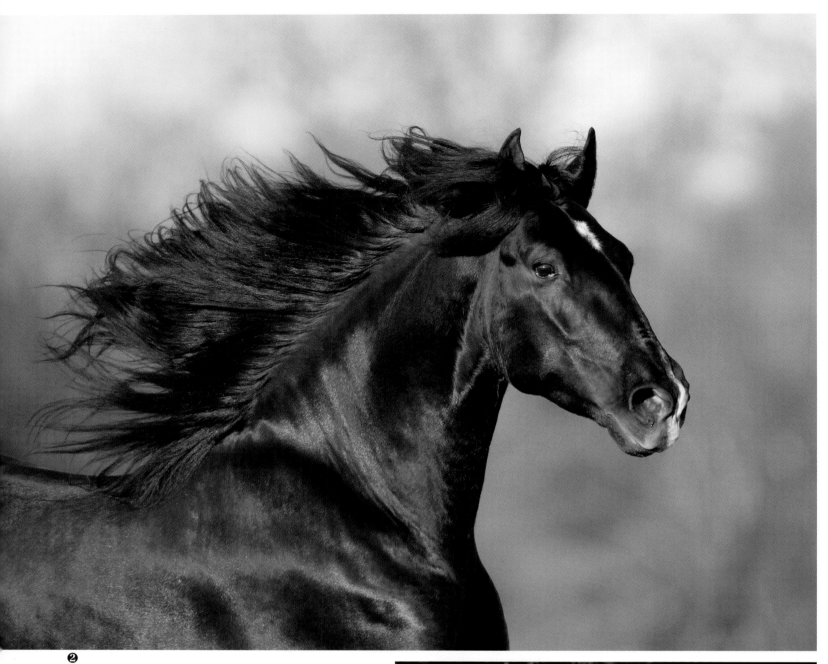

❷

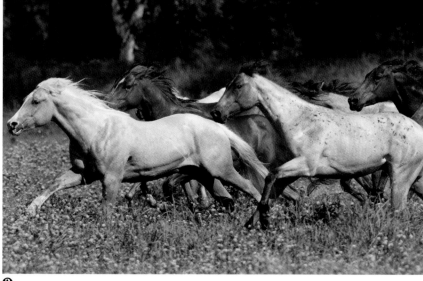

❸

Above:
One of Bob's recognizable images, a proud Andalusian head against a faded-out background focuses on the features of this magnificent animal. You can almost feel that glossy coat, and the sun highlights the colour. ❷

Previous double page:
A Palomino Lusitano canters across a large paddock during the fall in Florida. Palomino is technically a colour rather than a breed and is found in many breeds, especially the more ancient ones. The colour should be like a newly minted gold coin with white mane and tail. ❶

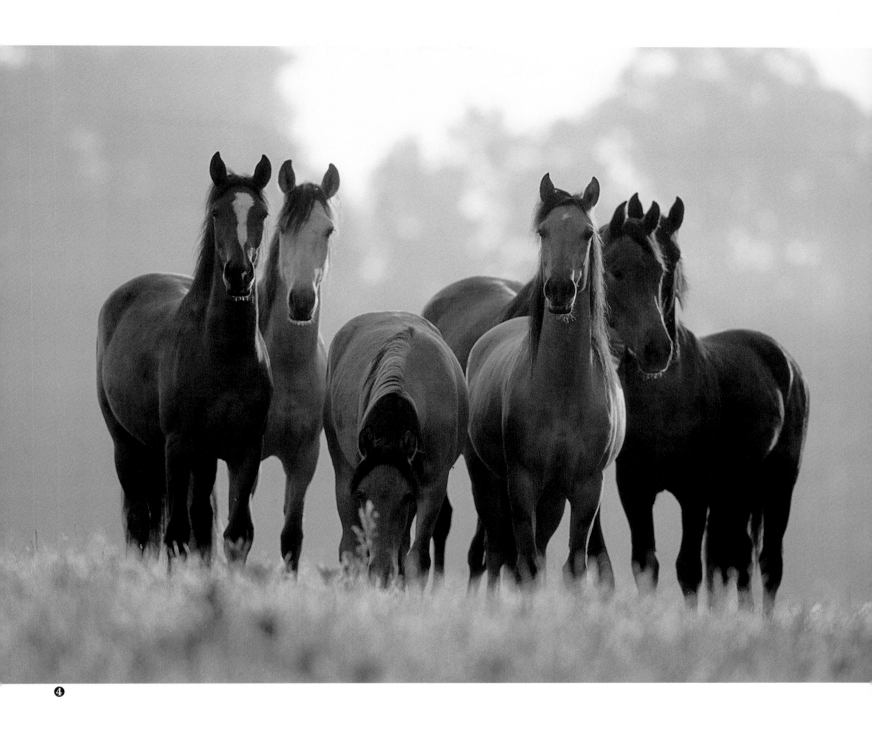

❹

Opposite:
A galloping group of Quarter Horses in Texas shows several different colours as the horses fly through the lush summer vegetation. Quarter Horses have incredibly powerful hindquarters and are recognised as one of the speediest breeds in the world. ❸

Above:
This group of young Kiger Mustangs was photographed in Florida in the early morning mist. The breed is becoming more sought after to be bred and trained as fine riding horses. Unlike other American Mustangs, this line appears to have been kept pure and has lived in isolation in southeast Oregon. ❹

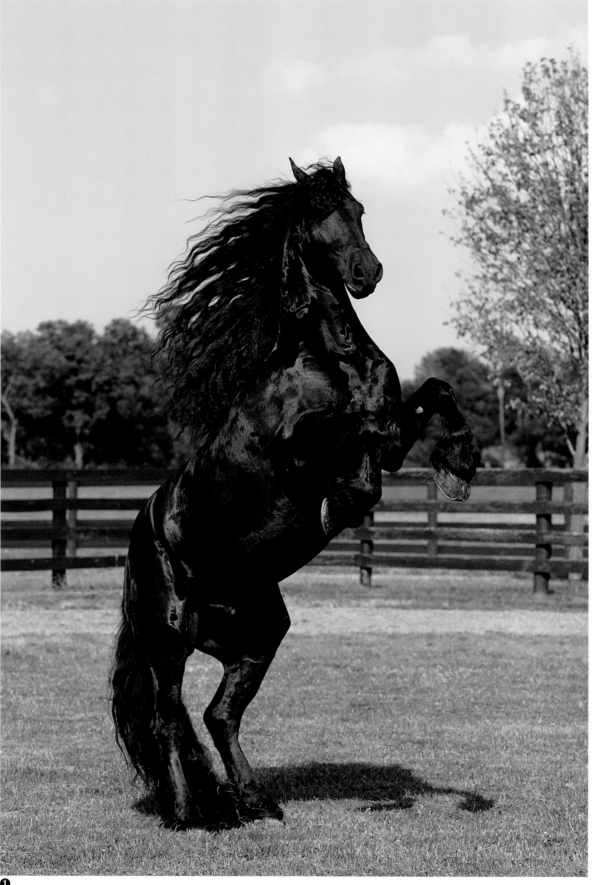

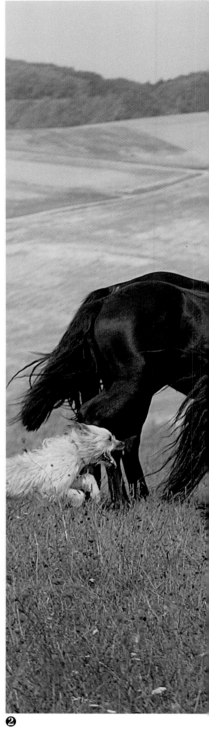

❶

❷

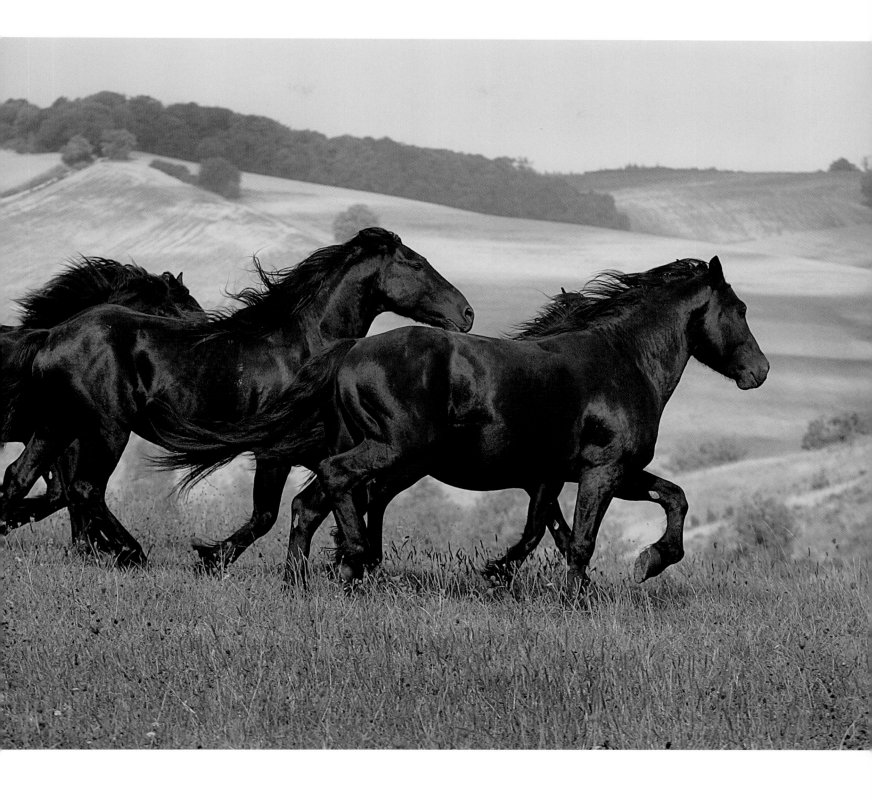

Opposite:
The Friesian stallion Joshua rearing on command in Kentucky has it all!
Some horses are easily trained to do this, while others are not so quick. It takes
patience, but those with the right temperament learn quickly so long as
the trainer is consistent, and the horse is rewarded for doing what is asked.
It is very important not to allow youngsters to rear in your direction when
they are foals because they will grow up thinking this behaviour is acceptable.
There have been several serious injuries caused by bad practice in this way. ❶

Above:
French Mérens run amongst the summer vegetation in the rolling countryside.
The dog was very helpful in getting the horses to move for this photo; however,
poorly controlled dogs all over the world have caused numerous accidents and
injuries involving horses, and it is essential to keep them leashed when near
other animals. ❷

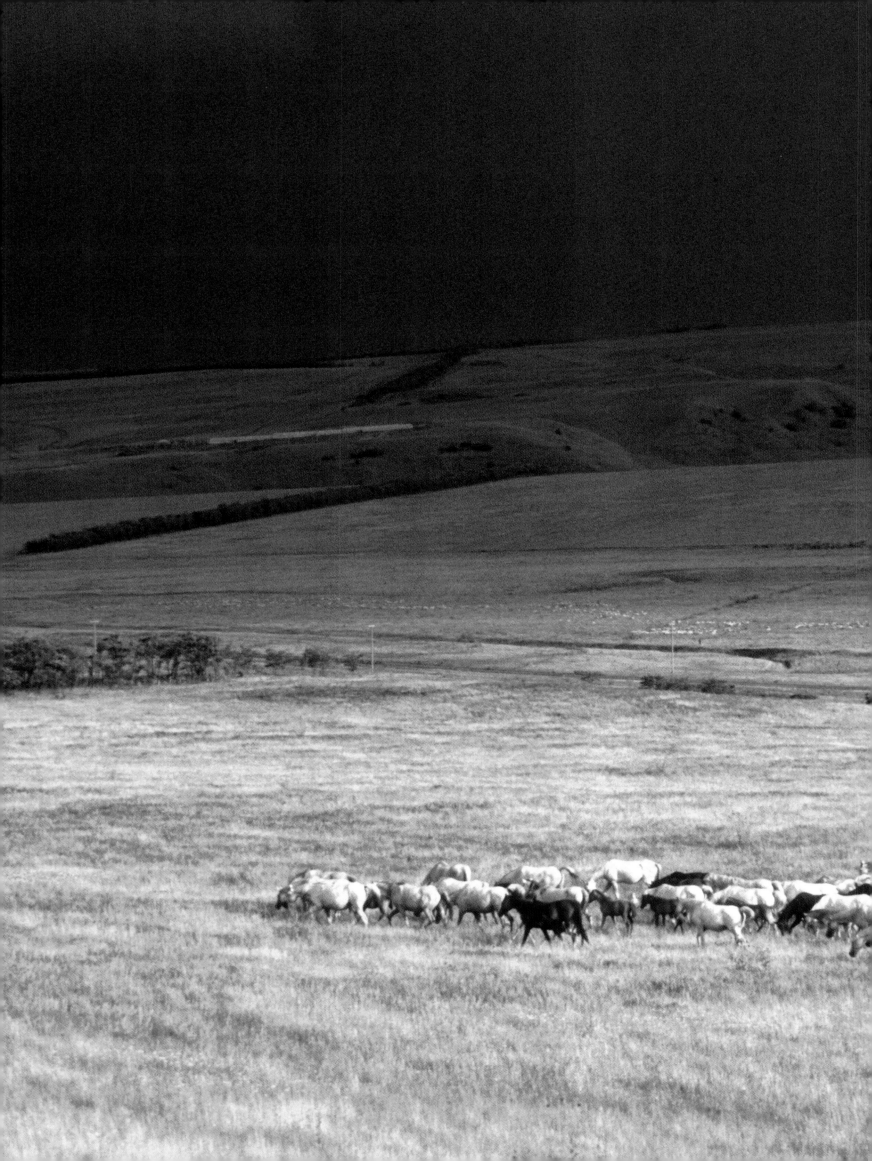

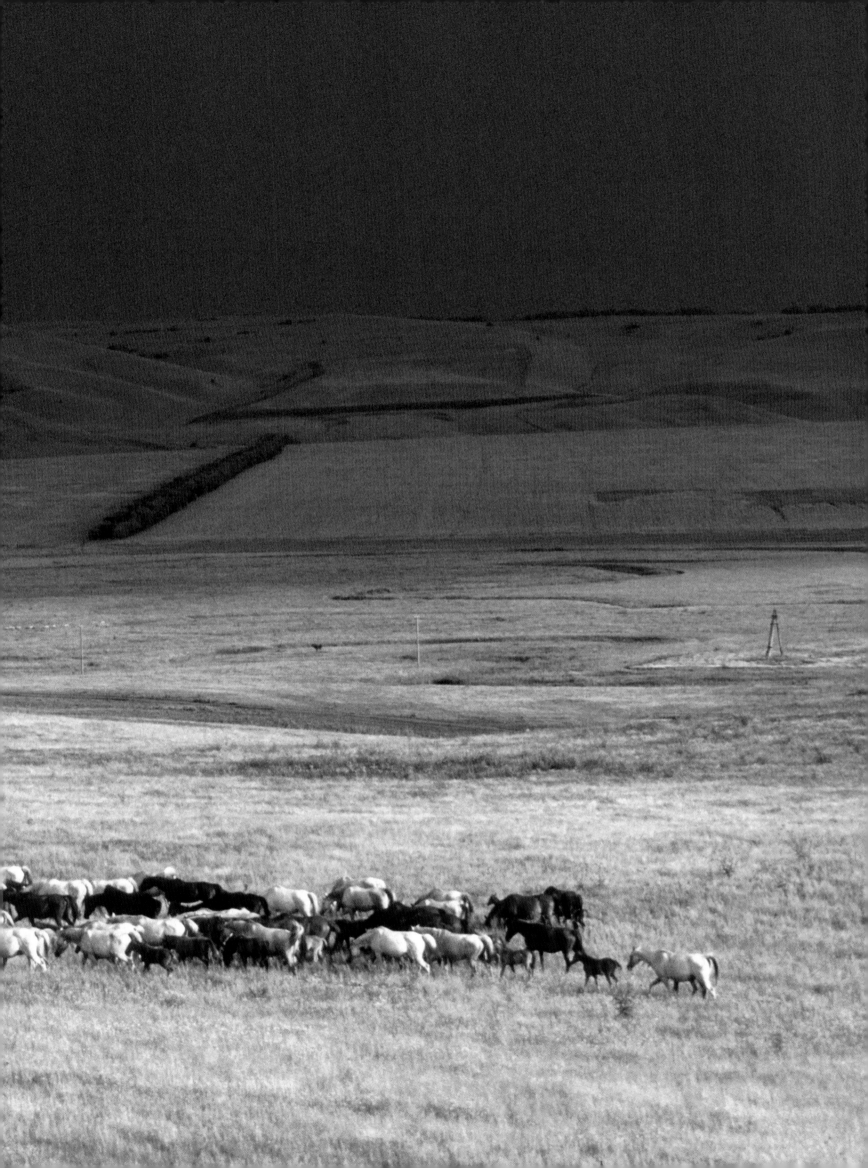

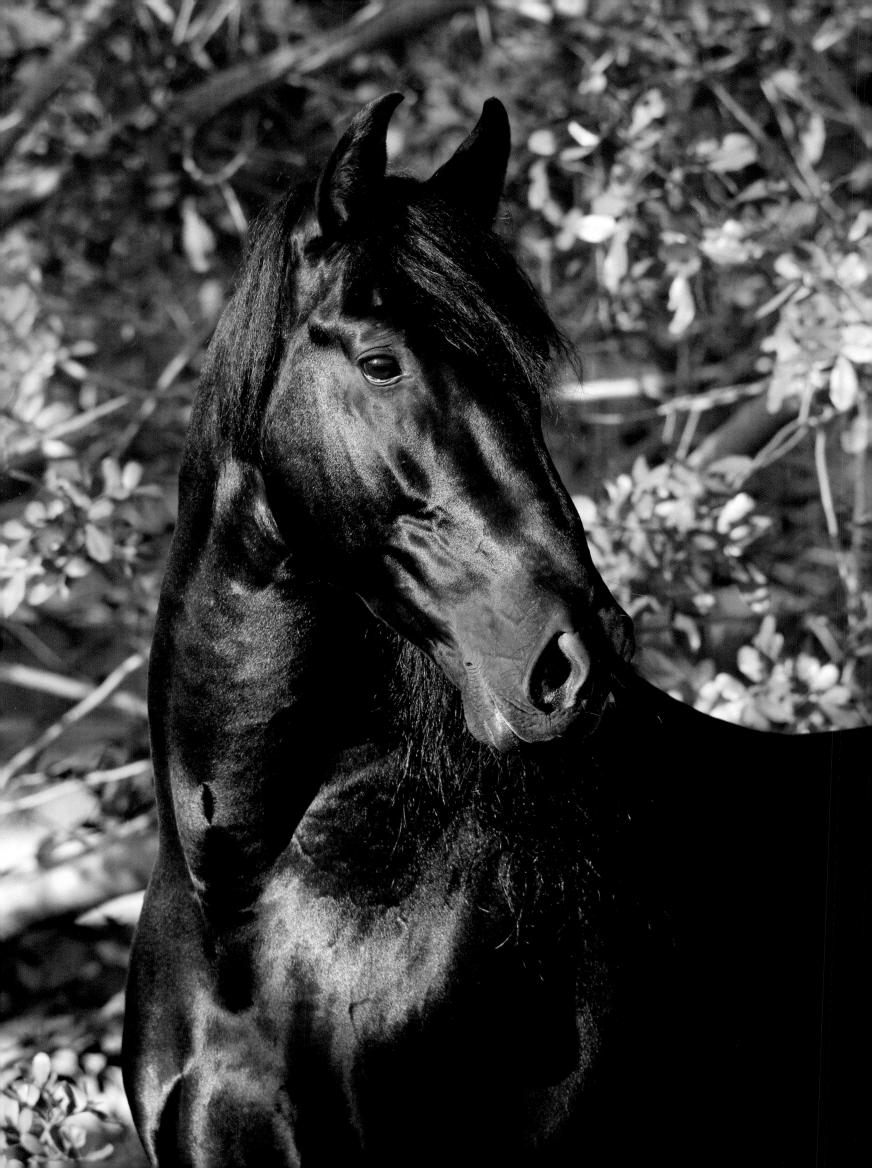

❸

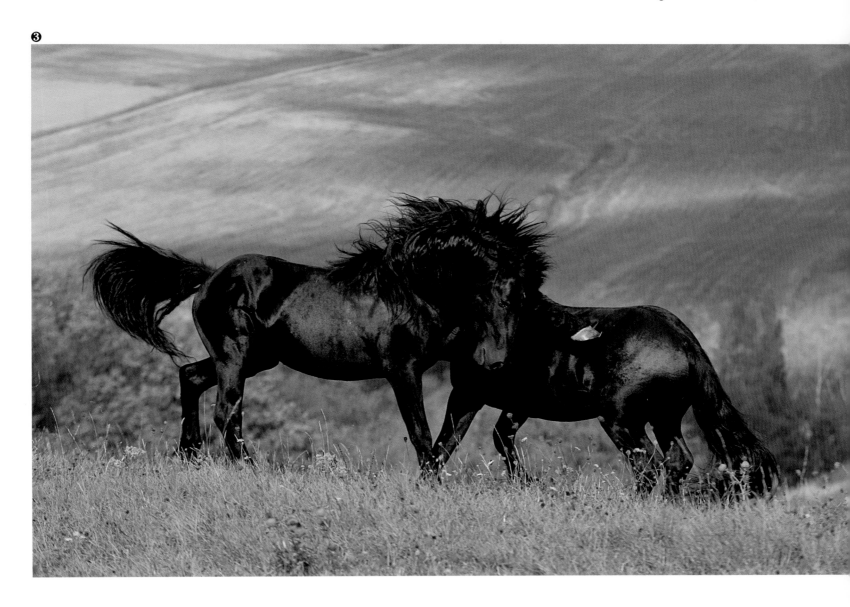

Previous double page:
The dramatic sky in this picture is a reminder of nature's ferocity, though the peaceful scene of a large herd of Tersk mares and foals moving gently along the Russian plain belies the impending rainy weather. The Tersk is another tough breed descended from the Arabian that came into existence during the early 1900s. It has a mild temperament and is used for riding and circus work. **❶**

Opposite:
A signature photo of an Andalusian set against a tree-lined fence in Florida. He is owned by Maria Mandina in Vero Beach, who specialises in producing black Andalusians. They can of course be bay, dun, black, roan, or grey. Andalusians have an amazing history that goes back centuries, and they are renowned for their calm temperaments, which makes them suitable for most equestrian disciplines. **❷**

Above:
Bob captured this image of two Mérens stallions fighting by pure luck. This is one of those situations that cannot be set up. Bob said he was lucky to be in the right place at the right time in this case. Stallions tend to get very territorial in the spring as grass improves and their testosterone levels rise. The dominant stallion may oust the inferior one out of his grazing territory. **❸**

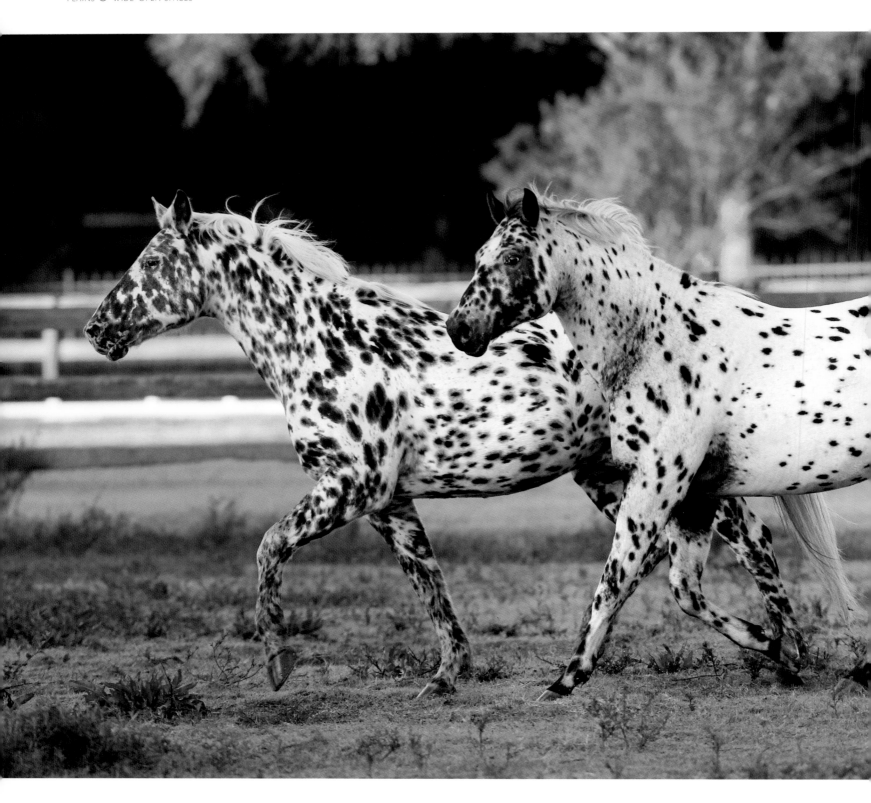

A striking pair of Knabstruppers was photographed in a paddock in Texas. They are owned by Rebecca Pennington, who set up many farm shots in Texas for Bob over the years. This Danish breed originated from one mare in Napoleonic times and was named for the estate where the mare was based. Tough, agile, and very docile, Knabstruppers are typically spotted with a roan background and stand about 15 to 15.3 hands high. ❶

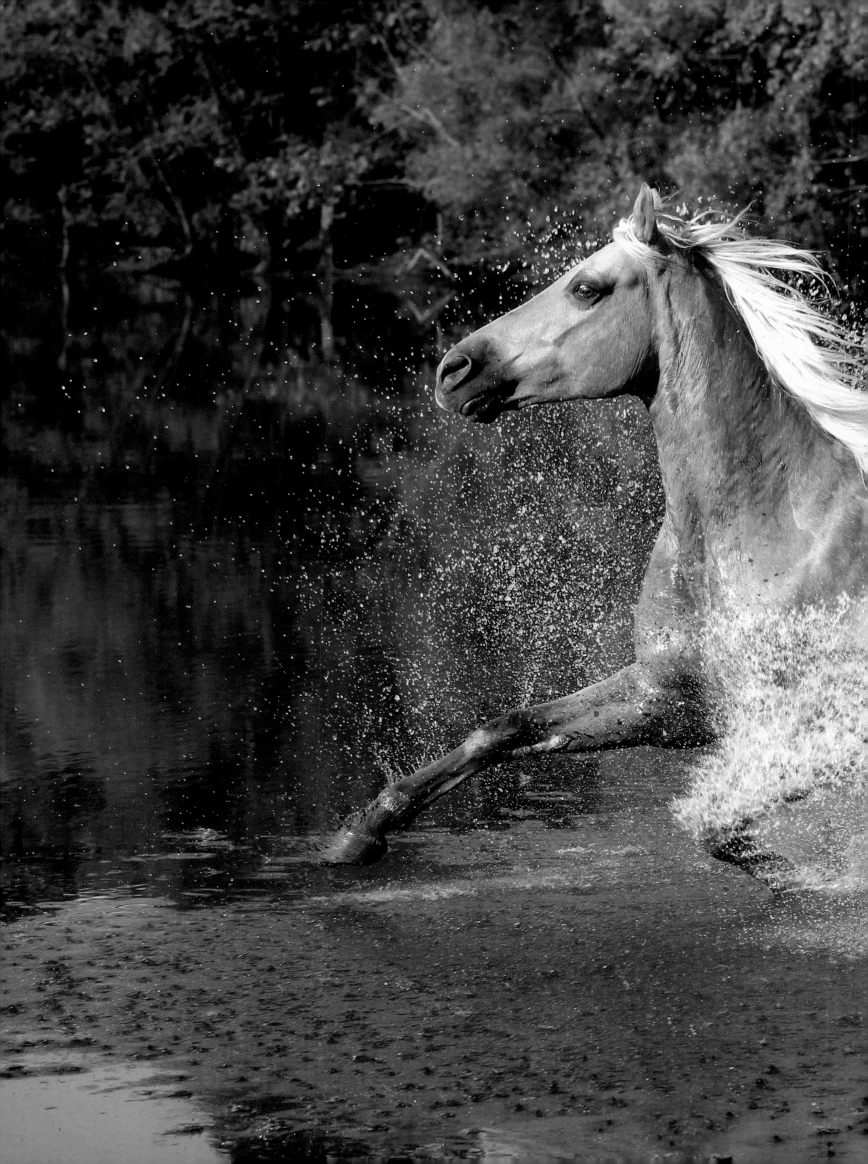

RIVERS, LAKES & MARSHES

A picture's beautiful background is the second most important feature after the horse itself and often takes a little bit of planning and management. It can take time to get horses to run through any type of water but doing this makes for a far more interesting picture that will have much more impact and *je ne sais quoi*. Sometimes you get lucky, and the perfect moment just falls in your lap, but usually you will have to set up the scene that is required. The best time to get these pictures is the first few hours in the morning or the last couple of hours just before dusk. Most photographers call these the "golden hours."

Several of the photographs in this section were taken in America, where Bob goes regularly to get the majority of his general photographs. On one occasion you'll see, the grooms had a grey Lusitano stallion beautifully clean for the photo shoot. When the horse saw the water, however, he went straight in, got down on his knees, and rolled over, absolutely plastering himself with mud. Bob was undeterred, saying he would photograph the horse's clean side, but the horse was enjoying himself so much he quickly dropped to his knees again and rolled over on his other side, much to the horror of those who had cleaned him up in the first place!

Bob would say that his signature picture is a horse galloping with a long flowing mane against a blurry background. It is what everyone visualizes and wants to see, but it is not always easy to capture on film. He generally uses a long telephoto lens, most often a 500-millimetre lens, and then can punch out the background and enhance the horse's head and mane thanks to modern technology. There are several stunning pictures in this section that fall into that category.

The art of getting good photographs is to exclude fencing or enclosure lines in the picture except on the rare occasion they add to the image. Springtime, when the flowers are out, is an ideal time to get good pictures of horses running through fields of buttercups or other vividly coloured flowers, which always reproduce well and will always look good, especially if water also appears in the image. The Fall season, particularly in North America, is another great time to get a coloured background.

Entering water can cause difficulty for many domesticated competition horses if they are not used to it, and very often it can take weeks of patient training, walking in and out of streams and through puddles, to get the animal confident enough to step into the unknown. Wilder and more feral horses, however, will have learnt all about this from birth as they follow in the footsteps of their mothers from day one. This is a lesson to us all that the more the young horse can be left to fend for itself in natural surroundings where possible, the more education it will get from having to work things out for itself.

Previous double page:
A palomino Tennessee Walking Horse splashes through the water in the state of its name. These fine gaited horses originated in America and were versatile for all farm work but sweet-tempered enough for the family to use in different roles. Today, they are mostly used for showing as they can perform the flat foot walk, the running walk, and the canter. They are extremely comfortable to ride. ❶

Opposite:
The Lusitano is one of the popular Iberian breeds originating from Portugal that has influenced many horse breeds throughout modern history. This one, his golden coat glistening in the Florida sunshine, shows the Palomino colouring which is hugely popular in the USA. The breed is known for its docile nature but impressive looks and is used in many competitive sports. ❷

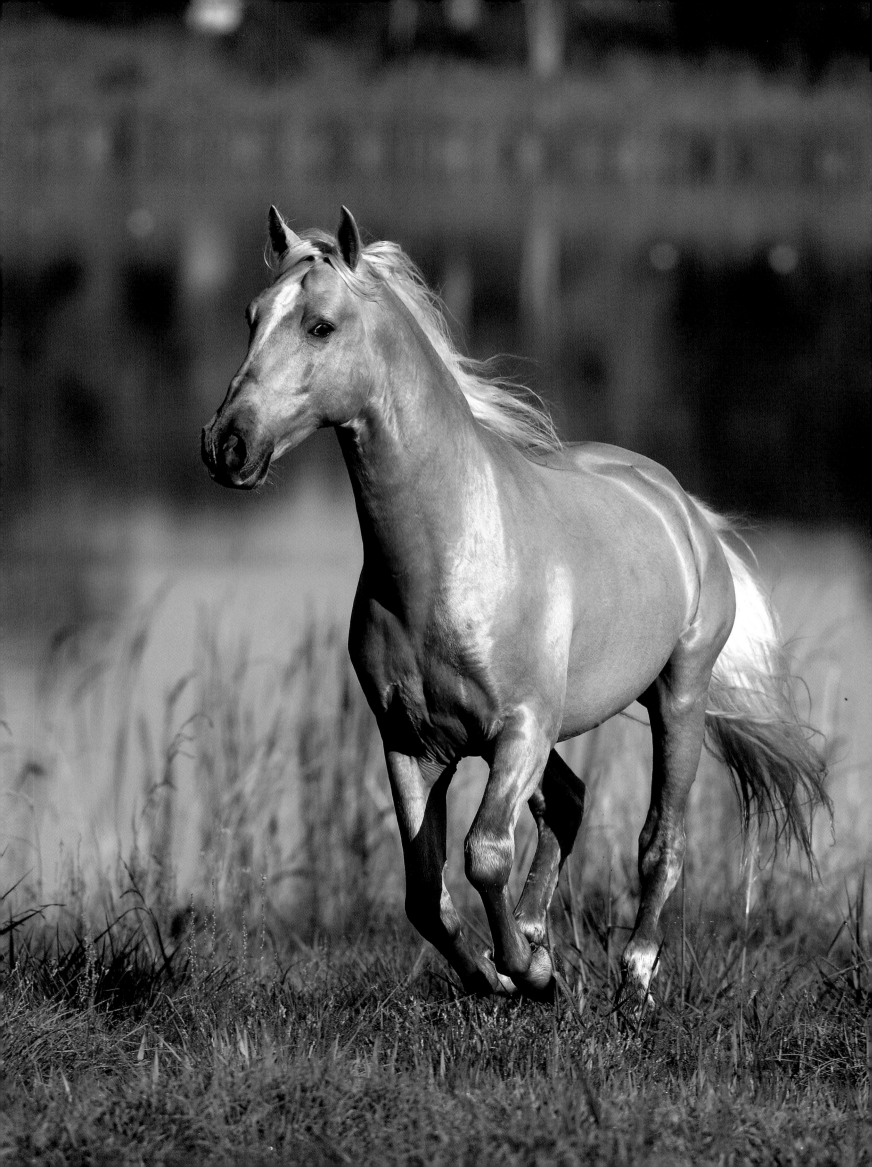

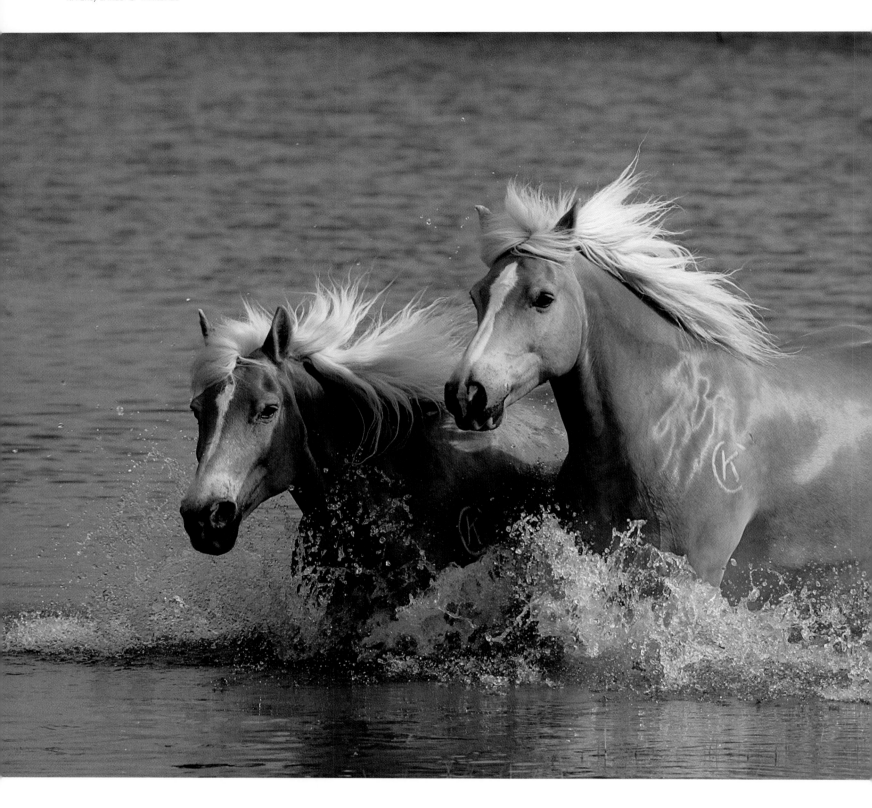

Two Haflingers splash through the water on a farm in Texas. This is an Austrian breed from the Tyrol region, where they were used for transport because of their famous surefootedness. They are now very popular as riding and driving ponies as they have a kind and docile nature. They are normally chestnut or Palomino with flaxen manes and tails. ❶

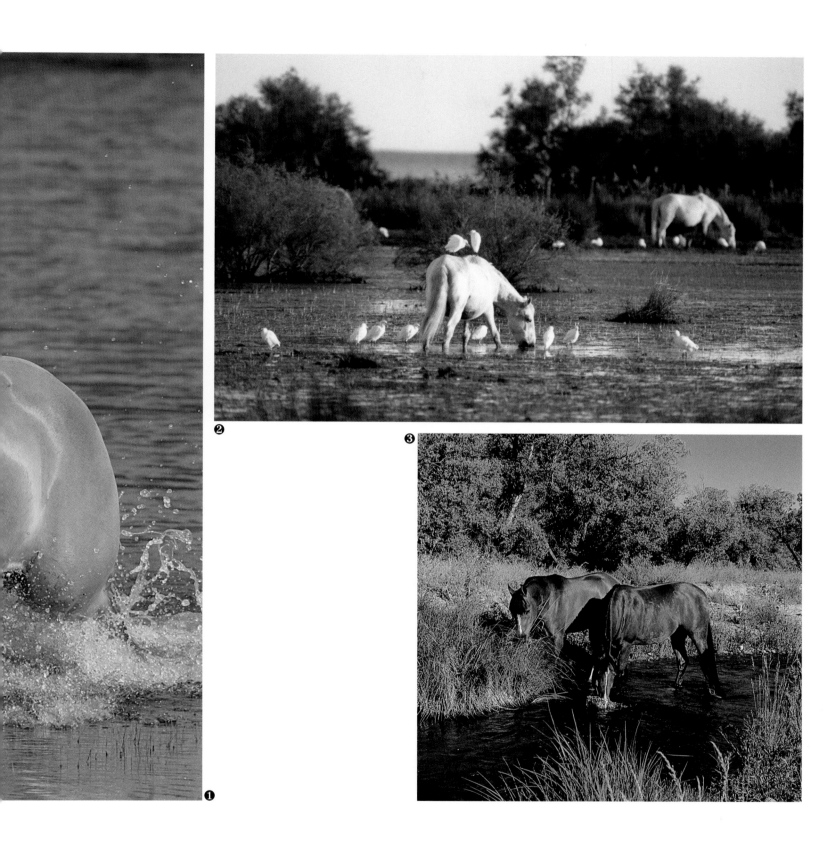

Top:
Camargue ponies browse amongst the marshy waters with egrets on their backs intent on taking some soft downy hair to line their nests. The ponies shed their winter coats in the spring, when birds are building their nests. It is common to see this mutually beneficial activity taking place worldwide in early summer. ❷

Above right:
These two Arabians in Colorado were led down to the river where they stayed without running off. Being real family pets, they made it an easy shot for Bob by staying in position, and he was able to get several shots. This is rarely the case! ❸

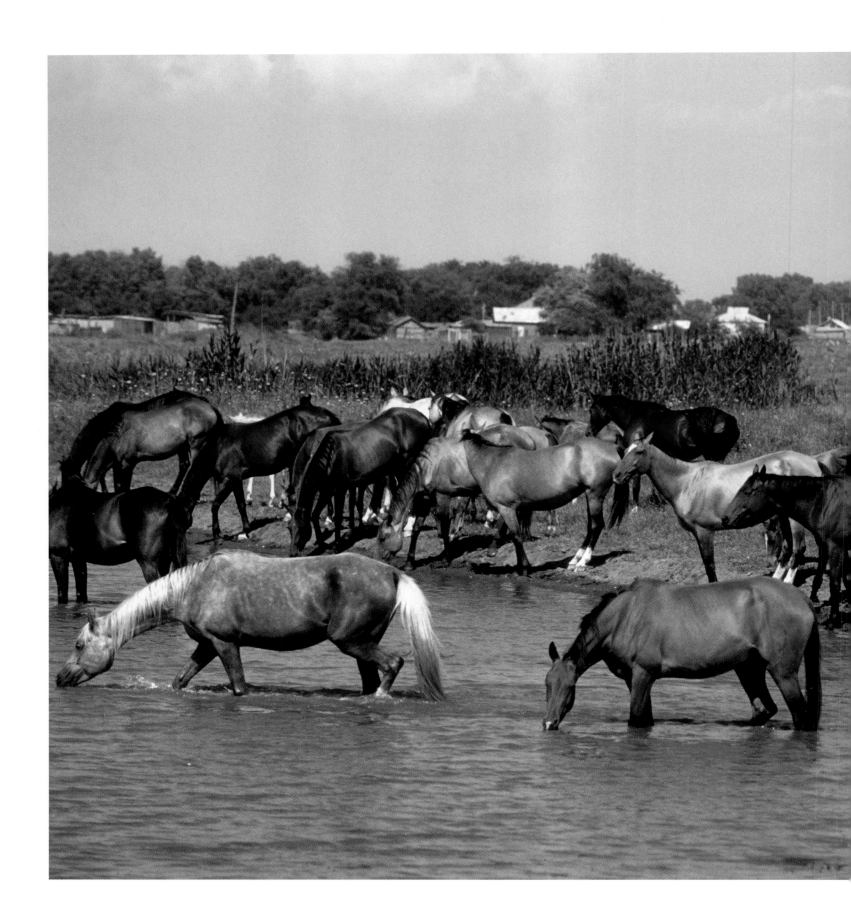

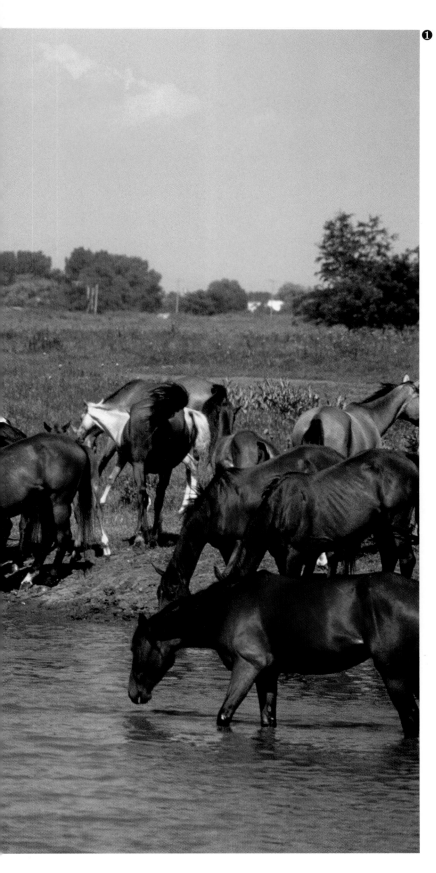

It's watering time in the summer sunshine for this large herd of Akhal-Teke horses from Turkmenistan. This is an ancient breed jealously guarded by the local tribes, who have kept the breed remarkably pure from early times. Originally used as a war horse, it is now popular for racing and competitive sports. The Akhal-Teke is remarkably tough, able to withstand extreme cold and survive on little food. ❶

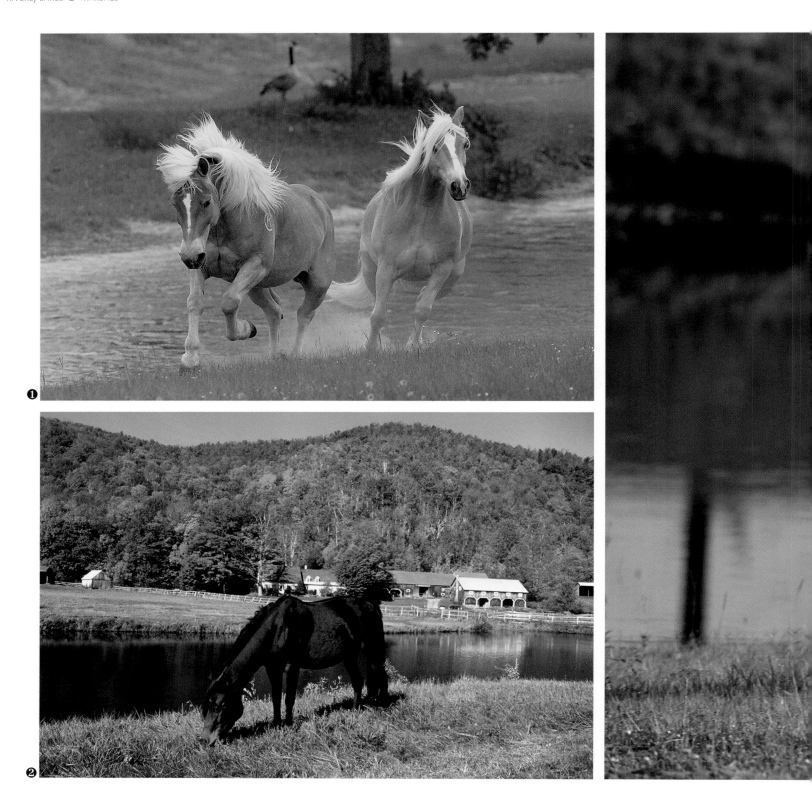

Top:
These Haflinger driving ponies in Texas
continue to do everything together when
loose, just as they do in harness. It is a known
phenomenon that if horses work together
for a long time, they will stay together when
not working. Haflingers are very popular
as riding and driving ponies, thanks to
their temperament and colouring. ❶

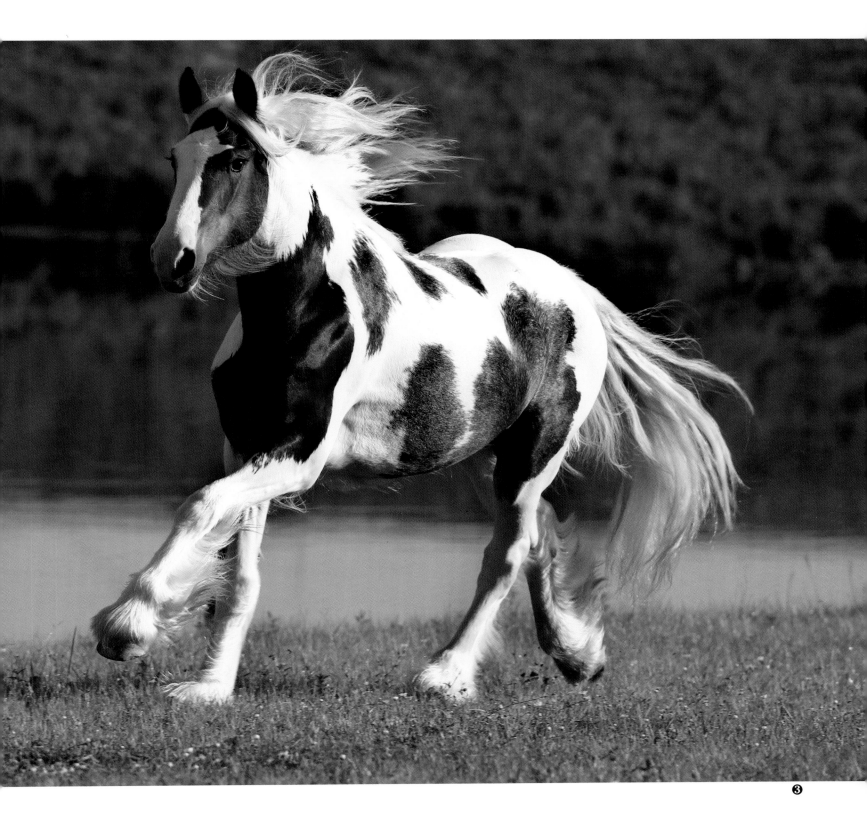

❸

Opposite bottom:
A Morgan grazes on the banks of a river in Vermont, with the stunning fall colours of the trees in the background. Morgans are always dark in colour and originated from one stallion with very dominant genes. They are a versatile breed, and popular far beyond the USA. ❷

Above:
A Clydesdale/Shire cross canters along the riverbank. Destined to be a Drum Horse, she has the striking colouring of the large Vanner and an abundantly flowing mane and tail, which will make for a spectacular picture when she is on parade dressed in military regalia. ❸

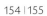

❷

❶❸

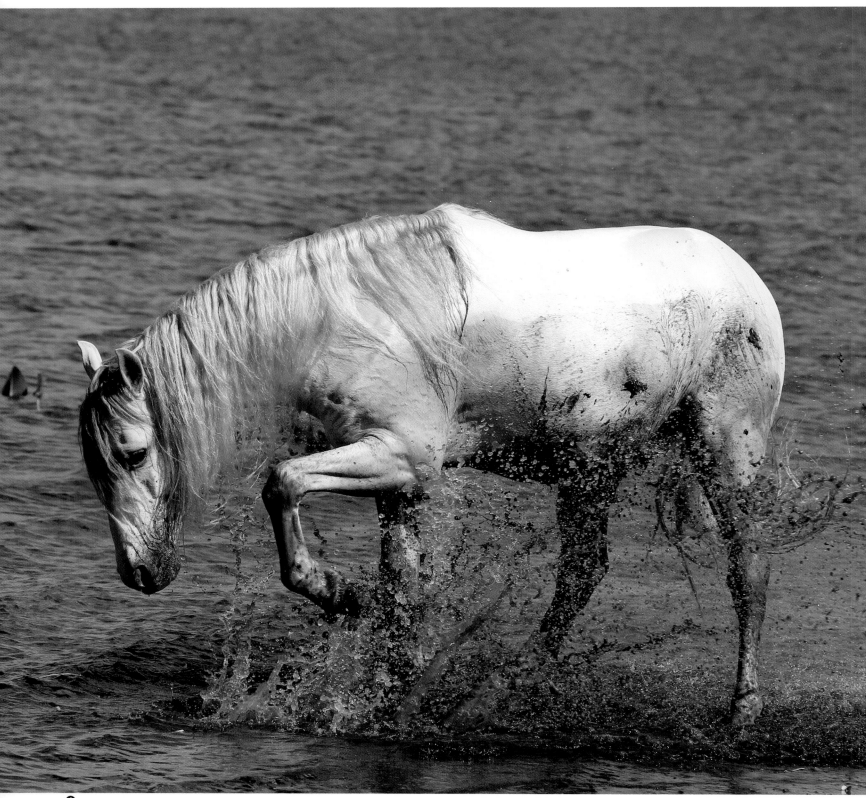

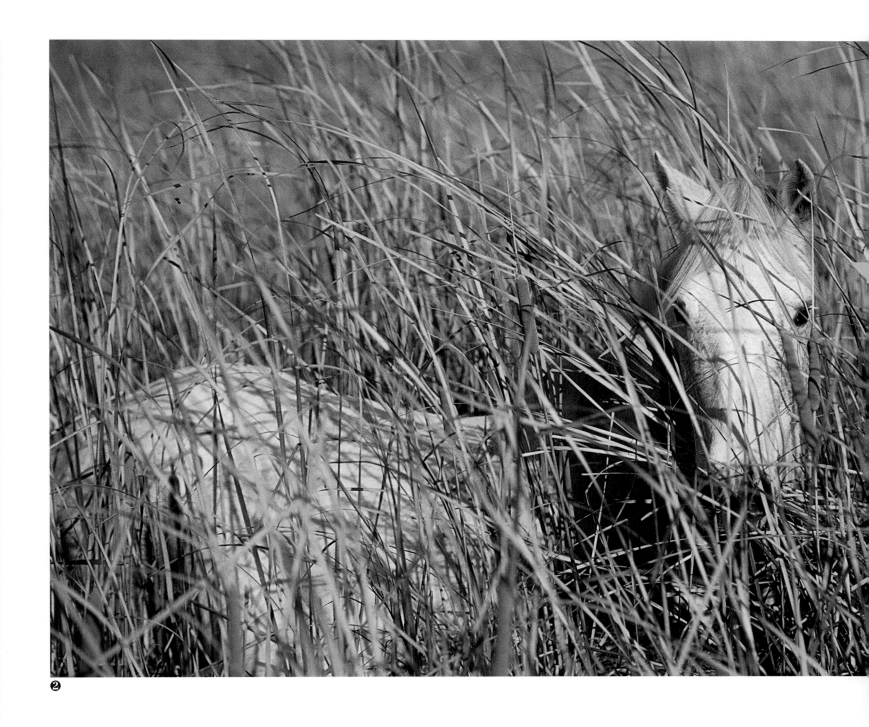

❷

Opposite:
This fine grey Lusitano had been brushed and polished to perfection, but as soon as he entered the water, Bob says he just pawed and pawed, plastering himself in black mud before lying down and coming out looking like a Pinto. Sometimes a photographer just cannot win! ❶

Above:
"Ha ha, you cannot see me!" This charming photo depicts a young Camargue foal lying amongst the reeds in France. Although a little wary of Bob, he was determined to sit it out and did not move. Hardy Camargue ponies have adapted to living on the salt marshes over many generations. ❷

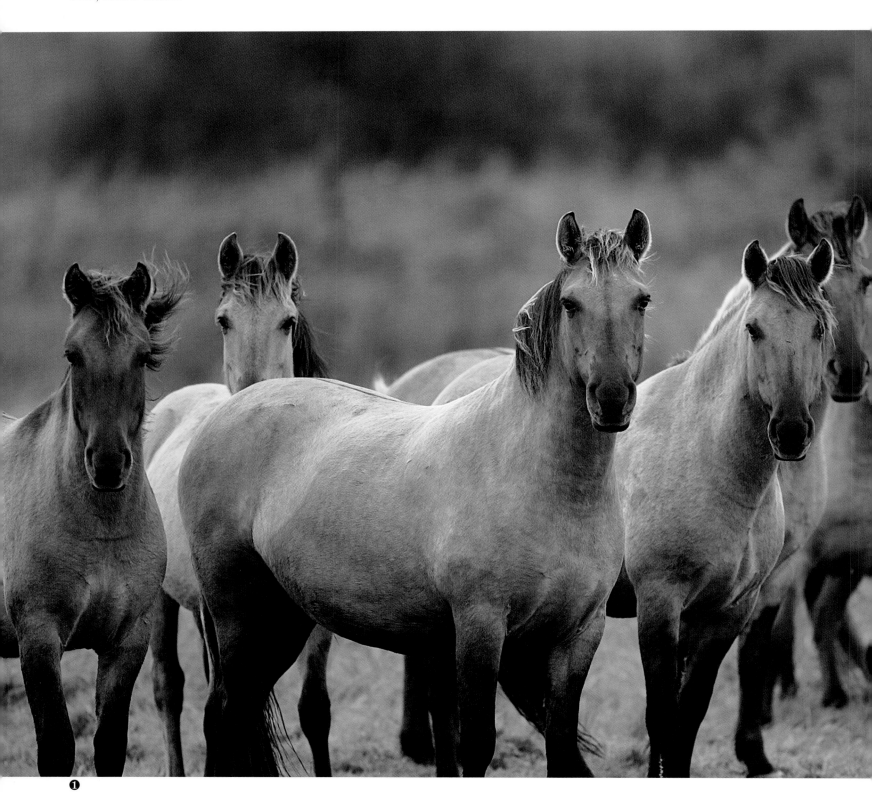

❶

Above:
Koniks are related to the now-extinct Tarpan from Poland
and Eastern Europe and the original wild Przewalski horse.
Uniquely misty grey or grey dun in colour with dorsal stripes,
they have features from many ancient breeds. ❶

Opposite top:
The head of the Konik tends to be large but has a docile eye.
They were renowned in their native Poland for their strength
and ability to live on little food. With the rise of mechanisation,
however, their use has declined, placing them in danger of
extinction; efforts to preserve them have helped enormously. ❷

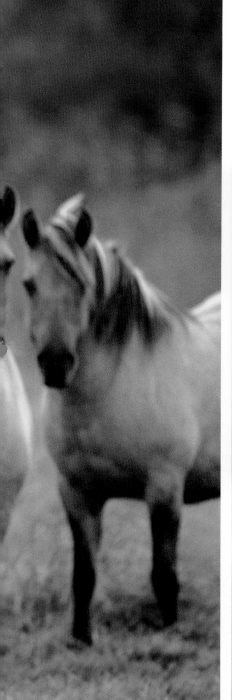

Bottom:
This herd of Koniks was photographed in Kent, where there has been a concerted effort to preserve and breed these rare animals who are so closely related to the original wild horse. Many institutions around the world are researching collaboratively to establish how the numerous breeds are connected and which were involved in cross-breeding over the centuries. ❸

❷

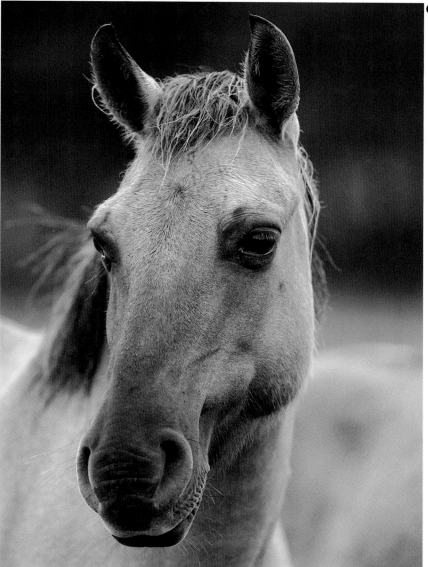

❸

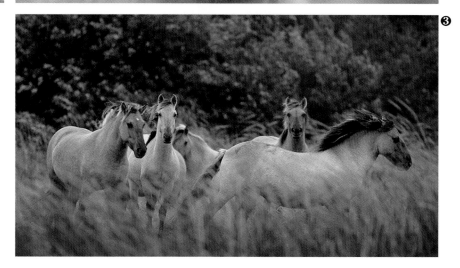

Bob took these pictures beside a lake in Florida. On the first attempt to have this handsome warmblood stallion gallop back to his friends in the stable, he set off in the opposite direction! On the second try, he was more helpful and passed by Bob's position between the lake and the stables. ❶

❶

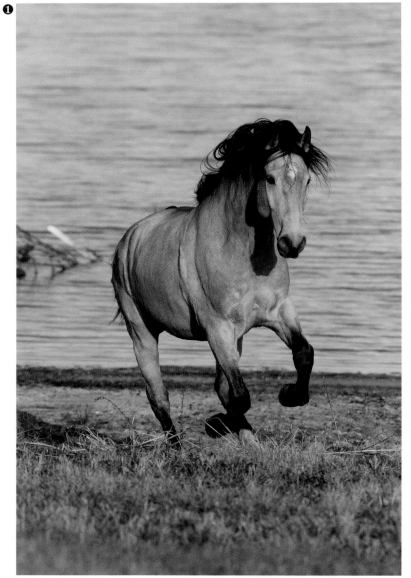

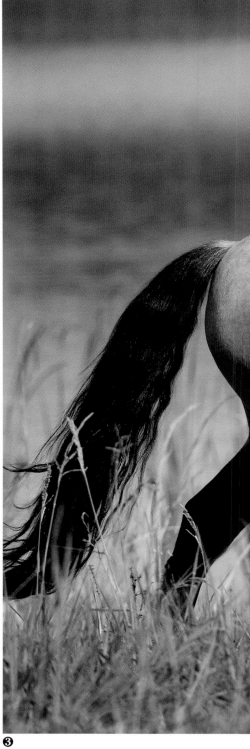

❷

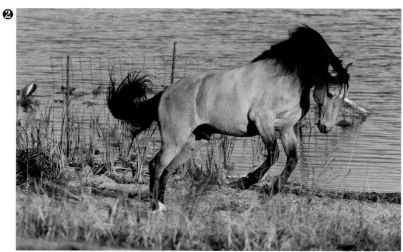

❸

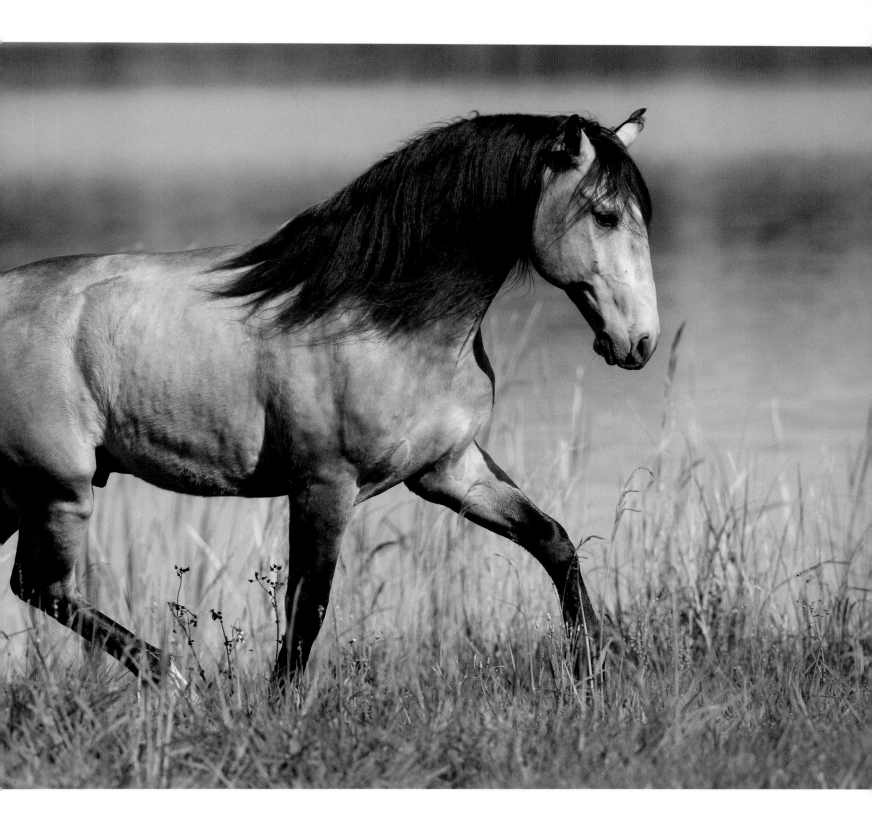

The horse made the most of his freedom and gave a few impromptu bucks and kicks along the side of the lake. The enjoyment of freedom experienced by domesticated horses is usually visible in this way, and sometimes the antics performed make one realise how lucky you are not to be on top of them on such occasions! ❷

After settling down, the horse performed a perfect trot past Bob, looking as if nothing could divert him from his path back to the stables. His golden colouring is known as "buckskin" in America, but it is known in the UK as "dun." The coat can be many different shades of this colour, but the manes, tails, and legs are always dark. ❸

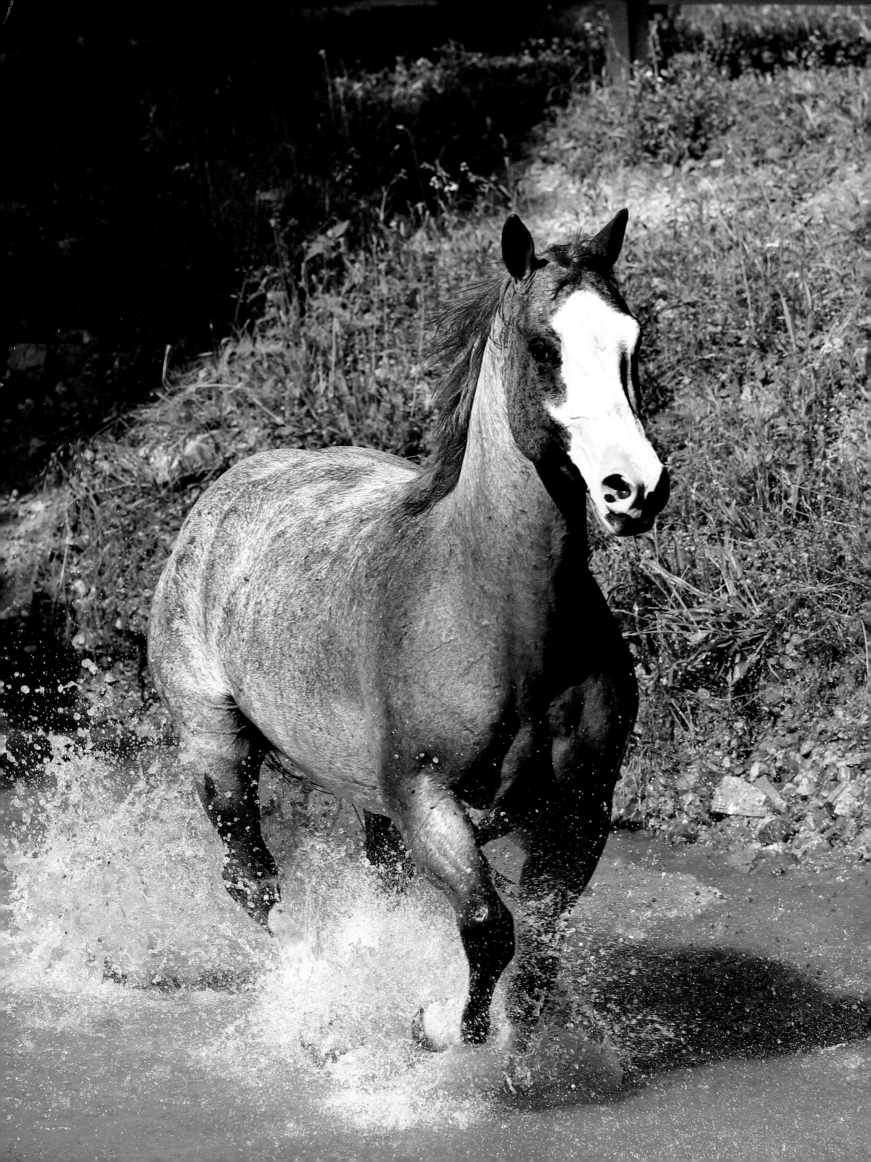

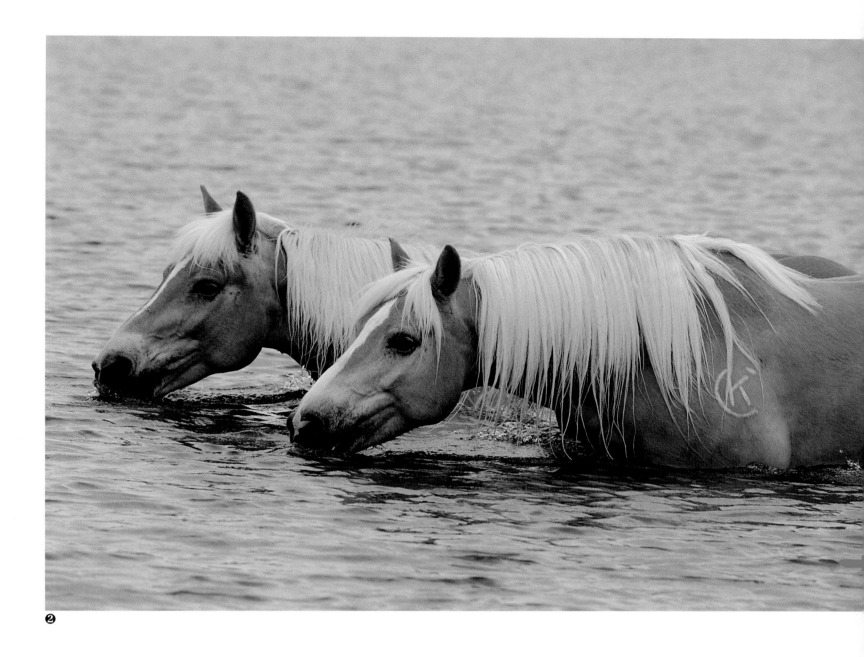

Opposite:
A white-faced Quarter Horse mare trots down a river in Tennessee. The breed is the most prolific in America. Agile, good-tempered, and extremely powerful, it is the fastest breed over quarter-mile distances, hence its name. Riders used to race them down streets of approximately this distance. ❶

Above:
The two well-matched Haflingers displaying the deep Palomino colouring of the breed drink together in this large Texas lake, quite happy that the water reaches well above the tops of their legs. Bob assures us he was not in the water with them! On the shoulder of the nearside horse is a clear "K" brand. Brands are used to denote a certain breed of animal in many countries, or for ownership, or as breeders' marks. They have traditionally been done with a hot iron, but now freeze marking—which is more humane—is becoming much more common. ❷

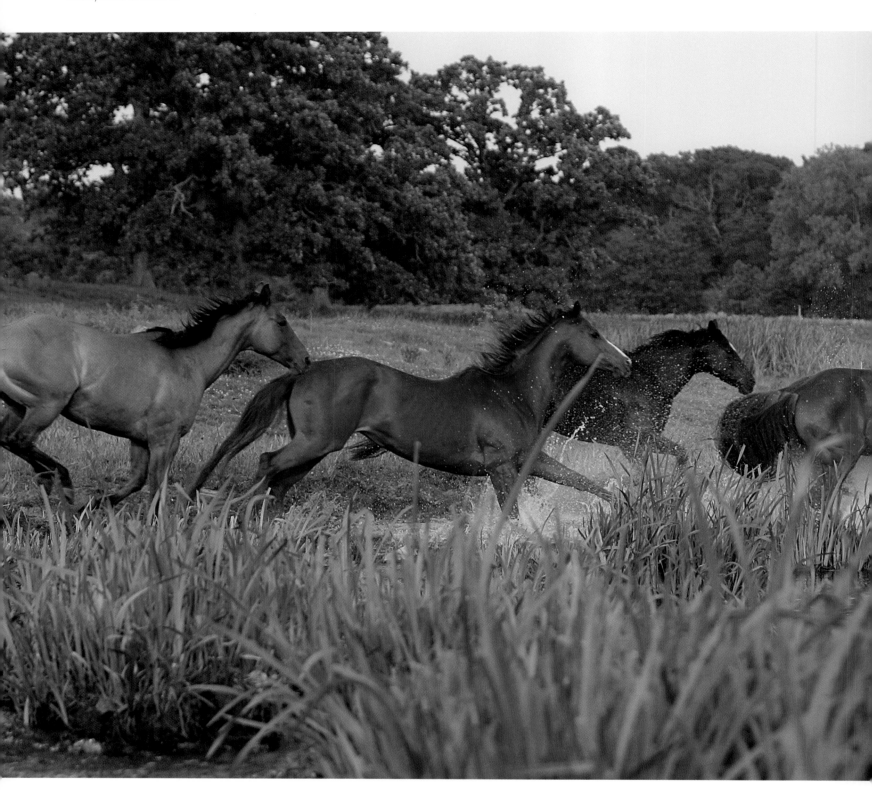

Above:
This group of riding horses in was rounded up to move to new grazing pasture in Illinois and was driven through this small lake so Bob could get the picture. Horses are rather messy eaters and tend to overgraze the places they like while abandoning areas they find less palatable. If possible, it is best to graze cows and sheep after horses to keep the pasture fresh and then rest it well before returning horses to the same area. ❶

Opposite top:
The Mangalarga horse is a rare Brazilian breed not often seen outside its home country. This one is from a stud in Florida. When he went to photograph the horse, Bob noticed the fountain in the middle of the pond and realised he might be able to catch this amazing rainbow effect. By manoeuvring a few horses in front of the water, he was able to capture this unprecedented image. ❷

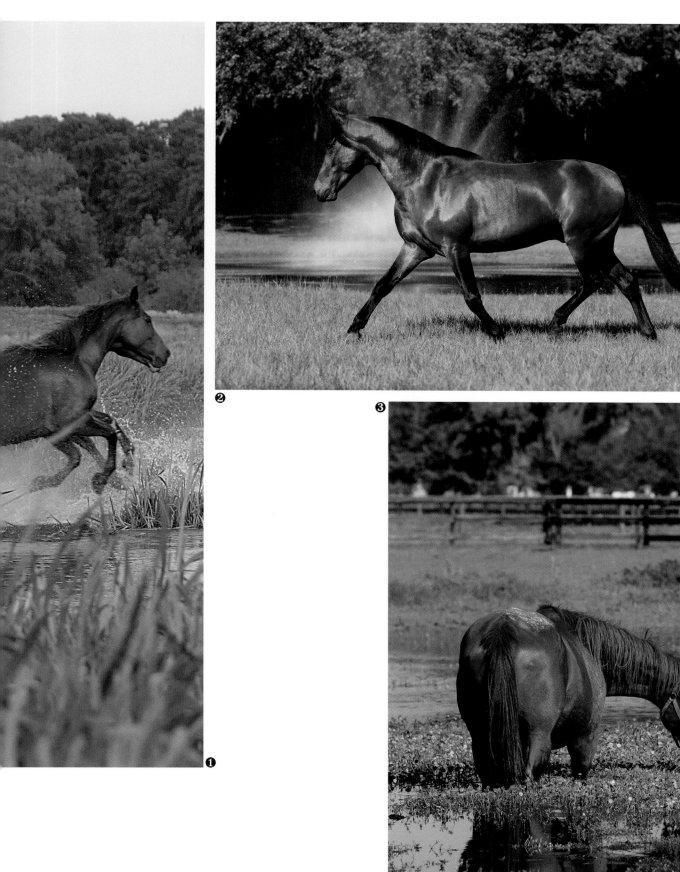

❶

❷

❸

Right:
This photo taken on a Quarter Horse farm in Florida did not have to be set up in any way and was totally natural; by pure luck, Bob was there at the right time. In very hot weather, horses will often venture into any available water to cool off, and some will get up to all sorts of antics splashing and playing around. ❸

FORESTS, JUNGLES & WOODS

Relatively few horses actually live in thick forests and jungles, but they may venture in for protection against inclement weather and to find shade. As flight animals whose instincts are to flee from predators in the wild, they always look for a safe escape route and will not normally venture too far into thick forests. From a photographer's point of view, however, the trees often make for beautiful backgrounds, and Bob has made full use of what was available.

In thick forests, there is very little ground vegetation to eat since the trees obliterate the necessary light to enable any cover to grow. There is more to eat in the open grasslands.

Shade is particularly important in the hotter climates when temperatures can get very high. Most animals will venture out during early dawn and at dusk to find food but try to find cover during the heat of the day. Their coats will often stand up in severe heat, allowing more air to circulate. Ponies may start to sweat profusely, to let heat escape through evaporation, and often will lie down to conserve energy in very hot conditions. Many of the horses and ponies in this section are shown in their natural habitat, which often includes areas where trees grow in abundance alongside open plains, countryside, hills, and mountains. Some animals are shown amongst foliage in southern Africa or amid the woods and forests of Europe. Others are at home in the Bahamas, Indonesia, and several locations in America.

During one of Bob's visits to Indonesia in the early 1990s, journalists had difficulties entering the country due to political unrest. Bob called on the head of the Indonesian Horse Society, who as it turned out was also an influential MP. On arrival at Jakarta Airport, instead of waiting in a long queue, he found himself ushered through the Diplomatic Channel.

After seven days of photography, Bob returned to the airport with a letter to use if he needed it. At Immigration, his bag was opened, and he was told that he must either leave the film –the fruit of all his efforts– behind or have it developed so they could all see its contents. Bob handed the letter to the officer, who went off to talk to his superior. Five minutes later he returned, escorted Bob onto the plane, and even got him upgraded to business class!

Previous double page:
These Brumby mares with their foals show cautious interest in Bob's activities as he gets into position in a forest in Australia. They have ventured in to avoid the strong midday sun and found a lovely shaded spot where they can snack on vegetation until the air cools. Foals learn from their mothers and it is common to see them copying whatever Mum is doing. ❶

Opposite:
This Abaco Barb — one of the few left in the world — takes respite from the hot midday sun with friends on the island of Abaco in the Bahamas, from which the breed takes its name. Abaco Barbs are closely related to the West African Barb. The horses are thought to have been shipwrecked on the island during the Spanish colonial era, and they have lived there ever since. Because of their isolation, they have remained remarkably pure and true to the Barb characteristics. ❷

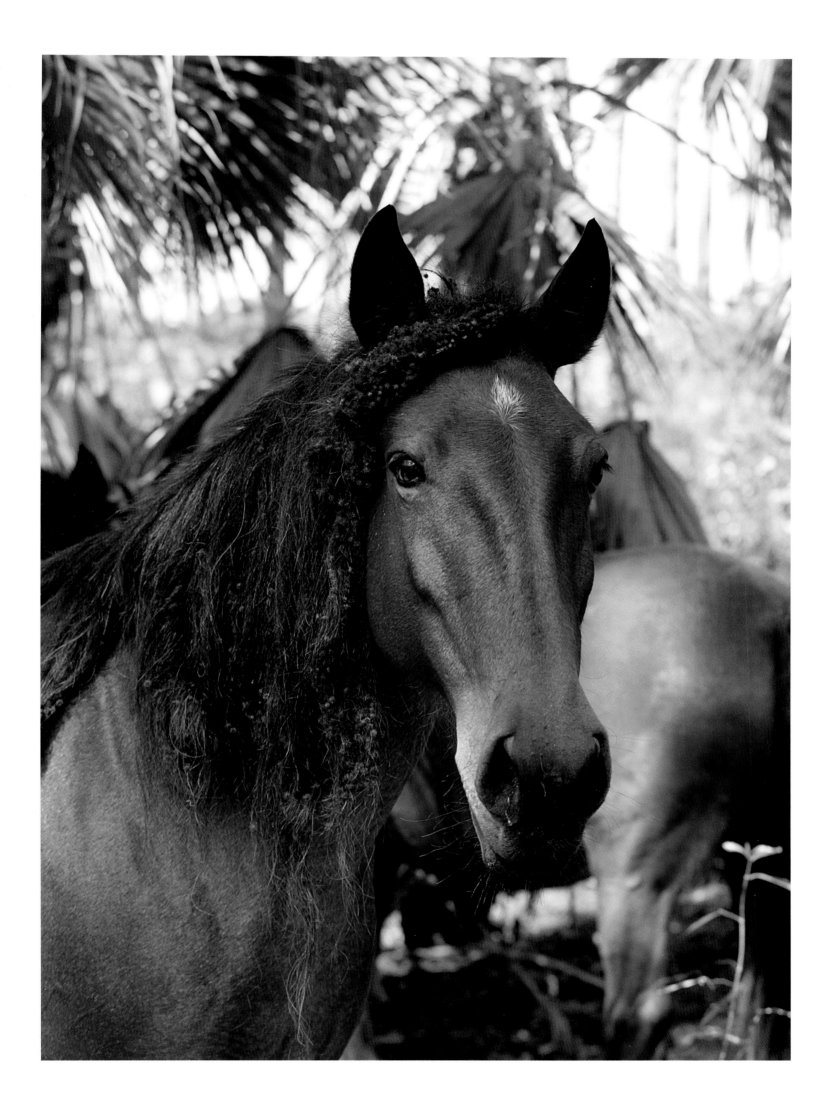

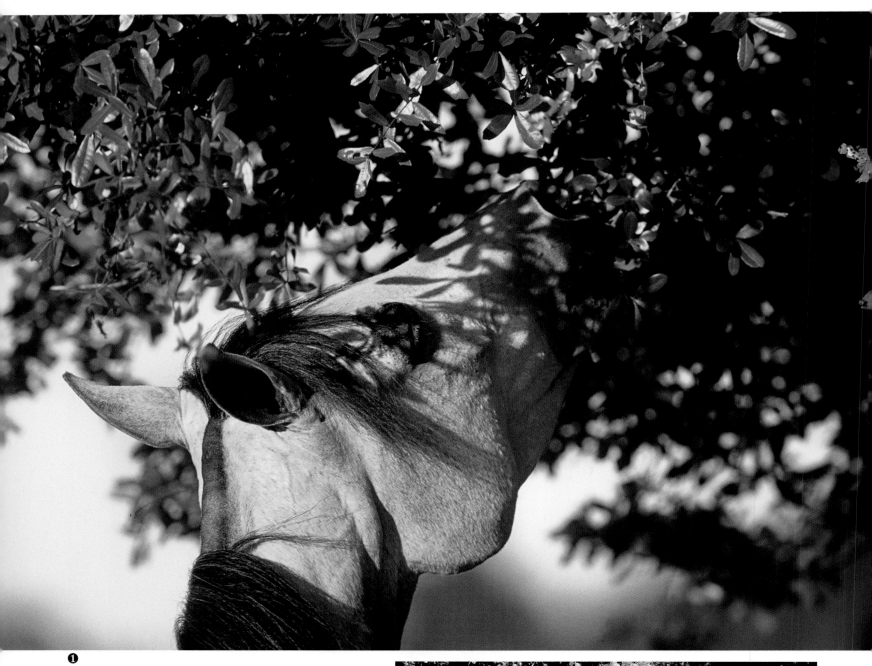

❶

Above:
Sometimes horses will eat tree vegetation if other fodder is in short supply. This tendency can be a real problem in domesticated horses as they can do serious damage and can even kill a tree if they chew the bark all the way around the trunk. They may do this when they are having trouble getting certain minerals. Occasionally horses are poisoned by certain fruits, nuts, or leaves from trees, but generally the toxic ones are bitter, which may sometimes let them know they are not safe to eat. ❶

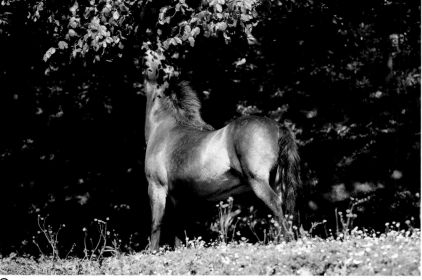

❷

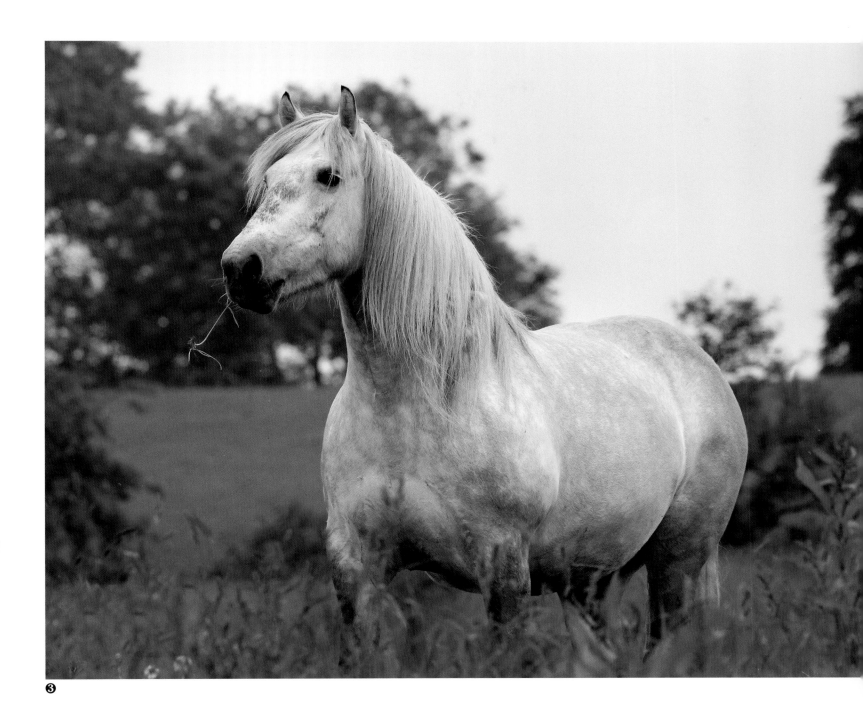

❸

Opposite:
This diminutive Exmoor in the UK is stretching to his full height to reach the tasty bits on this tree despite what appears to be plenty of food in his paddock. Some trees are poisonous, and although most wild animals seem to know what is good and bad for them, the domesticated horse is not so aware. Such trees as yew, as well as many types of ivy that grow on trees, can have catastrophic effects. Owners should be aware of the dangerous trees, shrubs, and plants in their region. **❷**

Above:
A curious Highland pony mare has found something interesting at Nashend Stud, only a mile from Bob's office in Gloucestershire, where they have been breeding Highland ponies — one of Britain's nine native breeds — for years. Originally used as pack animals for carrying stags down from the Highlands, they also make wonderful children's ponies and are used for trekking and hiking. **❸**

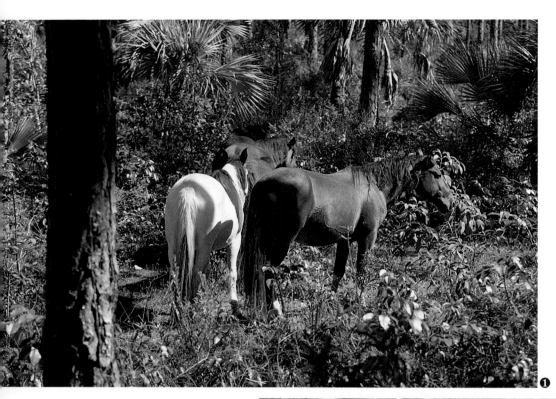

A peaceful sight is these Abaco Barbs resting under the shade of island trees. Originally, the breed was likely to have been full coloured — probably bay, brown, and dun — but over time new genes have been introduced; other colours and patterns are very common in the Americas. ❶

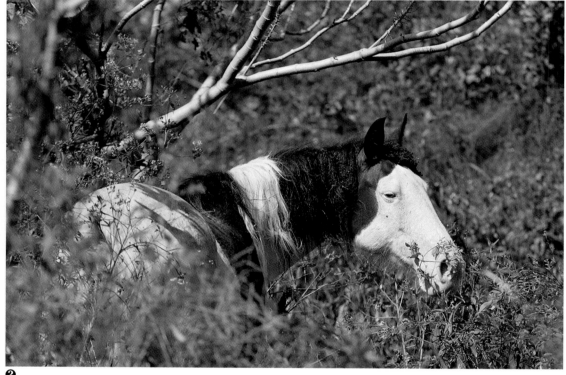

Above:
This fellow is fascinated by Bob and his camera. Some animals, like humans, can be very attuned to what is going on around them and enjoy the attention, while others are more reserved and don't want to cooperate in any way. This Abaco Barb was photographed in the Bahamas amongst the natural vegetation. ❷

❶❷❸

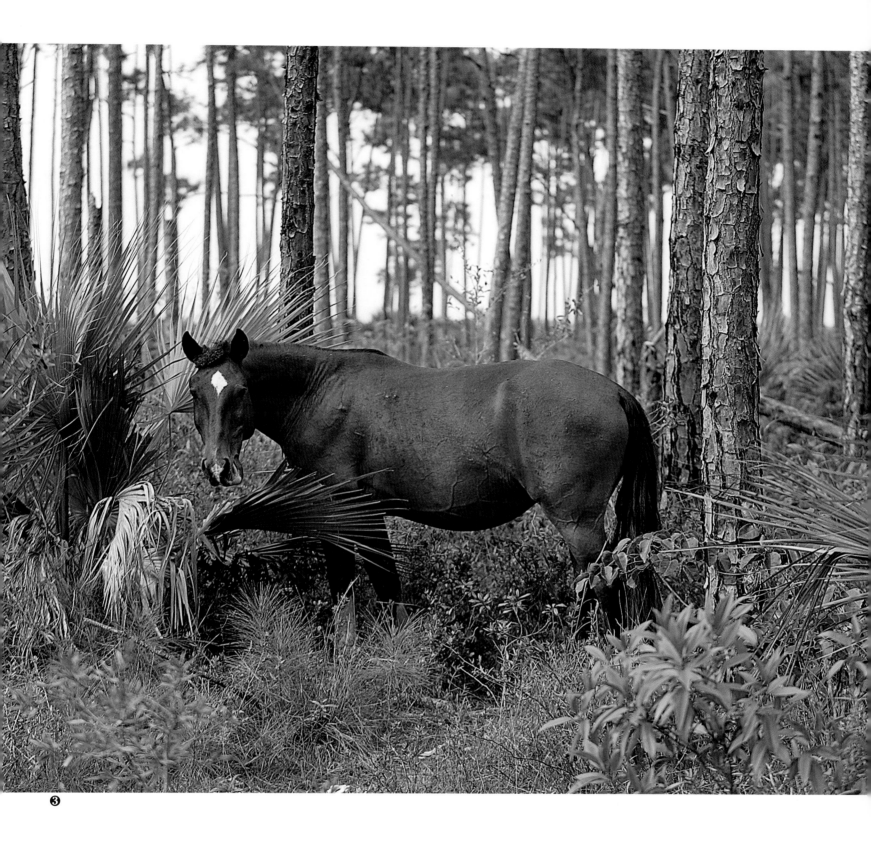

❸

Above:
This heavily pregnant Abaco Barb seems to have plenty to eat as she grazes the natural vegetation amongst the trees in the Bahamas. Nature has ensured that foals arrive at the best time of year when grass is in plentiful supply, so the mare will be able to produce enough milk to keep the youngster going until it is fully independent and able to graze on its own. ❸

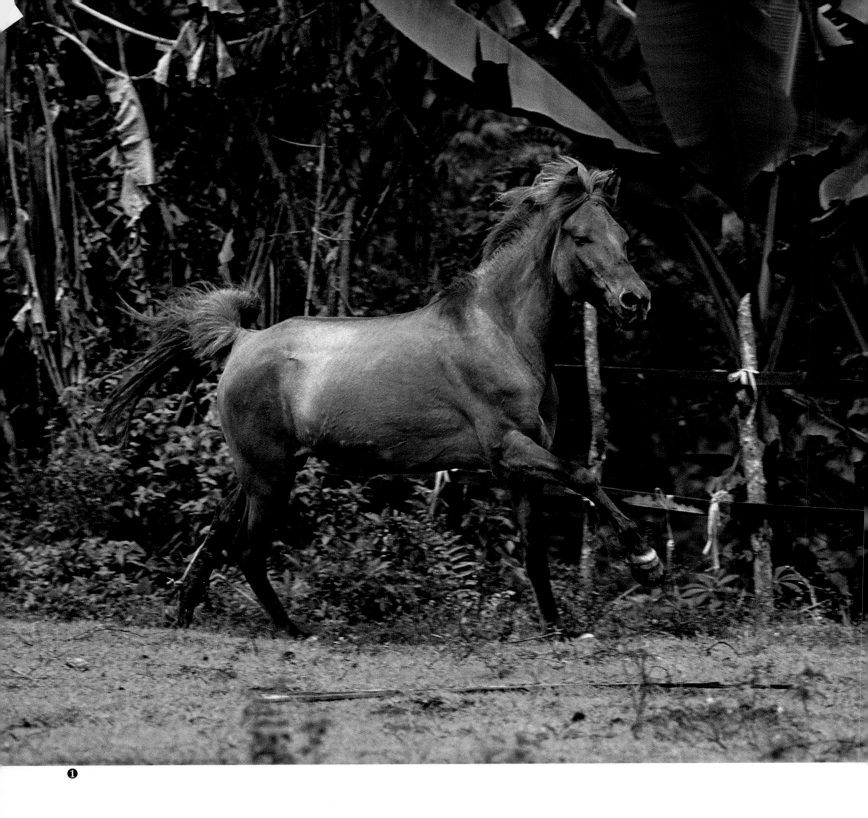

A Batak pony from Indonesia canters amid the thick jungle vegetation. Thought to have originated from Mongolian stock, the Batak has had a lot of Arabian infused into the breed over the years to make it lighter and more suitable as a riding pony. It is between 11.2 and 13 hands high and is usually bay but may be any colour. It was once used as a sacrifice to the gods, but today it has a much better lifestyle and is often used as a children's pony or for racing, which is popular in the region. ❶

❷

❸

❶

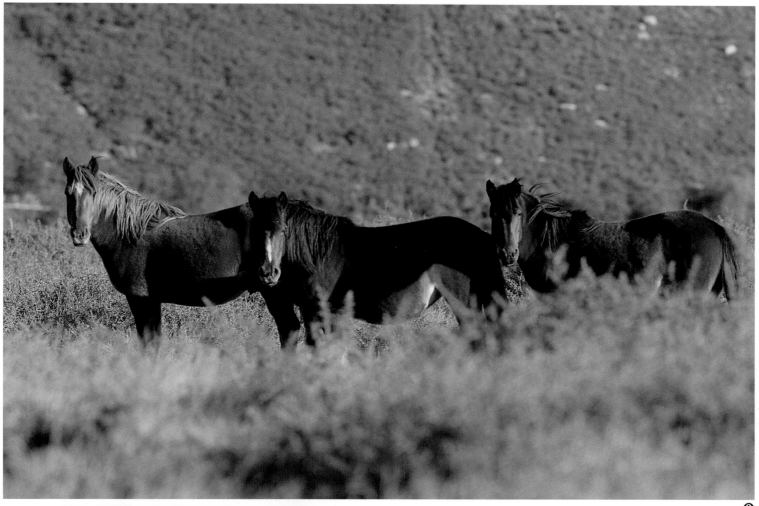

❷

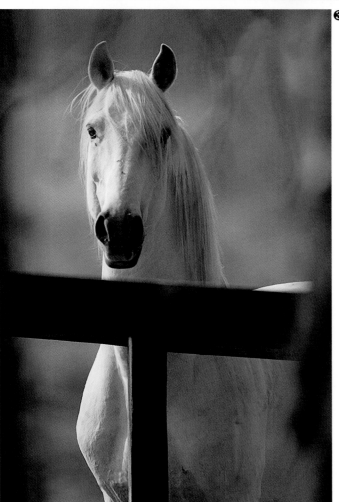

❸

Above:
Galician ponies from Spain look inquisitively at Bob as he shoots this photo in the mountainous woodlands of Galicia. Many have prominent moustaches, which they use to protect themselves and feel the prickly plants, such as gorse, that they feed on at certain times of year. **❷**

Left:
This handsome grey Lusitano was photographed at the famous Interagro Stud in Brazil and shows all the fine characteristics of his noble lineage. The breed was originally introduced to Brazil by Portuguese explorers in the 18th century and has flourished in various parts of the Americas ever since. Lusitanos are also popular throughout the Southern Hemisphere, particularly in South Africa and Australia. "One evening Cecila Gonzaga, who manages the farm, took me into the city," Bob remembers. "Just as we arrived, she warned me that the car was bullet proof. Her father, Paulo, is a well-known banker in Brazil. As we got to the house, solid iron gates opened and out stepped two men with automatic weapons to see us in. I'm glad I'm just the photographer..." **❸**

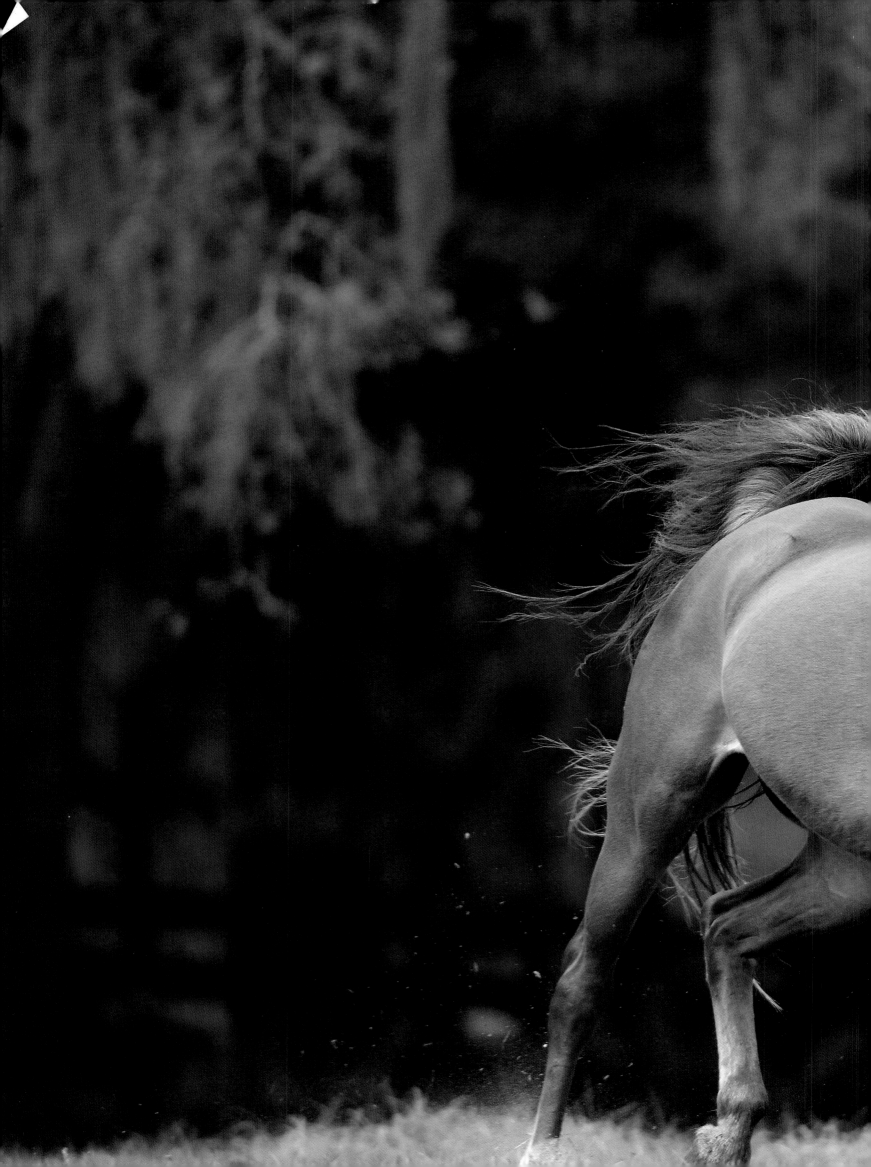

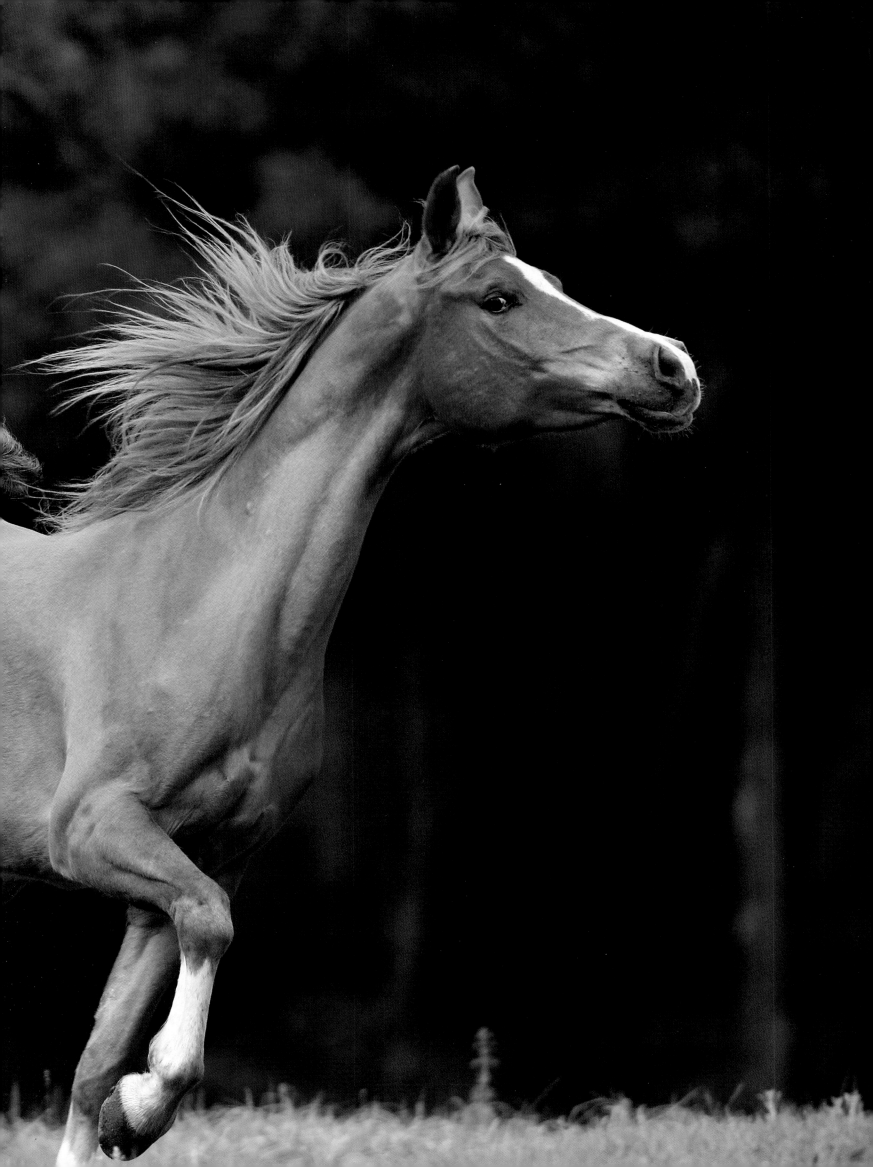

Previous double page:
This Arabian was photographed on the Plumwood Arabians farm in Florida using a long telephoto lens, which enabled Bob to capture the movement and agility of the steed. By punching out the background, he highlights the animal in the foreground. This breed is one of Bob's favourites to photograph. ❶

Top:
The New Forest pony is one of Britain's indigenous breeds based in the central south of the country. It lives in the woods and scrubland of this vast National Park and gets rounded up annually for health checks, identification, and sometimes for sale at the local Beaulieu Road sales. Commoners' rights enable owners to let their ponies run loose in the forest, as has been the case for generations. ❷

Above:
Wild Brumbies shelter near the eucalyptus trees in the Australian woods. Bob had to track them with a guide and could not get within five hundred yards unless he crouched down and hid. He used a 500-millimetre lens with a 1.4 converter making it 700 millimetres, then magnified by 0.3 to make a 910-millimetre lens, and still he could not get close. These Brumbies were truly wild! ❸

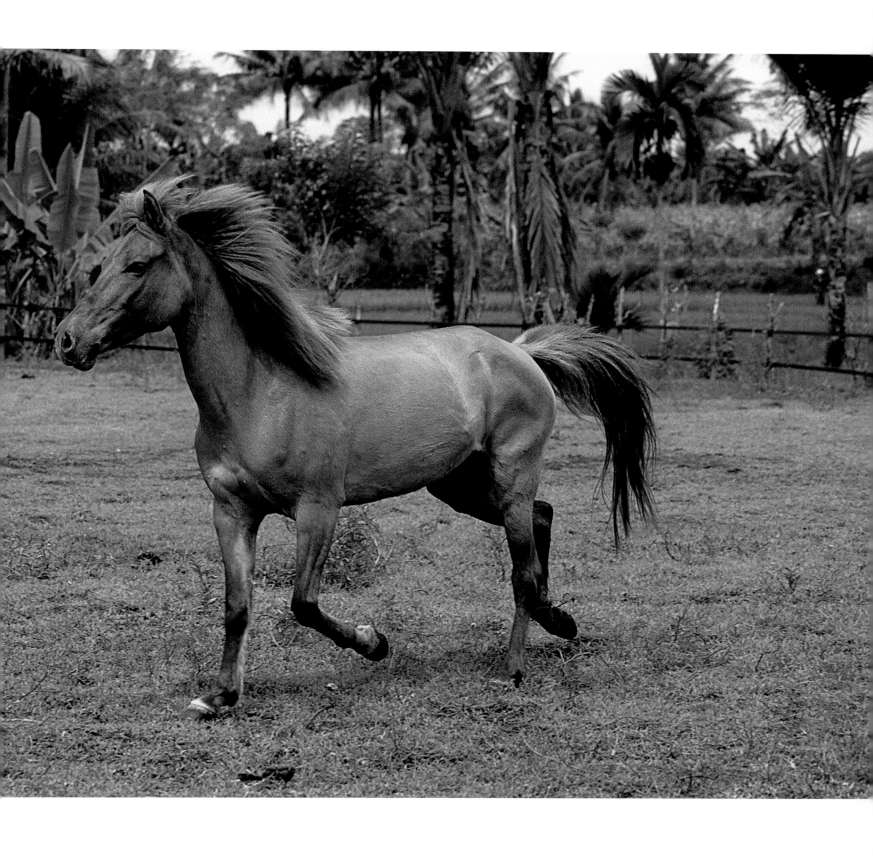

A Batak pony runs in a paddock cleared from the jungle and forest in Indonesia. After some refinement, this versatile breed now makes for good riding as well as pack ponies with a calm and willing temperament. All the breeds on this spread are photographed in their country of origin. ❹

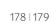

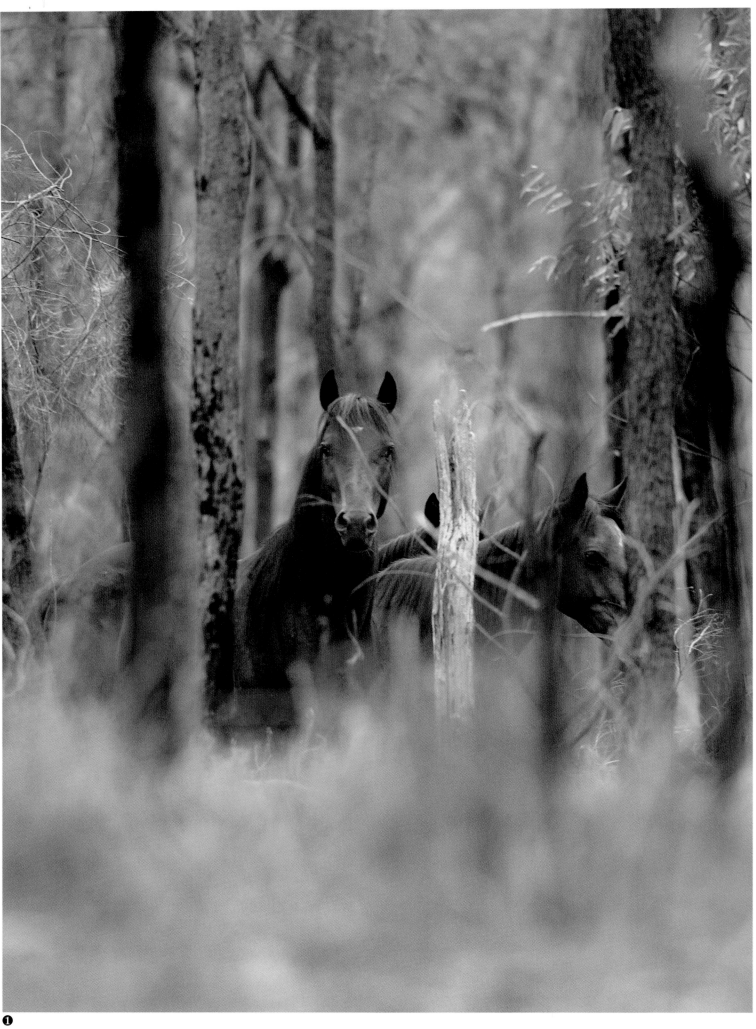

❶

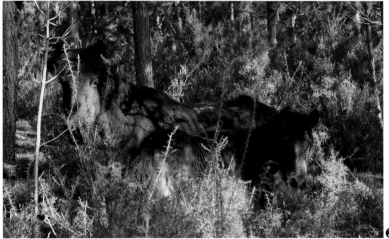

Opposite:
These wild Brumbies were tracked with a guide but were so timid it was difficult to get anywhere near them, and it took all Bob's ingenuity to get this picture. The result makes a charming sketch of these wild animals in the dense Australian woods of the Blue Mountains, not far from Sydney. ❶

Above:
The power of camouflage almost hides these little Galician ponies in the northwest of Spain as they rummage amongst the prickly shrubs and herbage of the Galician forests and mountains. The ponies range in height from 12 to 14 hands. Once a year they are rounded up for the "curros" festival, which has become a big tourist attraction. The semi-feral ponies are brought down from the mountains and branded. Their manes and tails are trimmed, and they're either sold or set free again. ❷❸

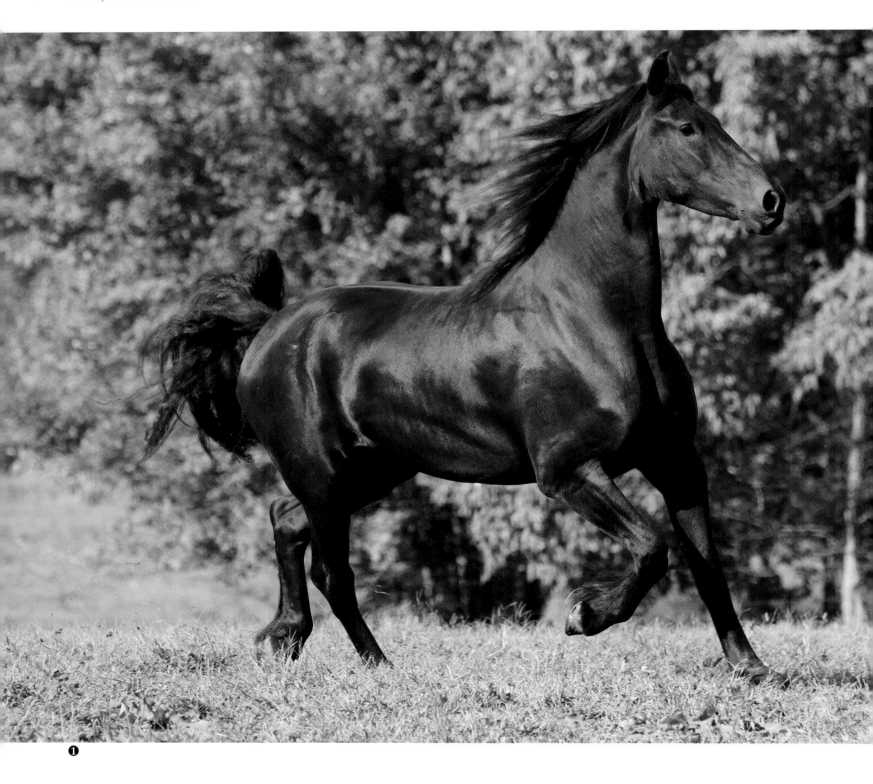

A Friesian in Indiana is pictured against stunning, colourful fall foliage, showing how the choice of background can make the photograph. This special photo shows off the powerful movement of the horse as it trots around the paddock. ❶

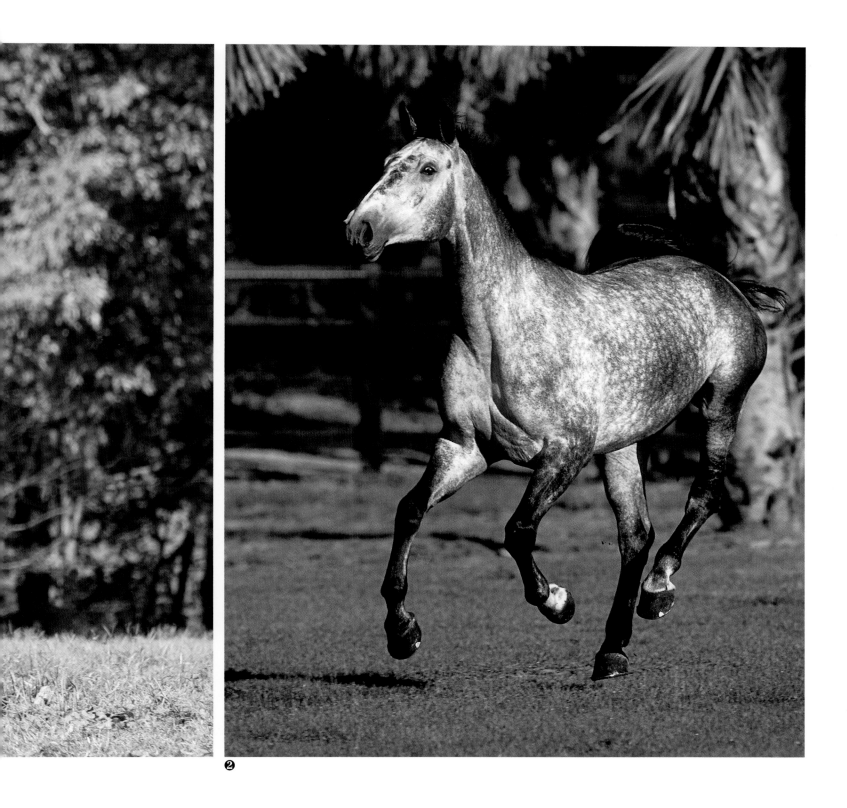

❷

The dappled grey Selle Français horse is
a popular French competition breed. This
horse was, in fact, bred in Florida at a Paint
Horse farm. Bob saw the animal while he was
there to photograph Paints and asked if he
could photograph it as well. "Goose" obliged
by galloping past the palm trees, and was
captured with all four feet off the ground. ❷

NATURE
IN THE SNOW

Taking pictures in the snow can prove a problem for a photographer, as the camera tends to complain once temperatures reach somewhere around minus 20 degrees Celsius–and the photographer's fingers soon stop working! In such conditions, the camera's batteries are also more quickly depleted. Speed is therefore essential if good pictures are to be taken, so many of the photos in this section had to be carefully set up before the shooting could start.

In their natural habitats, horses and ponies that live in more extreme temperatures will tend to migrate with the seasons to sheltered, lower ground in winter months to ensure there is enough vegetation to survive. Once the snow comes, it becomes extremely difficult to find food in any quantity, and only the hardiest breeds have adapted sufficiently over the centuries to cope in conditions where snow falls are extreme. One of these is the ancient Norwegian Fjord with its distinctive dorsal stripe that runs from the top of the head to the tail. The lighter outer mane accentuates this appearance, and people have traditionally cropped the outer mane short to show off this feature.

Domesticated horses let loose in the snow seem to enjoy it enormously and will usually put on a great display of cavorting and bucking, whirling about, rolling and galloping wildly backwards and forwards in sheer enjoyment. Most of Bob's pictures seen in this section show those moments, and it is plain to see from their expressions how much the animals are enjoying a winter break in the snow as they put on some special performances for Bob!

Nature has ensured that animals grow both a winter and a summer coat to enable them to adapt to the different seasons; the degree of warmth depends on how dense a coat they grow. The summer coat comes through during the spring as snows disperse, and this is a time when the horse can be seen rolling and rubbing against trees in an effort to shift these loose hairs as the softer, sleeker summer coat comes through.

The winter coat starts to grow as the colder nights set in during the autumn; these are usually darker in colour and have a much thicker density in preparation for what lies ahead. Certain ancient breeds that have to withstand extreme cold temperatures have developed a very dense "double" coat to enable them to survive more easily during the freezing conditions.

Previous double page:
Two gorgeous Norwegian Fjord ponies play in the snow in Alberta, Canada – in temperatures of minus 20 degrees! While such conditions create sharp pictures, they make it very difficult for the photographer to keep warm and the camera to function normally for long. Batteries tend to wear out much more quickly, and Bob was pleased this session worked out well on the first try. ❶

Opposite:
Most of the time Bob has to travel around the world to find impressive snow, but this shot was taken only one kilometre from his office at Bisley in the Cotswold Hills in Gloucestershire. This Thoroughbred Polo Pony belongs to Kate, who works part time in his office. ❷

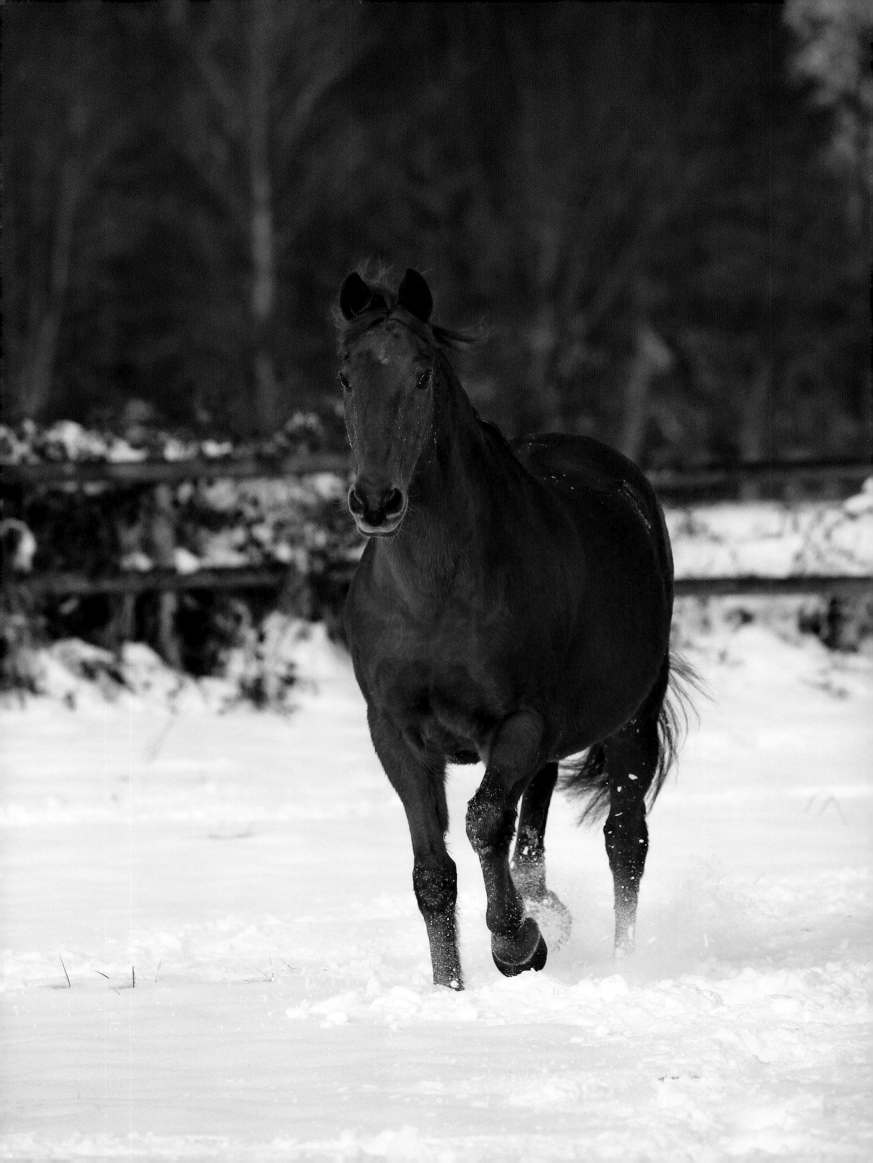

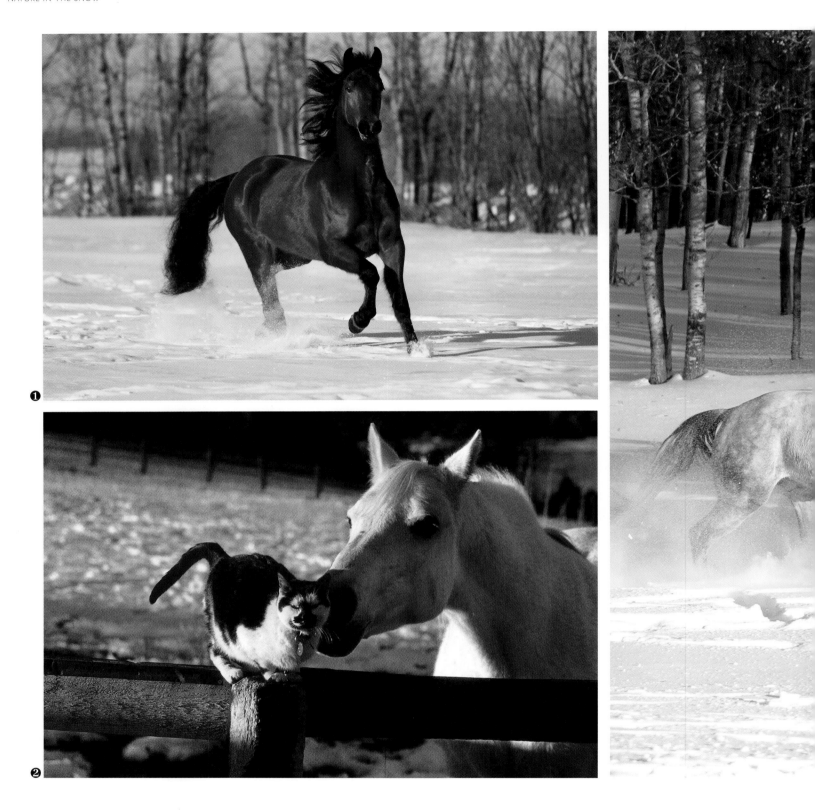

Top:
A typical Morgan horse at play in the snow on a farm
near Edmonton, Alberta, that specialises in breeding
Morgans. The horses performed beautifully and proudly
showed off in front of Bob, enabling him to get crisp and
clear snow pictures. Dark colours show up well and can
be put against numerous backgrounds. ❶

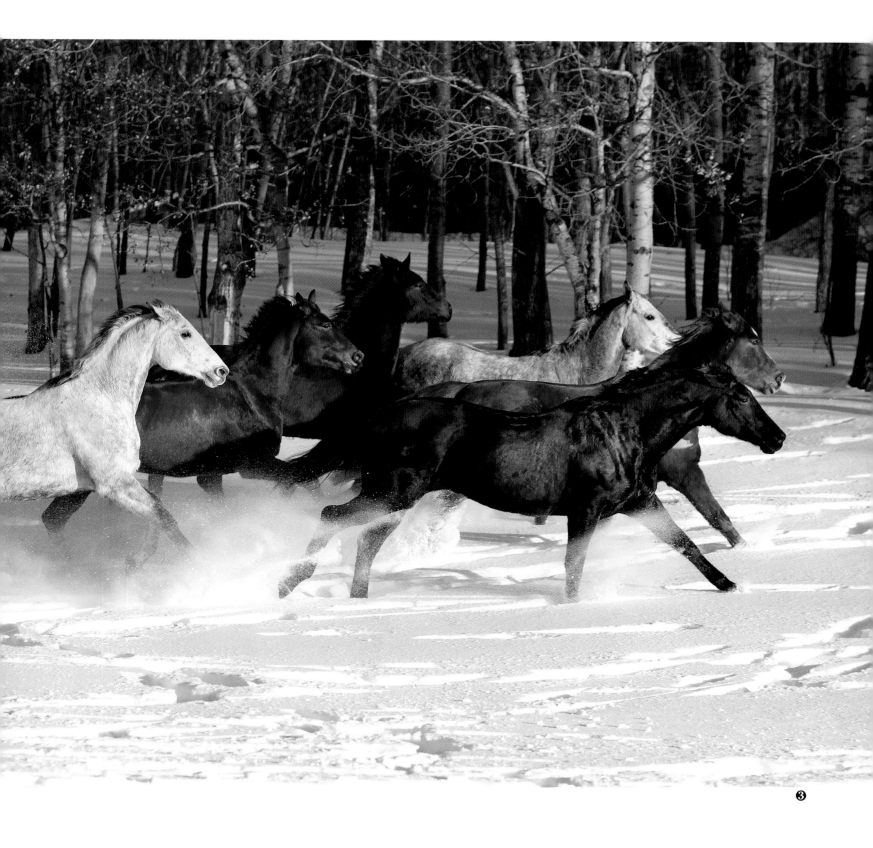

❸

Opposite bottom:
An Arabian mare nuzzles a friend at Bellinger Arabians in Paonia, Colorado, high in the Rocky Mountains. The cat was called Velcro because he would stick to anyone, human or equine, who showed him any affection! Horses often make friends with animals of other species, even much smaller ones. **❷**

Taken in Sherwood Park, Alberta, Canada, this picture shows a herd of Trakehners set free to gallop around for Bob's visit. In the cold air of minus 20 degrees, he was able to get some great pictures. Thanks to Elaine Poole, who set up his visits over a span of two to three years, it was possible to get different individuals or groups of horses in various fields. **❸**

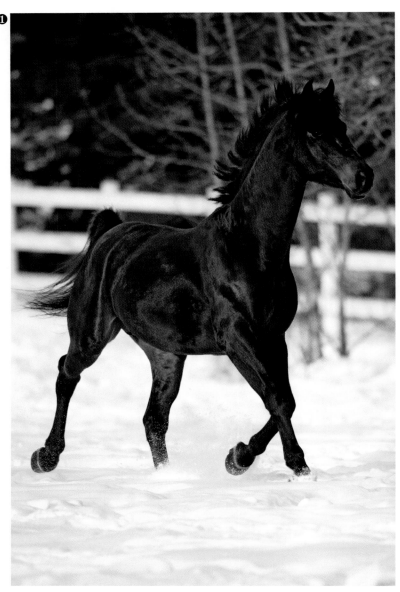

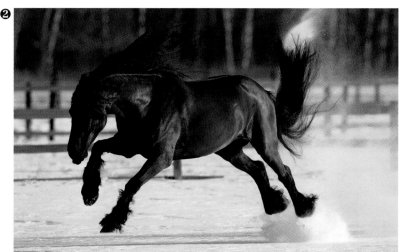

Top:
An Oldenburg stallion proudly trots across the snow enjoying his winter freedom in Alberta, Canada. The Oldenburg is the largest of the German breeds and was once famous as a carriage horse, but it is now more refined and has become a popular sport horse. ❶

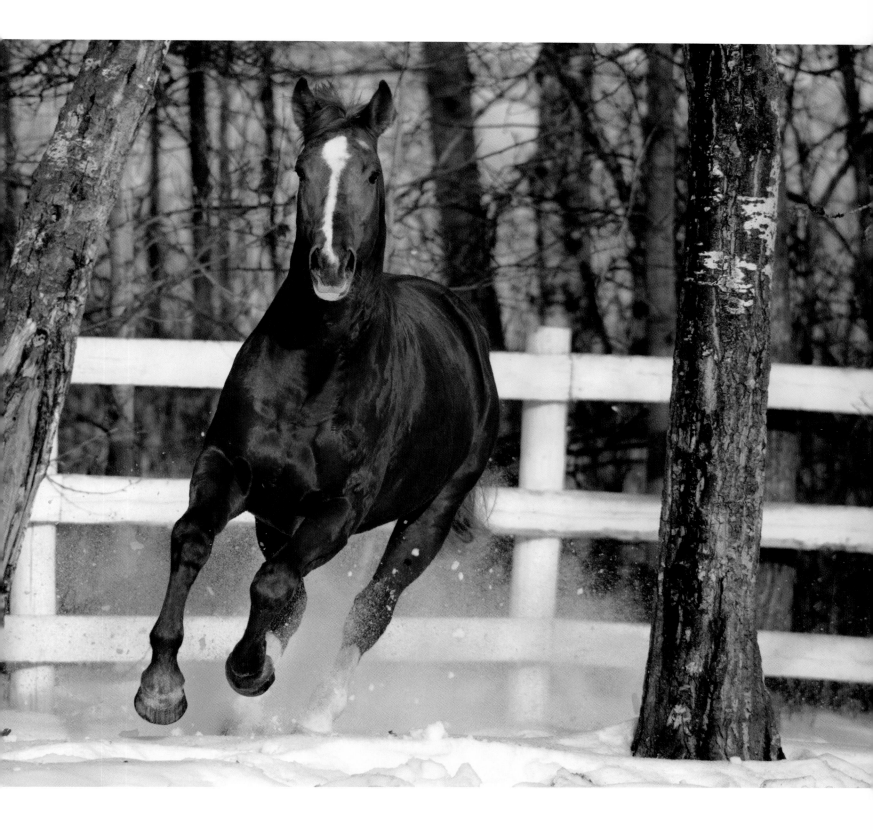

Opposite bottom:
This bucking Friesian was photographed on the same farm as the horse above but was far less sedate and plunged up and down through the snow like a mad thing. It certainly made an expressive picture! Bob says that generally pure black horses do not work well against snow; you may as well be using black and white film. ❷

Above:
A chestnut Trakehner stallion gallops between two trees in Alberta. This is one of those images that illustrate the difference between a professional and amateur equine photographer. Not many would have realised the horse would come at speed through such a relatively small gap. This picture clearly shows the balance and power of horses in motion, and it's one of my favourite pictures! ❸

❶❷❸

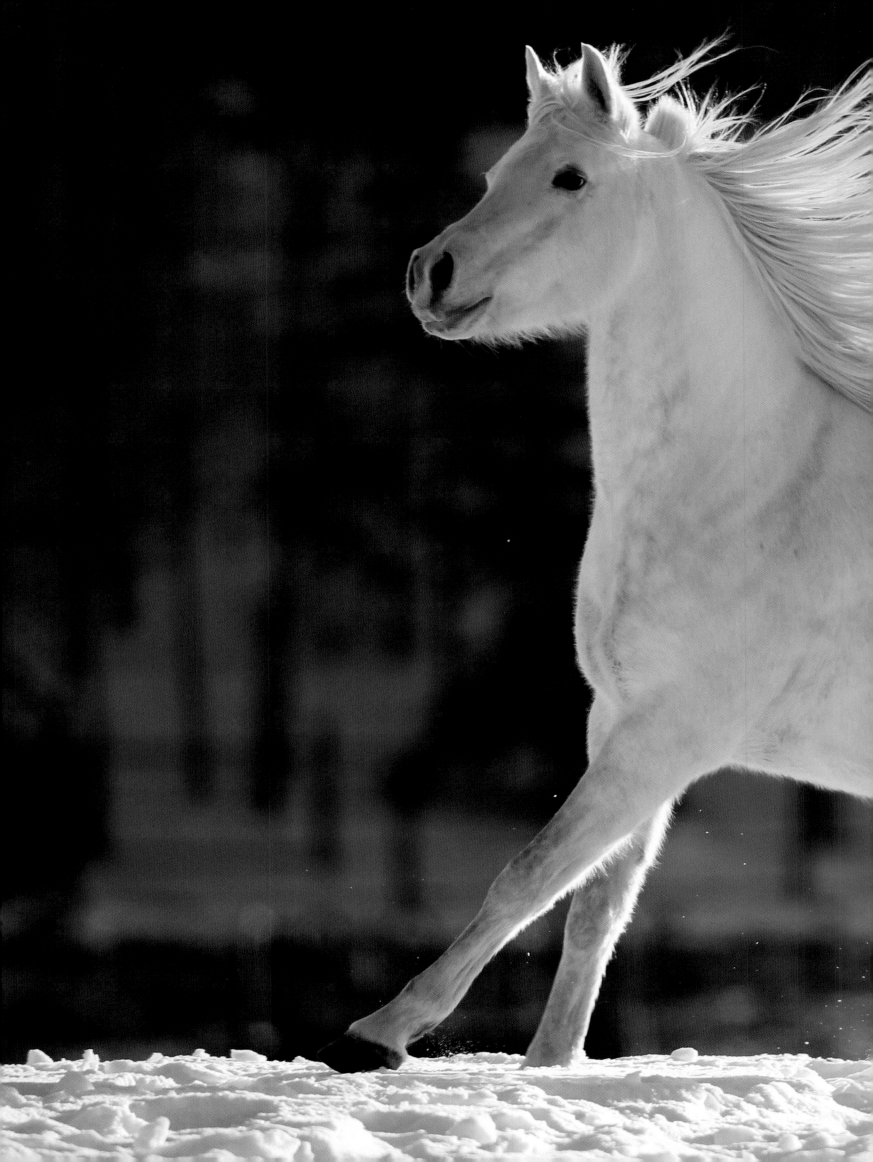

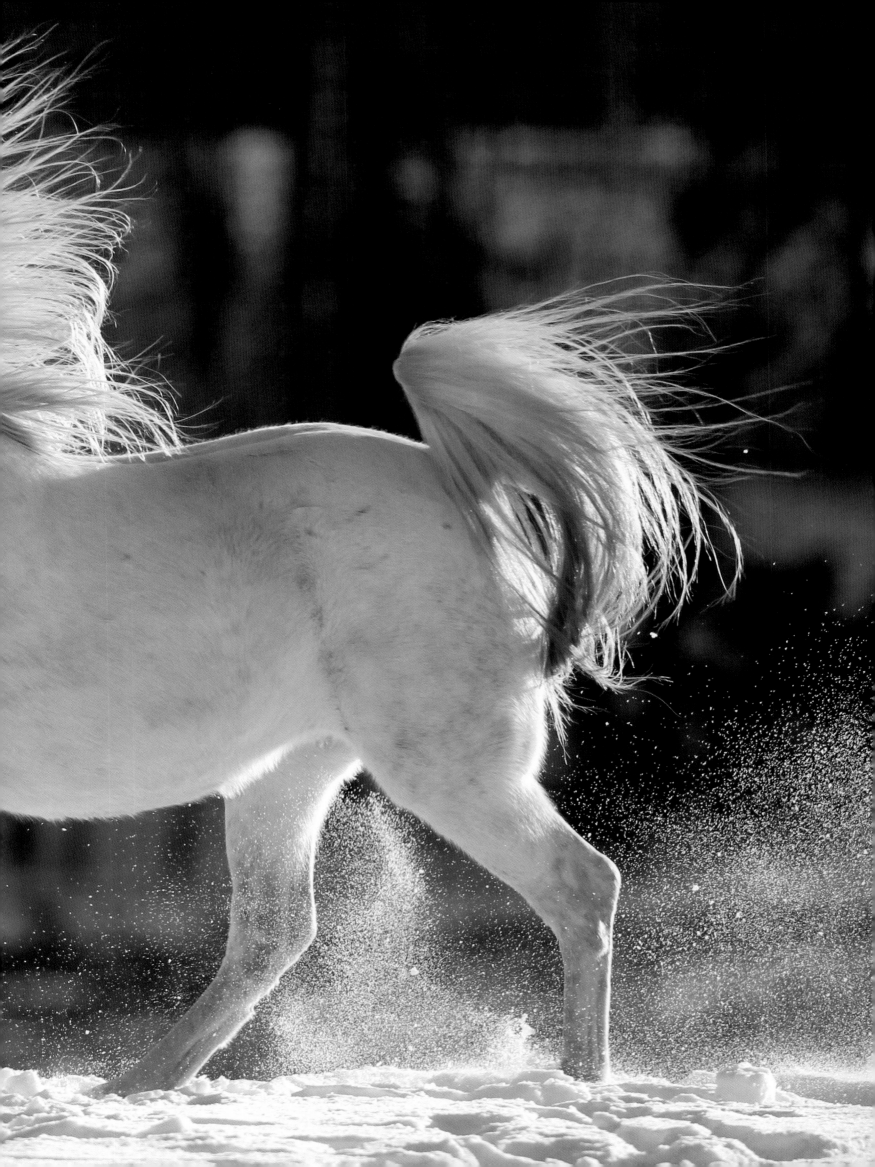

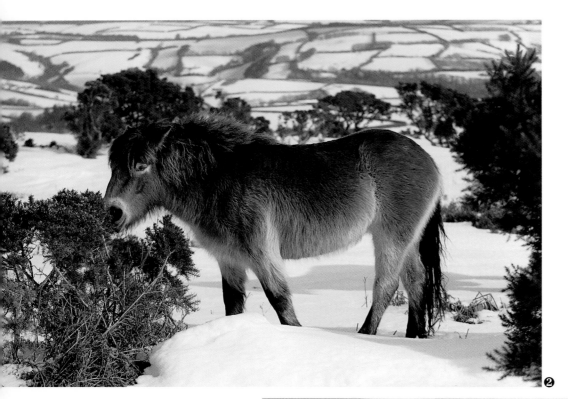

Previous double page:
An Arabian mare glows in the sunshine and snow of Alberta, Canada. Bob says he is not a great lover of backlit horses in pictures, but greys are an exception, and he says, "The end result proved me wrong; it's a great picture!" The animal's expression, the movement, and the light on the flying bits of snow make this picture memorable. ❶

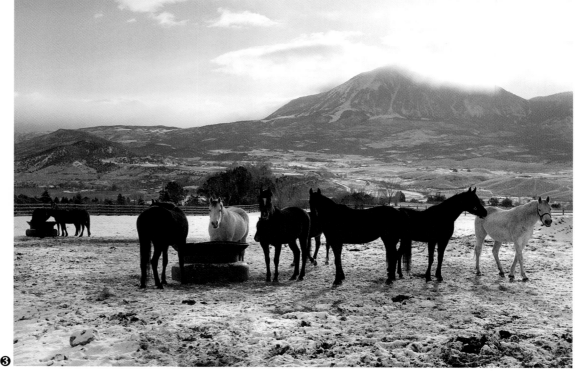

Top:
An Exmoor pony photographed in its natural habitat in North Devon in the UK. Bob always tries to get a variety of pictures of all breeds for his library, including ponies in the snow. This one is picking at the mineral-rich prickly gorse, the only vegetation available after the recent snow, and it needs to be nibbled carefully. ❷

Above:
A relaxed herd of Arabian horses at Bellinger Horse Farm in Colorado would not move away from the mangers. Bob tells the story of how his host, Donna, came out dressed as a bear and made growling noises, which scared the horses and made them take off past the camera. Donna taught him a lesson in how to attract his subjects' attention. ❸

❶❸❹ ❷

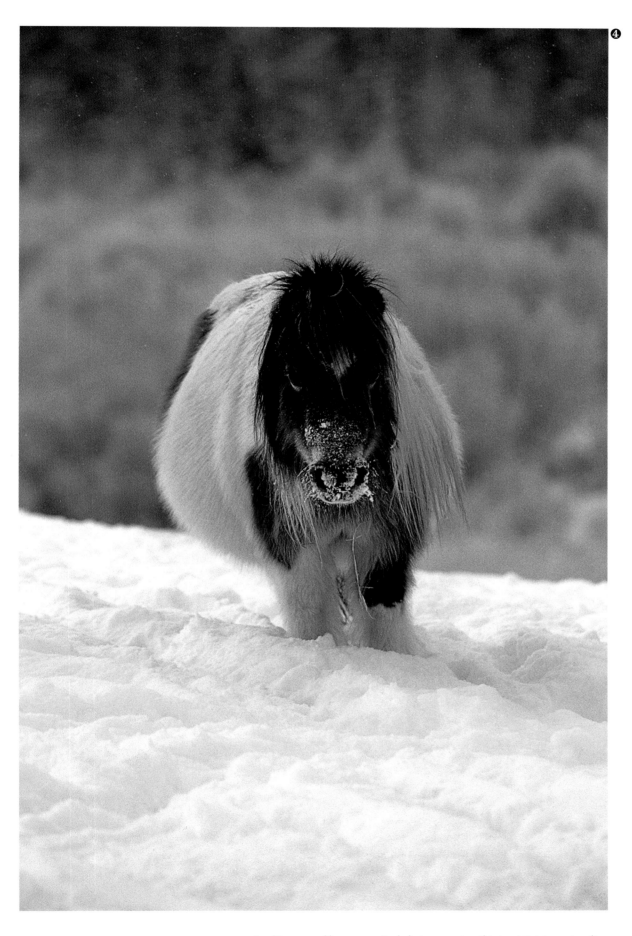

Looking more like an amazingly hairy monster, this is a Miniature standing just thirty-six inches high. It posed for Bob without any protest despite the temperature that day in Canada of minus 30 degrees Celsius! With its very thick coat full of natural oils, these animals can keep themselves warm, but unfortunately many people feel the need to interfere with their natural coping mechanisms and wrap them up, unbalancing their temperatures and often leading to unnecessary vet bills. ❹

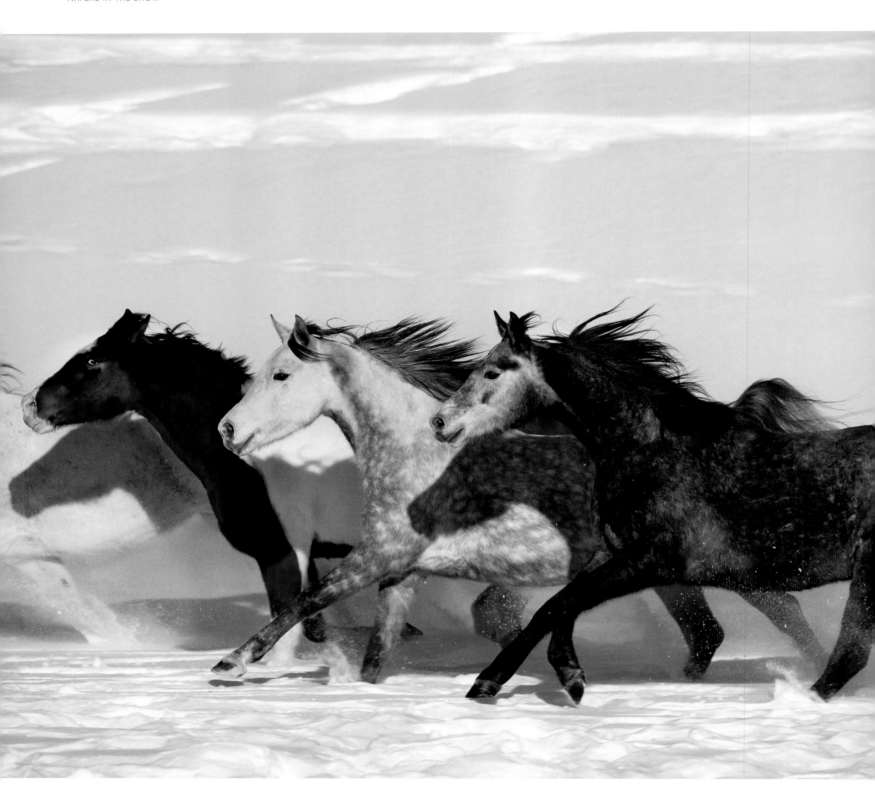

Above:
A Paint Horse joins a group of Arabians at Sherwood Park in Alberta, Canada. ❶

Opposite top:
Three grey Trakehners enjoy galloping through the snow with the woods in the background at Meadowview Farm in Alberta, Canada. Once they have let off steam, most horses will settle down to look for forage by nuzzling through the wet cold snow, but when the snow is very thick, this is not so easy. All animals need extra feed if left outside in these conditions. ❷

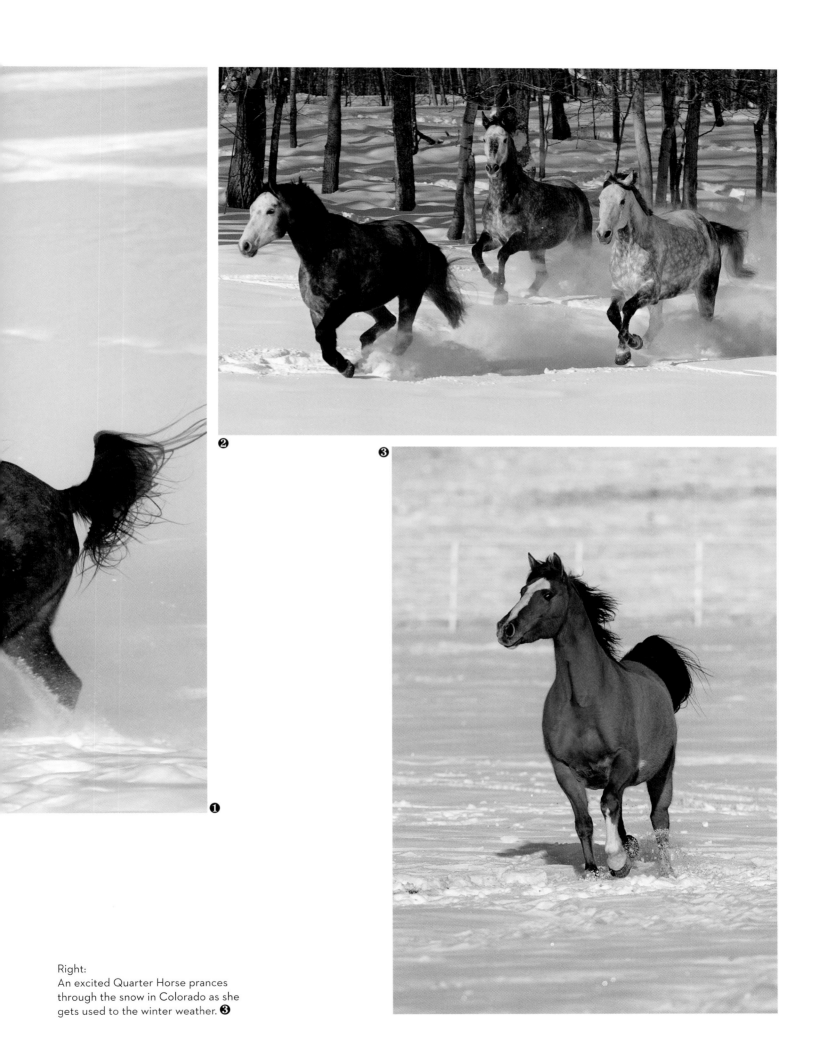

Right:
An excited Quarter Horse prances through the snow in Colorado as she gets used to the winter weather. ❸

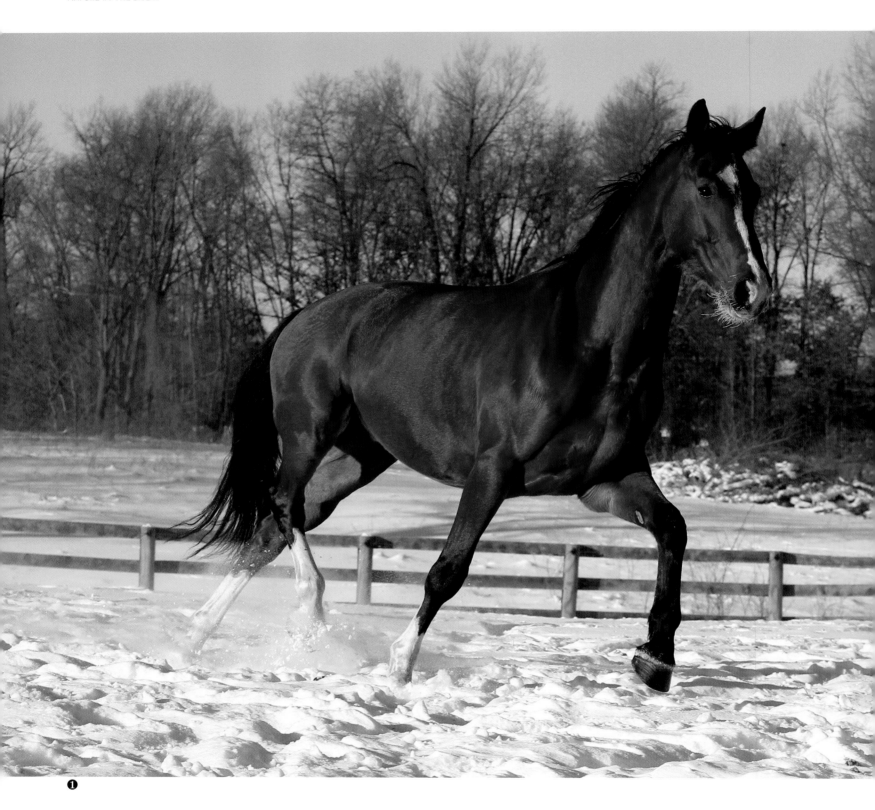

❶

Above:
This fine Rhinelander enjoys a trot round his paddock in Germany. Closely related to the more prolific Westphalian, the breed is now a quality competition horse capable of several disciplines. Germany is renowned for the number of top-quality competition horses it produces for all three Olympic disciplines: Dressage, Show Jumping, and Eventing. ❶

Opposite top:
A Morgan in Alberta, Canada, moves effortlessly through the thick snow. The uncertainty of what is underneath rarely seems to worry these animals. Indeed, it could be a concern if the area was not clear of anything which could injure the horses. This is why most horse farms and ranches keep dangerous materials in a contained area out of reach of horses. ❷

❷❸ ❶

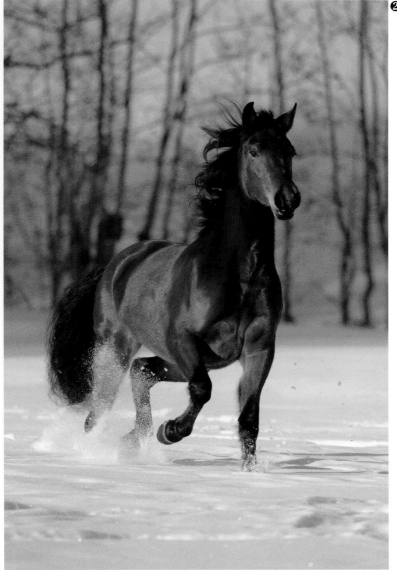

Bottom:
These two Morgan horses seem to be posing especially for Bob! Something has caught their attention, and they are looking round to see what it is. You always hope something will make the animals alert so that they perform for special pictures, and this is definitely one of those! ❸

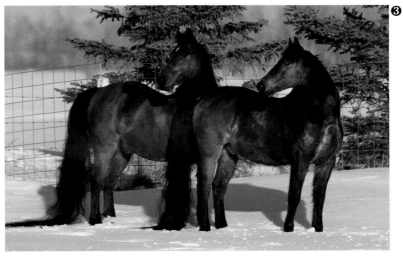

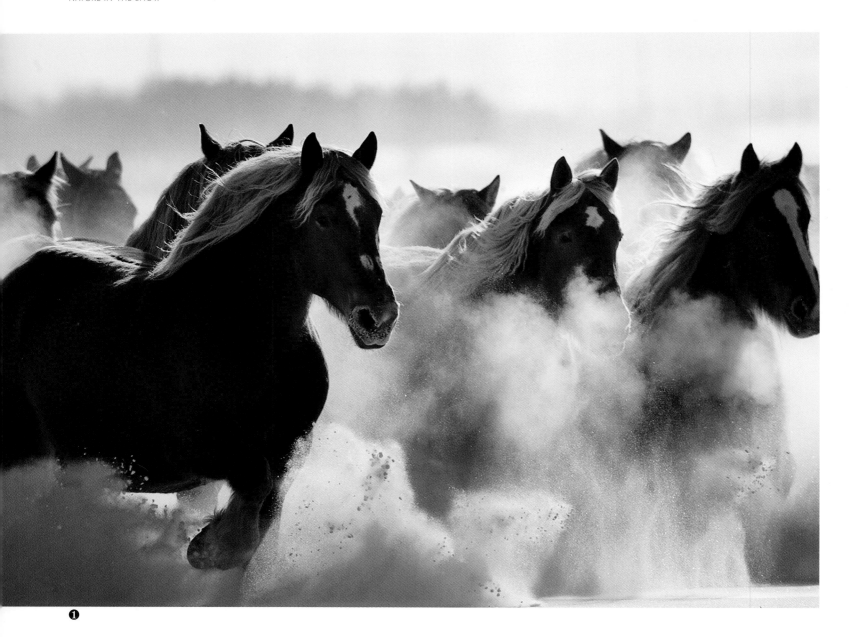

Above:
Often Bob goes to Alberta in Canada or Colorado in the USA for winter pictures. On this occasion, Bob was photographing a group of Belgian Draft horses in Canada as they were chased towards him. "I thought I was going to be flattened. As you can see, they were looking straight at me, but luckily, they split to either side, and this happened on two or three occasions!" he says. ❶

Opposite:
A fluffy Shetland pony poses just a few miles from where Bob lives in Gloucestershire, photographed from the roadside on the common. Shetlands are a very hardy breed and the smallest of the British natives. As their name suggests, they originate from the Shetland Islands in the north of Scotland. ❷

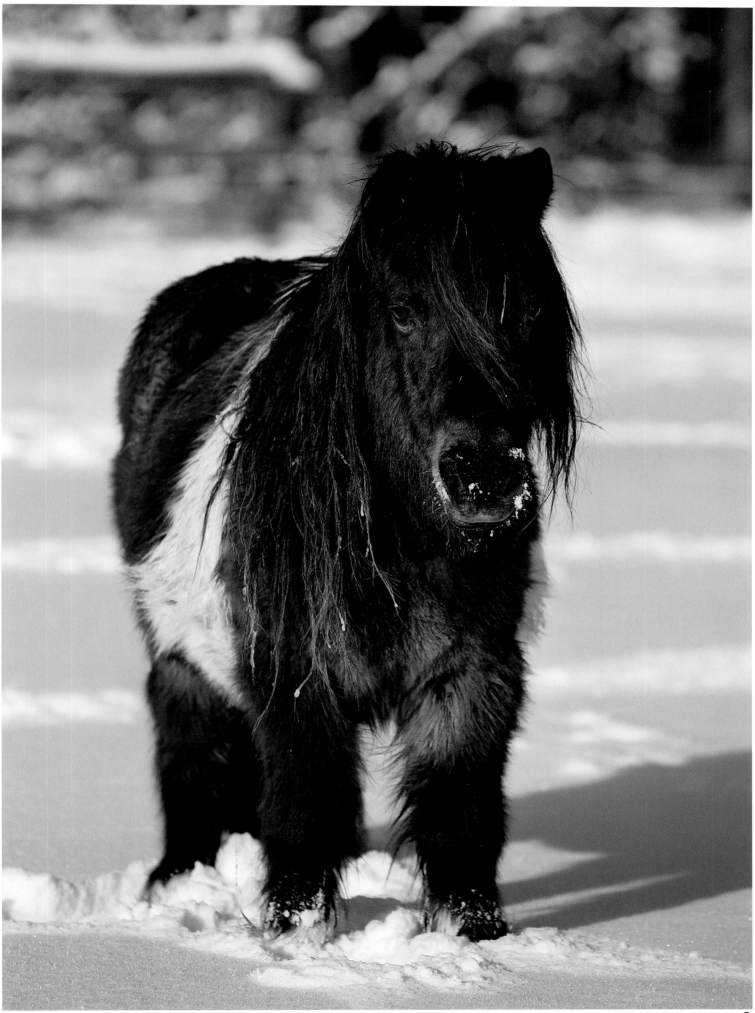

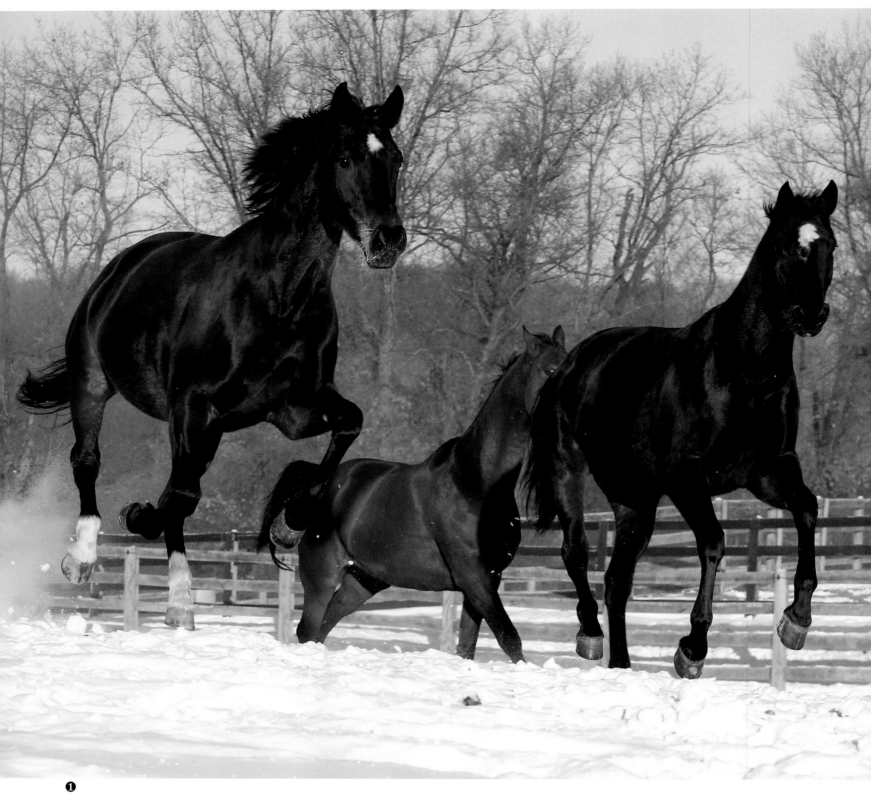

❶

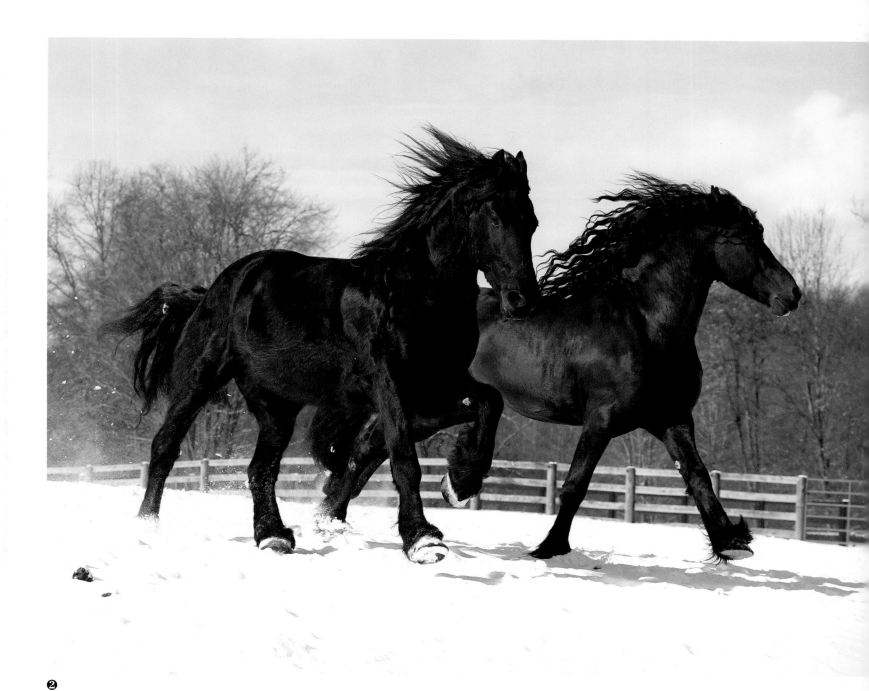

❷

Opposite:
These fine Oldenburg and Hanoverian mares are thoroughly enjoying their downtime in the paddock at Appin Farm in Michigan, USA. The owner brought them over and let them loose especially so that Bob could get these pictures of them during one of his winter visits to the States. ❶

Above:
Two purebred Friesians thunder across the snow at the same farm in Michigan midwinter. It is amazing to be able to see the underside of these magnificent animals' hooves as they gallop across the paddock, demonstrating their flexibility. ❷

❶❷

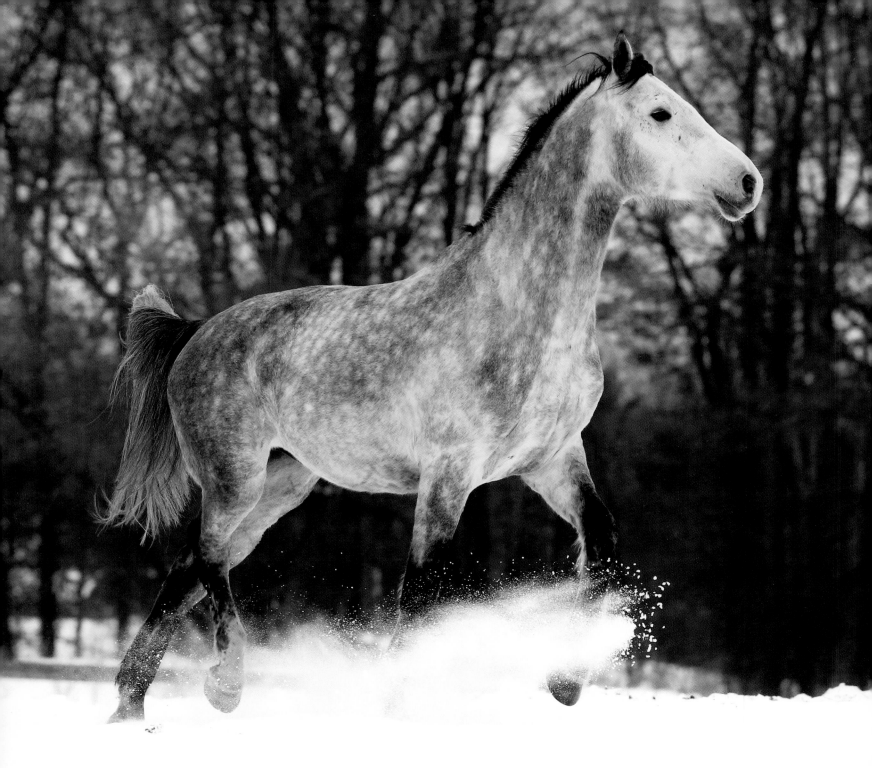

❶

A grey Rhinelander, one of the lesser
known of the German breeds, trots across
the paddock at Appin Farm, Michigan,
where a huge breeding project of several
sport horse breeds is in operation.
The Rhinelander is a close relative of the
more famous Westphalian horse, originally
coming from Warendorf, Germany. **❶**

❸

❷

❶

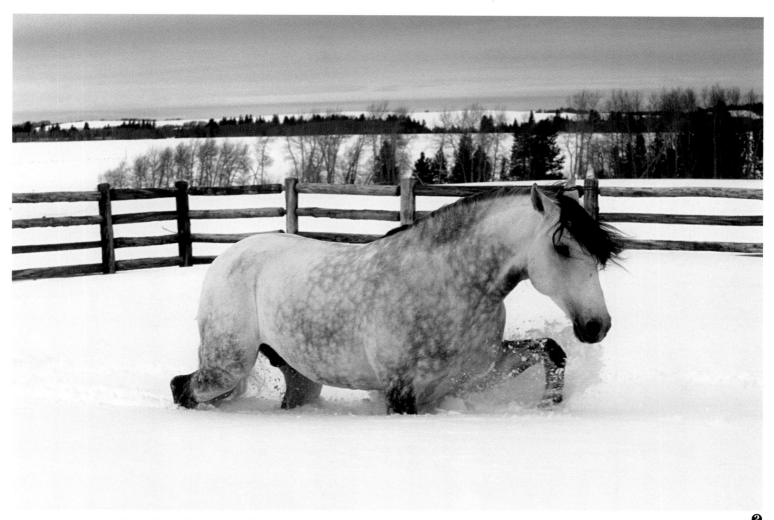

❷

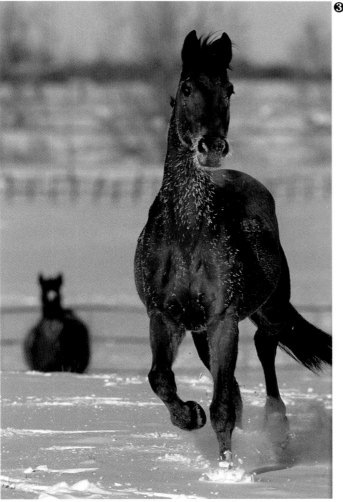

❸

Above:
This Lusitano stallion, owned by Bill Robinson in Idaho, was put out into very deep snow for exercise and for Bob's benefit, so he could get this unusual photograph. ❷

Left:
A Hanoverian obliges Bob on one of his winter visits to Calgary thirty years ago, hosted by Spruce Meadows, home of the famous International Horse Show. Bob persuaded the owners to turn some horses out in the snow, and they duly performed in front of the camera. ❸